STYLE IN THE SECOND WORLD WAR

FASHION
ON THE RATION

JULIE SUMMERS

In Partnership with Imperial War Museums

P

PROFILE BOOKS

For Catriona, my very dear and beautifully dressed friend
and chapter six for George B.

Contents

Introduction

*Keep up the morale of the Home Front
by preserving a neat appearance.*
The Board of Trade, 1940

When the Second World War broke out in September 1939, it was to be total war, a war in which there were no non-combatants. Civilians and the military would both have to face 'the enemy', as the government had warned the public as early as 1932. Stanley Baldwin told the House of Commons: 'I think it is well also for the man in the street to realise that there is no power on earth that can protect him from being bombed ... The bomber will always get through.'[1] For many, especially those who had lived through the First World War over twenty years earlier, this was the worst conceivable nightmare. For others, it was thrilling and terrifying at the same time. A young journalist writing for Mass Observation recorded in her diary just four days after the war had broken out: 'My horror of all this war business is qualified by an eagerness to be a unit of it. I feel as if I have been waiting for this all my life and I have just realised it.'[2]

The Second World War wrought almost incalculable destruction

and horror, but it also produced astonishing bravery, great leadership and determination, as well as creativity and inventiveness. And as this was total war, these characteristics were mirrored on the home front as well as on the battlefield. The war accelerated the process, begun in 1914, of moving women 'out of the wings' and into an active role, if not usually into active combat. Only the very young, the sick and the very elderly were passive participants in this war.

At the beginning, the government hoped that it could get away with the minimum amount of social and economic dislocation. The evacuation programme put paid to the former – and the hole in the nation's budget, which only got worse during the early months of the war, put paid to the latter. By the time France fell in June 1940, it was clear to everyone that the country was in for a long war and the government, which had by then already gained considerable control, took ever more steps to manage every minute aspect of people's lives. As the novelist Barbara Cartland grumbled, in 1944 everything was rationed except, possibly, love.

If you ask anyone who lived through the war about clothes rationing, they will almost certainly tell you about coupons, parachute silk, utility clothing, Make-Do and Mend and perhaps Mrs Sew and Sew. Words such as drab, grey and threadbare are often applied to wartime clothing. Certainly, evacuee children who returned from abroad after the war were shocked by the absence of colour after the bright shades they had been used to in Canada, Australia and the United States. How we see clothing in wartime Britain is shaped by our knowledge in hindsight of the whole war and the years of austerity that followed it. Some people believed that the fashion industry stagnated during the war; others claim that it carried on creatively. The truth is somewhere in between. Far from being a story of drabness and misery, it is a story of colour, inventiveness and determination to carry on regardless of the shortages and constraints of the coupon culture.

The aim of this book is to take an overview of clothing and fashion during the Second World War in Britain. There was a marked difference then, as there is now, between haute couture and what the man or woman on the street wore. Early in the war, this gap narrowed and the style of

*One of a number of posters injecting a sense of urgency
into the Make-Do and Mend campaign.*

everyday clothing changed and simplified, reflecting the desire to avoid wanton extravagance and frippery while men were away in the forces, fighting for the country's freedom. I will look, too, at the consequences of having over 15 million Britons wearing uniform of one kind or another, and tease out the rationale and bureaucracy behind clothes rationing. Many myths have grown up around wartime clothing, from parachute silk underwear to Make-Do and Mend, obscuring some fascinating details of the real story, and I will examine these too.

While women's fashion changed twice a year, men's suits and clothing tended to be mass produced and so did not go out of fashion so quickly. Thus it is the focus on the changing face of women's fashion that this book

will concentrate on, though the austerity measures brought into play in 1942 had a major impact on the length of men's socks and the abolition of turn-ups on men's trousers, which caused uproar. Not everyone in Britain sought to wear the latest fashion all the time: for some it was a matter of choice or practicality; while for others it was simply that fashionable clothes were beyond their budget. Some had well-stocked wardrobes, others had plenty of dressmaking material, while many struggled on a meagre supply of pre-war clothing and what they could get with coupons. All these factors are relevant in illustrating how ordinary people dressed on and off coupon during the Second World War in Britain and how the fashion industry changed to reflect the different moods in the country over the course of the war.

During the early years of the war, the fashion houses continued to produce spring and autumn shows, and sometimes even a mid-season range would appear. In February 1940, the Paris couturiers presented their spring collections, which the London fashion editors quickly absorbed and recycled with comment for their readership. The emphasis was on coloured accessories such as scarves and hats, as well as nails and lipstick, to complement the grey-green, pinks and delicate blues of the early year. Tweeds were much in vogue and the cut of the two-piece costume for women and the suit for men owed much to the military uniform which was by then seen everywhere. *Vogue* featured 'Rhavi's tweed coat ... tailored on guardsman lines, with spanking gold buttons. They make it in coral, too (more practical as a housecoat). Price 20 gns'(approximately £1,100 in 2014).[3] Paris still produced fashion into the summer of 1940 but their ability to export ended after the occupation of France.

Later on in the war, fashion became constrained by shortages of materials, and designers simply had to work with what was available. In 1989, Maggie Wood published a slim volume to accompany an exhibition on wartime clothing at the Warwickshire Museum. The book, entitled *We Wore What We'd Got*, offers a revealing and highly entertaining snapshot of women's fashion away from the high street and the pages of *Vogue* or *Harper's Bazaar*. Like many, Wood had expected to find an overall picture of women 'usually in a queue – dressed in severely tailored coats, with

heads bound in turbans. The impression ... of a nation of women in a kind of civilian uniform.'[4] Yet she was astonished and impressed by the patience and imagination of women determined to maintain their individuality: 'they created clothes, shoes and accessories from the most unlikely of materials, and "customized" plain utility dresses with embroidery, paint and home-made trimmings. Such garments were not "high fashion", and not always very elegant, but they ensured that beneath the austerely functional coats and jackets some women were uniquely clad.'[5]

For the poorest members of society, clothes rationing actually had a beneficial aspect in that the quality of clothes they could purchase increased significantly after utility cloth and clothing was introduced. This is one of the lasting legacies of rationing for mass market clothing. It was always the government's intention that good quality materials would be used to make clothes that would be sold at prices that could be afforded by all. For the wealthy, the impact of rationing was barely felt. Far more significant for them was the reduction of formality, the demise of the evening dress and 'occasion-based garments' so loved by *Vogue* and the other fashion magazines, though that demise had already been foreseen by editors before the war. It was the men, women and children sandwiched in the middle who were most affected by clothes rationing and the coupon culture of the 1940s.

I have been involved in researching the Second World War for the best part of fifteen years and fashion and clothing are a fascinating aspect of the social history of that era. It was a time of uniformity on the one hand and individual expression on the other. What people wore and how they felt about it – whether smart in battle dress or tatty in patched and darned clothes – said much about the spirit of the time.

Some of the most revealing and enticing details are found in personal documents and I have made use of the letters, diaries and archive notes of a number of men and women who kept records of their wartime experiences. The first is Bill Fagg, who worked at the Board of Trade from 1940 until the end of the war. At the age of just twenty-seven, he was in charge of utility clothing for men's outerwear, a daunting responsibility. His friends would tease him about his role and in March 1942 one of them,

Edmund Rolfe, wrote: 'My *Daily Express* warns me of all sorts of new sartorial developments for the future. I suppose the Board of Trade has to be kept going somehow.'[6]

Florence Hyatt, known as Flo, was a typist at Oughborough House in Godstone, working for the Cereals Import Committee. She had family in America who would periodically send her clothes, and she responded with long letters telling them all the latest war news. Fifty years after the war, she settled down to turn the surviving letters into a book. 'Panic! I'll never do it!' she wrote in the Introduction to her unpublished book. 'Am I trying to convince myself that these letters will be of interest years after the events took place to a generation who did not experience them? I think: was it really like that? Did that happen?' Flo died before finishing the edits but they were completed by her niece, Janine Hyatt, and comprise nearly 300,000 words. They are a priceless record.

At the outbreak of war, Eileen Gurney was married with a baby boy. Her husband John was away from autumn 1940 and her letters to him are full of details about dressing herself, baby Richard and later her daughter Stella. They offer a vivid snapshot of life in London for a young mother during the war and of the frustrations of day-to-day life. She wrote to John: 'I have hundreds of wet nappies on the line so I am just praying the rain will hold off till they dry. I wage an eternal war against the weather, trying to get the washing dry each day. At the moment the weather is definitely winning.'[7]

Gladys Mason's diaries tell the war story of a young woman who married in October 1939 in a wedding costume made by her mother in just four days. Her observations are matter of fact and sometimes almost comically juxtaposed with the enormity of events in Europe. On the day the war broke out, she wrote: 'Lovely day. Germany given until 11 a.m. today to withdraw troops. Refused, so we declared war on her. Prime Minister spoke at 11.15. Air raid warning at 11.30 but false alarm. France at war at 5 p.m. Felt better today. Frank came. Had terrible thunderstorm in the night.'[8] The dress and the diaries are in the collection of Gladys' daughter, Barbara Hall, and they have never been published.

Zelma Katin was a tram conductress in Sheffield during the second

half of the war and her autobiography gives wonderful detail of life in uniform for a middle-aged woman. Of the interview day she wrote: 'Women, even as strangers, tell each other far more of their private lives than men divulge to their own sex, so it was not long before we knew that among us were three housewives, a tailoress, the manageress of a food shop ... a typist, an ex-university student and a music-shop assistant. We were not nervous. On the contrary I liked the philosophical way in which everyone accepted the situation.'[9]

May Smith was a schoolteacher in Derbyshire and wrote a diary that was published under the title *These Wonderful Rumours!* One of her preoccupations during the war was shopping for coats and dresses. She was one of a new class of post-First World War women whose families had moved out of the cities to suburban Britain. They had jobs and therefore money to spend in the new chain stores which had sprung up on the high streets throughout the country.

The final voice is that of Audrey Withers, the wartime editor of *Vogue*, and my grandfather's cousin. She was one of the most powerful and influential women in British fashion and was responsible, with other senior editors of women's magazines, for disseminating the government's thinking on clothes rationing and helping to shape ideas about design, fashion and hairstyles. She wrote in her autobiography, 'Women's magazines had a special place in government thinking during the war because, with men in the forces, women carried the whole responsibility of family life; and the way to catch women's attention was through the pages of magazines.'[10]

I have set out to cover all aspects of wartime wardrobes from haute couture to flourbag shirts and parachute silk undies. The story of *Fashion on the Ration* is one of inventiveness and creativity, determination and stoicism, all laced with rich humour. We will follow the chronology of the war by looking first at the clothes and wardrobes of the 1930s, through uniform and functional fashion, to rationing, utility and the concept of beauty as a form of national duty. The final chapter takes a glimpse of the New Look which swept through fashion in 1947 and finally blew away the cobwebs of austerity in Britain in the early 1950s. When all is said and

done, the world of fashion judged the war years of utility and austerity to have been a positive time for British design, even if the collective memory tends towards recollections of dreary Make-Do and Mend. I hope this book will present both sides of the story.

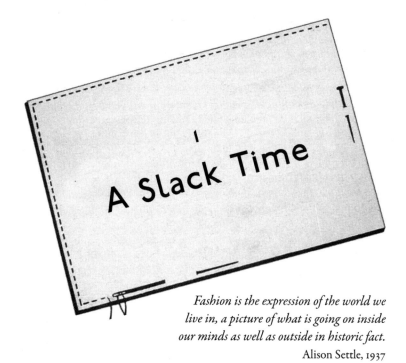

1

A Slack Time

*Fashion is the expression of the world we
live in, a picture of what is going on inside
our minds as well as outside in historic fact.*
Alison Settle, 1937

At the beginning of the twentieth century, most women either made their own clothes or had them made up. Some, who could afford it, had them designed *and* made, while a lucky few had their own dressmakers on their staff. The 'well-bred, well-off' British woman understood only too well the importance of correct dress, as opposed to fashion, for the right occasion. Britain in the late 1930s was a country deeply divided by tradition and class. The decade had been scarred by mass unemployment and poverty, while the affluent seemed to grow ever richer. The gulf between the unemployed of Jarrow and the smart set of Mayfair was immense, but in between was the burgeoning middle class that had moved into newly-built suburban Britain and shopped on the high street for Paris fashion look-alikes. The desire to buy and wear beautiful clothes seems never to have been stronger.

In 1939, what you wore still said a great deal about who you were. It

defined what class you came from and was a powerful reflection of status. Men and women in the highest tiers of society changed several times a day and always for dinner. The *Vogue* pattern book for June–July of that year defined five categories of clothing: 'For Town, Active Sports, For Afternoon, For Evening, Spectator Sports'. Although for some time clothes had been designed with greater flexibility so that the wearer could go between town and country without having to change constantly, dinner jackets and dresses were still de rigueur for the evening. While it was acceptable to look business-like and efficient during the day, the image of the woman in the evening as 'mysterious, alluring, witty, veiled, gloved, corseted and even button-booted as any romantic, fairytale queen'[1] persisted.

By contrast, the poorest town and city dwellers might have only one set of clothes, which meant they could not go out on washday and their children were often lacking adequate footwear to attend school in the winter. Their plight was largely invisible and it was only with the onset of the war and the evacuation scheme that the government put in place in 1939 that the conditions of the poorest section of the population came to the wider public's attention.

In the middle class, men wore suits and women wore skirts, stockings, hats and gloves to go to work, to go shopping or to attend church. Wardrobes changed with the season. Winter clothes were put away when the warm weather set in and summer dresses and shoes were given a brief few months in rain or shine. According to a Mass Observation survey, conducted in 1941, the average wardrobe of a middle-class woman consisted of seven dresses, two or three 'costumes' or two-piece suits, a similar number of skirts, three overcoats, one mackintosh and five or six pairs of shoes, split between the seasons; while a poor woman might have only three dresses, one skirt, one or two overcoats and one or two pairs of shoes. A middle-class man might have three suits, two overcoats and four pairs of shoes; whereas a poor man was likely only to have one suit, one overcoat and a pair of shoes or clogs. Iris Jones Simantel's family belonged in the latter category: 'Mum, as I recall, had two dresses, both of which Dad had made for her. One was made out of an old curtain and the other cut down from someone else's very large cast-off. He made hats out of an

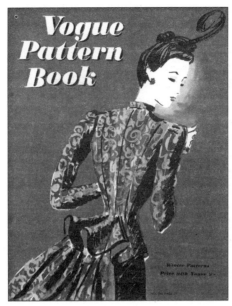

*Published seasonally with Vogue, the pattern book was used by
dressmakers in the trade as well as for private clients.*

old astrakhan coat. Dad also made my brother and me winter coats out of
an army blanket – the coats were so stiff, they stood up on their own in
the corner.'[2]

Although Paris was the undisputed fashion capital of the world,
London set the tone. Edward VIII, as the Prince of Wales, led the change
towards an elegant but unstuffy approach and gave the aristocratic style a
fashionable boost which confirmed London as the arbiter of taste for the
upper classes. Society was still hidebound by the traditions of country-
house weekends, the London season and presentations at court, as well as
Ascot and Henley. There was a dress code for every occasion. People knew
the rules and woe betide anyone who got it wrong. The fashion maga-
zines constantly reminded women how to dress correctly. In August 1939,
Vogue told its readers: 'This is the hat to wear with your new town suit,'

illustrating a black felt hat with a broad scooped brim tilting well over the nose: 'Behind, it's a snug hood, hiding most of your back hair (which, this season, is more than likely to be out of the public eye).'[3] At the same time, it was warning readers that the autumn furs would be balloon-sleeved ermines for evening wear, chunky stone-marten for the day and basqued beaver for around town, with leg-o'-mutton sleeves being described as a 'town-into-country' jacket.[4] Although Paris tended towards wool for high fashion, tweed was a favoured material of both men and women in Britain and continued to be worn throughout the war. The tweed suit had become an icon of Britishness. Lady Denman, the impressive and sometimes formidable Director of the Women's Land Army and Chairman of the National Federation of Women's Institutes, was overheard expressing shock that an interviewee had said she would arrive from London by train in Sussex wearing pink. Lady Denman, sure that pink was a city colour, drove to collect the woman in a cloud of cigarette smoke and concern, only to greet her warmly as she stepped down from the train, saying: 'What very smart pink *tweed*.'[5]

Vogue editor Audrey Withers explained the annual routine in London during the 1930s. 'Twice a year the Paris collections, interpreted and publicised by the press, laid down "The Look". Fashion-conscious women would come to London in spring and autumn to buy their clothes and, before they bought, they would ask *Vogue* the position of the waist, the length of the skirt, the favourite fabrics and colours; and we could give confident rulings. This was a powerful incentive for buying the magazine.'[6] In the 1930s and 40s women wanted a strong lead from the fashion editors, whereas in the 1950s, when Audrey Withers was still editor, women wanted to dress as they wished and looked to magazines for 'drama, excitement and a dash of the outrageous'.[7]

Coco Chanel and Edward Molyneux dominated fashion on the Continent in the 1930s and their designs inspired the younger British designers Digby Morton, Hardy Amies and Norman Hartnell (who will all feature later in this book). The 'look' had changed from the flat-chested, dropped waist, mid-length dresses of the 1920s, associated with the golden age of jazz and the economic boom that followed the First World War, to a more

curvaceous silhouette, with nipped waists and the bust no longer flat and mono, but divided and shapely. By the middle of the decade, padded shoulders had made an appearance, emphasising a slim waist and comely shape. Chanel developed the tailored suit that remained popular for the rest of the 1930s, leading into the military-style women's two-piece costume that was to become so familiar (though pared down to the minimum) during the war. The decade saw designers alternating between white wool and brightly coloured silk or cotton fabrics, though the colour in 1939 was ominously described in *Vogue* as 'storm-coloured'. It was above all a decorative era. Large pieces of costume jewellery were used to enhance plumed hats and gauntlet gloves; hairstyles became more dramatic so that by 1936 hair was worn brushed to the top of the head in a mass of curls and the natural bone structure of the face emphasised by make-up. In 1938 the innovation was the backless evening dress with 'gorgeous drapings' on the bodice and skirt. While male fashion tended to change less than female's, nevertheless men were also susceptible to outside influences, one of the most noticeable being Anthony Eden's Homburg hat, which was worn and carried by so many that the style became typical of the quintessential English businessman.

It was not just the Paris fashion houses that influenced women's dress, however. All the fashion magazine editors looked to Queen Elizabeth as the symbol of the 'lady' in 1930s society. 'She was gracious, refined, strong but not assertive, moral, caring and aware of her debt to society. Her appearance, understated and smart, although never gaudy, was crucial.'[8] It was important that the Queen should look elegant but not fashionable. This was a key distinction. If she wore the latest fashions, her clothes would soon look out of date. She understood this, and so did the man she chose to dress her from 1940 onwards, Norman Hartnell. Having started his career in the theatre, Hartnell understood better than most that every time the Queen appeared in public she was stepping into the limelight. 'Royal dress must never be pedestrian. It requires a style outside the prevailing conventions of modishness. It must, in fact, reflect the current fashion as little as possible if it is to retain its dignity. A Queen cannot dress so much in the fashion that a picture of her ten – or even five – years

later will cause people to smile and think her old-fashioned. That is why Queens require their own style.'[9] During the war, Hartnell underlined the monarch's role to inspire the women of the nation. She was entitled to wear any one of five service uniforms, but although she was photographed in the uniform of St John's Ambulance featured in *Picture Post* in September 1939, she chose to avoid them after that.

More women than ever were working either in the home or outside, so that daytime clothing became less formal and more practical, although, as we have seen, evening dress was still luxurious. Then, in 1934, the 'little black dress', with its skirt below the knee, made its first appearance and became universally popular. It was soon seen as an essential for every wardrobe as it could be dressed up or down to suit the occasion, but above all it represented good taste. By the end of the 1930s, there was a growing sense amongst some in the fashion industry that opulence was outdated. Alison Settle, a fashion writer for *Vogue* at the time, declared that 'the woman to envy in her dressing is not the woman with the excellent and complete wardrobe of clothes but the woman who, with a handkerchief from the handkerchief drawer twisted and tied with *chic* round the neck of a dull dress, causes you to forget the dress and only admire her *chic*.'[10]

While some *Vogue* readers could afford to have their clothes made up in the capital, such extravagance was not possible for everyone. A dress by one of Britain's top designers, such as Norman Hartnell, could cost anything up to 45 guineas (£2,500 in 2014), a sum well beyond the reach of the vast majority of the population and equivalent to four months' rent for an average house outside London. So *Vogue* printed a separate pattern book which it published with the main magazine. It was aimed at home dressmakers but was widely used by the trade as well, since it was possible to make dresses and costumes for a fraction of the price paid in the London fashion houses. At this time there were thousands of dressmakers throughout the country, and their role in disseminating fashion trends outside London cannot be overestimated. It is also true that almost every middle-class woman had some skills in needlework, so she would be able to alter clothes and repair them, if not make them from scratch from these patterns. This would stand them in good stead over the next few years.

Rather than copying the Queen, the newly wealthy middle classes aspired to dress in clothes they saw on the screen or in magazines, but for a fraction of the price. May Smith, a teacher in Derbyshire, spent most of her earnings on clothes. In April 1939 she wrote: 'Mother, Auntie Nell and I go to Derby in search of a New Coat. Go to Bracegirdles in some despair, having seen nothing at all that I like in the window. However, modish and vastly superior assistant produces a nice blue edge-to-edge coat which I try on and like. Then try on frocks to match, though really cannot afford one. Eventually plunge on Gay Flowered thing and emerge broke. Mother has to pay for my tea.'[11] Two days later she went to Burton on her own to buy a hat and was pushed by the 'oily tongued vinegary-looking' shop assistant towards 'the most vile, noxious and fantastic creations which she calls Models. Try on coarse straw monstrosities, a Modern Beret Shape and an off-the-face Fantasmagoria, and many more.'[12] May let out a howl of horror at the price tags – 35 shillings – but was reassured that these were the latest fashions from France, just in. She escaped from the shop with some difficulty and found a hat in another store for 12s 11d (£33.75 in 2014), which she bought on the spot, noting in her diary that 'it is the quickest time on record for my ever having bought a hat'.[13]

Materials had improved greatly over the previous decade, thanks to the need for higher quality cloth for the mass-produced, cheap fashion inspired by Paris or Hollywood and available on the high street. Marks & Spencer had been doing research into colour fastness, shrinkage and waterproofing of cloth since the mid-1930s. The result was better standards for the textile industry as a whole, and major improvements in the British mass-produced, ready-to-wear clothing industry that had been established during the inter-war years. Chain stores like Marks & Spencer and shops such as Dorothy Perkins, or Bracegirdles mentioned above, fulfilled this need by creating ready-made fashion lines for the budget shopper. These flourished on the high street in the 1930s. But those who could not afford even these cheaper ranges had to resort to second-hand markets and clothing clubs, both of which sold cheap, poor quality clothing. Thus the disparity between rich and poor was more noticeable than it had ever been.

When war broke out on 3 September 1939, everyone was expecting

a devastating attack by the Luftwaffe on London and all the other major cities. When the Chief of the Air Staff had given his analysis of the air expansion programme in Germany, he suggested the Germans could start with a massive bombardment, launching 3,500 tons in the first twenty-four-hour period, which could result in up to 175,000 casualties. So when Prime Minister Chamberlain announced that the country was now at war with Germany, it had an immediate and paralysing effect on Britain. Mass Observation diarist Muriel Green wrote on 3 September: 'Feeling of hopelessness. Think of friends who will eventually be called up. Decide to think of them as killed off and then it will not be such a blow if they are.'[14] Fifty-eight-year-old journalist and housewife, Constance Miles, who had lived through the previous war, wrote in her diary the same day: 'It seems incredible! ... How one longs for all this NOT to have happened,' adding 'How I wish I were near some friend I really love just now.'[15]

All over the country, people were terrified of the air raids that would surely come within hours. There was a warning at 11.30, soon after the Prime Minister had spoken, but it turned out to be a false alarm. Nevertheless the government immediately ordered all cinemas, theatres and concert halls to close. Race meetings and sporting fixtures were cancelled and people were discouraged from gathering in large numbers. In the end this lasted for less than two weeks, but the effect was dramatic and it changed people's perception of normality. In those first few weeks a great deal happened and yet at the same time very little occurred. Life on the home front had been disrupted, while the war on the Continent brought hitherto unfamiliar names and places into Britons' lives. The Allied powers, although at war with Germany, had not launched any significant military operations against the German Reich. The period, which became known as the Phoney War, lasted from September 1939 until the launch of the Blitzkrieg on 10 May 1940. It was an unsettling time – people began to think ahead, to plan for an unknown future and, above all, to try to work out how to live under the new conditions.

Although the bombers did not come and the cities were not attacked in this early phase, normal life had been badly disrupted by the mass evacuation of over 3.5 million children, adults, disabled and sick to the

countryside, including 2 million privately evacuated people. Businesses, too, had moved en masse. The General Post Office was installed in the George Hotel in Harrogate, while the British Museum relocated its treasures to Northamptonshire (though the largest sculptures were stored in Aldgate Underground station for the duration). The make-up company Max Factor moved to Pulborough in Sussex, where it operated for a few months, though many of its young, mainly female workforce found village life limiting after London. The Board of Trade made arrangements for their offices to be relocated to three hotels in Bournemouth. In the early weeks of the war, the newspapers reported extensively on the fighting in Poland, the loss of HMS *Courageous* on 17 September and the assassination of the Romanian Prime Minister Armand Călinescu on 21 September. The public followed the war intently and watched as Russia invaded Poland, Mussolini attempted to broker peace and the first attempt on Hitler's life failed in Munich on 8 November.

The outbreak of the Second World War came just at the time when the fashion houses were about to bring out their new collections and for several weeks mayhem ensued. Jean Smith of the London Fashion Group told Mass Observation: 'Most fashion houses closed down altogether. Everything was in a terrible mess.'[16] The Mayfair houses abandoned their autumn shows on which they had been working for months. The majority of their London clients had left for the country and although a few came back after the first panic, the designers decided they would have to take their work out of the capital. In November 1939, Digby Morton took a travelling fashion show to Bristol. He teamed up with the Elizabeth Arden Beauty Salon, Aage Thaarup, a hat designer, and Woolf, a furrier, taking four models plus 'six large dress baskets, ten hat boxes, 10 make up cases and £4000 worth of furs'.[17] Over 150 people, including eight men, paid 2s 6d to watch the models show off thirty-six gowns for an average cost of 18 guineas (nearly £1,000 in 2014). They were also given tea. This tour, organised so hastily, showed that the fashion industry was far more flexible than many might have believed, and it set a precedent for a closer working relationship with the government in due course.

Betty Penrose, who was the editor of *Vogue* until spring 1940 when

Audrey Withers took over, stepped into the breach and addressed the uncertainty that faced her readership. She wrote that, in accordance with the government's wish that businesses should carry on as far as possible, '*Vogue* will continue to be published during the war, but as a monthly magazine ... The next issue will appear October 25. Look out for it, subsequently, on the last Wednesday of every month.'[18] She promised that *Vogue* would offer helpful, practical advice as well as 'the usual charming, civilised articles on fashion, manners and other things besides':[19]

> We believe that women's place is *Vogue*'s place. And women's first duty, as we understand it, is to preserve the arts of peace by practising them, so that in happier times they will not have fallen into disuse. Moreover, we believe that women have a special value in the public economy, for even in wartime they maintain their feminine interests and thus maintain, too, the business activity essential to the home front. *Vogue* found this to be true in the dark years of 1914 to 1918, during which it was born and throughout which it mirrored women's many sided activities ... So once more we raised the 'carry on' signal as proudly as a banner. We dedicate our pages to the support of important industries, to the encouragement of normal activities, to the pursuit of an intelligent and useful attitude to everyday affairs – and to a determined effort to bring as much cheer and charm into our life as possible. This, we are convinced, is the best contribution we can make to national defence.[20]

This was the attitude, widely celebrated after the end of the war, that came to be known as the Blitz spirit, but which, at this stage, was simply a determination not to let the war get people down.

A direct effect of the 'war paralysis' felt in the first few months was that people stopped shopping. In November, Sir John Simon, the Chancellor of the Exchequer, asked the public to buy only what was absolutely necessary, not just in relation to clothes but in all their purchases. This was a disaster for the clothing industry and retailers, coming as it did after the government's closure of all forms of amusements, including cinemas and

the theatre during September.[21] *Vogue* recognised the impact this policy would have and encouraged its readers to buy clothes for their autumn wardrobes rather than holding back: 'every time you hold back from buying, you knock the national economy a fraction off its balance. Multiply that by millions, and it becomes a considerable punch on the very chin which the dress trade is trying to keep up.'[22] Constance Miles went up to London on 11 September and visited Swan & Edgar to buy a winter coat. She was struck by the fact that people no longer needed to dress up. Where would one go out to be seen? She wrote in her diary: 'Strange to glance in at the great evening dress department, all pretty models, with not one soul buying.'[23]

Many theatres and cinemas in London did reopen but only the rather racy Windmill Theatre remained open uninterrupted for the entire war. Valerie Hudson was a showgirl at the Windmill and trained to become a fully-fledged air raid warden while the theatre was closed between shows. *Picture Post* showed her looking glamorous in slacks, wearing her ARP helmet and carrying a stirrup pump, but wrote that 'a patriotic showgirl cannot go on being a patriotic and voluntary worker indefinitely'. By October she was back in her dancing costume, entertaining audiences while at the same time promising to work as a warden should she be called upon.

It seemed that Britain would not fight the war in sackcloth and ashes after all. Although the immediate clothing supply in Britain was stable, the atmosphere around all transactions was uncertain, so that prices fluctuated wildly and rose in some cases to double the pre-war level. Profiteering was a major issue and was addressed in November through the Prices of Goods Act 1939, which 'limited the profit earned per unit of a commodity to the amount received at the end of August 1939'.[24] The Act had only limited success and was only rendered effective when the Goods and Services (Price Control) Act 1941 was brought in. Until then, the lack of control and paucity of policing meant that prices continued to rise way ahead of inflation.

However, it was not just the price of clothes that had an impact on how people dressed in the early months of the war. With the outbreak of hostilities, men had foregone dinner jackets in deference to those wearing

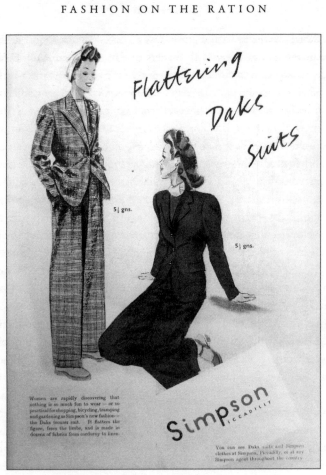

*Magazines ran advertisements for slacks for women but
outside the capital they were still considered eccentric.*

uniform, and this had the immediate effect of women opting for short
frocks. *Harper's Bazaar* reminded its readers to celebrate the soft silhou-
ette with the compulsory 'little black dress', as well as suggesting they aim
for posterity in a portrait photograph wearing a Balenciaga pink and silver
heavy satin gown.

When it came to fashion, there was no magazine with more authority than *Vogue*. The New York owners of the magazine, Condé Nast, had set up the London office in 1916 and in the 1930s the editor was an American, Elizabeth (Betty) Penrose. She was succeeded in March 1940 by Audrey Withers who, by the end of the war, was one of the most influential women in the world of fashion. Born into a wealthy family in 1905, Audrey was educated at Somerville College, Oxford, thirty-five years after her mother, Mary Summers, had been one of the first women undergraduates to study there. Her uncle, Harry Summers, helped out financially during her education but she knew she would have to earn her own living once she left university. She joined the staff of *Vogue* as a sub-editor in 1931 and she learned her skills on the job, recalling one incident when she had given instructions as to where to split the word 'knickers' in a picture caption. She received a call from the printers to say: 'Those knickers of yours, Miss Wivvers. They won't split where you want them to.'[25] Two years later, when the managing editor took early retirement, Audrey was promoted in her place and found herself at the heart of the magazine's production. By this time she was twenty-eight. She described herself as 'an unsophisticated nitwit juggling three balls in the air',[26] but that was far from the truth. She was clear-minded, efficient and endlessly energetic. At any one time she would have one issue being planned, another in production and a third about to go to press.

Audrey was not a fashion critic in her own right, but a focused, politically left-leaning businesswoman who earned the respect of her colleagues by her belief in inclusive decision making. She knew what she did not know and she had great respect for her journalists, photographers and fashion experts. Over the next few years her relationship with the American photographer, Lee Miller, would see *Vogue* – perhaps unexpectedly for a fashion magazine – at the forefront of war reporting. Audrey Withers described the relationship between Condé Nast and the British *Vogue* as similar to that between a parent and an adolescent child. 'The Americans didn't really believe that we could be trusted to do anything important without supervision ... It took the enforced separation of the war years to persuade them that we had grown up. They were impressed

that we survived and even succeeded, and a new element of respect crept into the relationship.'[27] It was during Audrey's editorship that *Vogue* came of age and earned the respect not only of its American owners but of the wider media in Britain.

Determined to do her bit, Audrey joined the Auxiliary Fire Service as a driver. She had visions of driving a fire engine and even took time out in her lunch breaks to obtain her HV (heavy vehicle) licence, though she never drove anything larger than an ancient taxi in which she ferried officers between fire stations. In the early days of the war, she and her passengers had to wear gas masks. 'There were no street lights. Traffic lights were blacked out, with only a cross-slit showing a glimmer – which was all that the car lights gave. Advice had not reached us that a gas mask would mist up unless the lenses were rubbed with soap, so before long I was the blind driving the blind. There was no ditch to fall into, but there was a tense moment when, in making a right-hand turn, I found myself across the bonnet of a bus, which also had minimal lighting but was fortunately going slowly.'[28]

As the first weeks and months brought no bombing raids or gas attacks, life at *Vogue* went on as before. Then, in early 1940, *Vogue*'s editor, Betty Penrose, told Audrey that she would be going back to the States for several months to renew contacts in New York. 'But first she would visit the Paris collections and then go on to Italy – where she only just caught the last boat from Genoa, because the Phoney War had become a reality.'[29] Penrose was not allowed to leave the US after her return, so Audrey was asked to edit *Vogue* for the duration and was given a place on the board. 'Even after the war, when the board membership grew to six, I was still the only woman director and the only representative of the editorial side of the company,' she said.[30] Audrey Withers was the longest serving editor of British *Vogue* in its history, until Alexandra Shulman took over the editorship in 1992, a position she still held at the time of writing in 2014.

In her autobiography, published in 1994 when she was eighty-nine, Audrey wrote: 'I am very well aware that I would not have been an appropriate editor of *Vogue* at any other period of its history. I had come up through copy-writing and administration, with no fashion training ... I set special store by the quality of the fashion staff. I needed to rely on their

A Slack Time

taste and judgement, and that ability to spot future trends which is the key to success in matters concerning design.'[31]

The fashion magazines assumed a key role during the war and not just with regard to advice on fashion. They broadened their remit over the next few years to encompass everything from clothing economy to hairstyles for factory workers. The government used every resource available to communicate its message. With men away fighting, it was women who carried the responsibility of family life. It was those women the government needed to address and the most efficient way of catching their attention was through the pages of women's magazines. Given the different character and spread of these magazines, from *Vogue* and *Harper's Bazaar* to *Woman's Own, Good Housekeeping, The Lady, Home and Country, Woman's Magazine* and at least a dozen other titles, it was not unreasonable to imagine that their message reached almost every woman in the country.

During the early weeks of the war, women were urged to be both feminine and resolute. The magazines encouraged it, the government expected it and some commentators complimented them on it. Initially the focus was on having an upbeat attitude and being brave. Travel writer Rosita Forbes wrote in *Women's Own* on the last day of September: 'In these hard times, when the utmost is required of everyone, the most important virtues are courage and kindliness. Women's courage is the valour of endurance, of standing up to endless small difficulties, of putting up with things and making things do. When you are sick and tired and frightened of the future as well, and you go on working without making a fuss, then you are quite as brave as the first person who flew across the Atlantic.'[32]

By October, women were being encouraged to make the most of their looks. *Woman and Beauty* was determined to emphasise the importance of being beautiful as well as brave: 'We can go on being beautiful, charming, graceful. Beauticians, couturiers, dieticians and shops are carrying on as normally as possible.'[33] The editor of *Mother and Home*, Elizabeth Lee, was less openly optimistic. She wrote in the November issue: 'Since September 3rd life has completely changed for every single one of us. The last was a soldier's war. This one is everybody's.'[34] The concept of total war, in which there are no non-combatants, was a relatively new one for Britain.

London had been bombed in air raids during the First World War with some 1,500 civilian deaths recorded. The most recent precedent was the Spanish Civil War of the late 1930s during which the civilian population had been targeted, and the images of the air raids on the town of Guernica were still in people's minds. It was a frightening time.

Vogue was determined that the war would not affect attitudes to outward appearances and on 20 September announced that 'It would be an added calamity if war turned us into a nation of frights and slovens.' Meantime, *Home and Country*, the monthly magazine of the Women's Institute, offered practical advice. The editor had commissioned an article on darning and patches to appear in the September issue and the following month she published knitting patterns for a matching set of vest and knickers. *Vogue* remained resolutely upbeat. In November an article appeared entitled 'Fashion Meets the Challenge of War', which began: 'London, all set in September for a fresh fashion season of wasp waists and fragility, now, with the brilliance of an acrobatic somersault, turns a new fashion face towards a new future. There's immense chic in restrained evening elegance. There's immense charm in the robustness and shrewd commonsense of day clothes.'[35]

However, the fashion editor would have no slacking in the evenings. She gave the thumbs down to women who carried on wearing their functional clothes to nightclubs, to restaurants or even at home, those women 'who pad around in hairy sweaters and flannel bags, on duty and off; letting themselves go – and other people down – slackers in slacks'.[36] Slacks had entered the clothing market in the 1930s but were still not widely worn by women. Although Katharine Hepburn and Marlene Dietrich were often seen in photographs wearing trousers, they did not take off as a fashion garment in Britain until the war. *Vogue* first featured women in slacks in 1939 and in April reproduced a stunning photograph of a model in an exquisite Eastern headdress wearing fawn trousers and red slippers. The editor encouraged her readers to let their imaginations 'run riot' when deciding what to wear with their trousers: 'And if people accuse you of aping men, take no notice. Our new slacks are irreproachably masculine in their tailoring, but women have made them entirely their own by the

colours in which they order them, and the accessories they add.' She sug-
gested that the fashionable, modern woman should wear slacks 'practi-
cally the whole time' – unless she was the guest of 'an Edwardian relic
with reactionary views'.[37] Fashion historian Geraldine Howell explained
how *Vogue* advised women to 'own several pairs for the country wardrobe
as well as a heavy silk or velvet suit for evening wear. The primary rules
regarding trousers were that wearers were to be under 50, weigh less than
10 stone and never wear them on a grouse moor, which would be, for
unexplained reasons, embarrassing.'[38] Perhaps the embarrassment might
have come if ladies had to answer a call of nature out on the moor with no
trees to protect their modesty.

Vogue also insisted that women have the 'wartime musts', which
included a top coat – though 'not the nip-waisted one you might have
bought if war had never broken out but a coat for comfort and compan-
ionship'.[39] They should also buy a mackintosh, as 'there'll be many days
when the rain comes down and not a taxi in sight'.[40] Also recommended
was a bag for the ubiquitous gas mask and *Vogue* thought that the Arden
pigskin holdall at 5 ½ guineas (about £320 in 2014) from Fenwick's was
a good bet. Constance Miles received a present of one from her hus-
band and wrote in her diary: 'Robin gave me a waterproof case for my
gas mask to sling over my reluctant shoulder'.[41] She had previously been
critical of people carrying their masks in clumsy receptacles 'and walking
about looking cross and worried'.[42] The transformation of fashion from
frippery to functional was accomplished quickly. There were soon echoes
of military uniform in padded shoulders, short jackets and knee-length
skirts, as well as neat, pill-box and other practical hat shapes that echoed
military caps.

Fortnum & Mason advertised their newly laid out store in *Vogue*,
showing how quickly they had adapted to the wartime conditions: 'Every
woman's a heroine in these days, and heroines will find every sort of smart
and sensible clothing on the 1st Floor at 182 Piccadilly. We have added
a Service Equipment Department and a Shelter Equipment Department
to our usual peace-time dispositions. You will discover country tweeds,
sturdy cashmeres and woollens for off-duty hours and on for "on duty",

dungarees in which you can tackle a man's job, split cycling skirts and white mackintoshes which, quite apart from their valuable waterproof qualities, lessen the risk of blackout collisions.'[43]

In the autumn of 1939, the editor of the *Vogue* pattern book told women not to moan about the long evenings caused by blackouts, but to make the most of them by dressmaking. She encouraged the beginner to start with easy patterns because 'nothing is more demoralising than failing to produce the finished article'.[44] A prescient suggestion was to consider working over last season's dresses and bringing them up to date with additional drapery to 'emphasise the shoulders, accentuate the tiny waist, hug the hips and swathe the bosom'.[45] In order to appeal to a wide spectrum of the fashion-conscious public, *Vogue* routinely published 'six pages of smart fashions for limited incomes', which included dresses and costumes for less than 50 shillings (or about £150 in 2014). While this might sound expensive to some, it is worth remembering that the relative price of clothing was much higher in the 1930s.

If you did not fancy making your own outfits, ready-to-wear clothes were also becoming more widely available in the 1930s and not just from the fashion houses. Department stores such as Harrods, Fortnum & Mason and Debenham & Freebody had their own teams of designers who worked in the 'model gown' departments and were very popular with the 'women from the shires' because they 'created their own models, sold direct line-for-line copies of Paris originals and stocked the fashionable labels from the top end of the ready-to-wear lines'.[46]

The number of middle-class suburban housewives had also risen hugely during the inter-war years. Over four million new homes had been built in the south-east alone, mostly on the outskirts of towns and cities. These houses were occupied by professionals such as teachers or minor civil servants. Their wives might not be qualified but their children were likely as not to go to university, possibly the first generation in the family to do so. These women needed to establish themselves in their new environment. They aspired to dress as well as their upper-class counterparts but to do it for a fraction of the cost. They shopped at Marks & Spencer, Dickins & Jones or Bourne & Hollingsworth. This new suburban

housewife was the woman most likely to add to her wardrobe by making her own and her children's clothes.

One of these women was Eileen Gurney, an avid reader of *Vogue*. She lived in Honor Oak Rise in Southwark, a tree-lined street with some houses built in the 1930s, of which hers was one. She was married to John Gurney, a shoe salesman, and they had a young son, born in 1939. At the outbreak of the war, Eileen was evacuated with baby Richard to Hanborough in Oxfordshire, from where she wrote long letters about how unhappy she was to be separated from her husband, but also asking him to send items from home so that she could make up clothes for Richard and underwear for herself. John wrote to her in frustration that he had begun looking for a pattern she had asked him for at 6.30 p.m. and had given up by 11.15: 'I have been through every pattern in the house and there is not a 36" pattern cami-knicks as far as I can see. Anyway, I'll have another look later on. By the way, I thought you told me it was too cold for cami-knickers.[47] You were very lucky to get the frock pattern enclosed. I found it purely by accident in the cardboard box of baby things behind the curtain in my bedroom. I have found the blue grey stuff and the silk. In a <u>suitcase</u> in my bedroom!!!'[48] She replied the next day: 'It <u>is</u> too cold for cami-knickers, Mr Clever, but I use the same pattern for petticoats.'[49]

For the first year of the war, John Gurney continued to work, travelling throughout the country selling shoes and visiting Eileen in Hanborough every couple of weeks. She was miserable and lonely in the country and told John that she missed dressing for dinner or getting into an evening dress 'even though there is no one here to admire me'.[50] When the feared bombing did not materialise, she moved back home to Southwark with Richard and lived with John for a whole year before he signed up to join the army in November 1940. For the next eighteen months he came home occasionally on leave from North Wales, where he was stationed, and then later from Northern Ireland. In March 1942 he left Britain for India and that was the last time Eileen saw her husband for four years. In between times, their baby daughter Stella, conceived on his last leave before he set off, had been born and had grown into a toddler.

Throughout the war Eileen Gurney made clothes for herself and

the children, for her neighbours and also for others who commissioned clothes from her. In her letters to John she described in lively detail, often accompanied by drawings, the garments that she made from new material or converted from old clothes. She was endlessly inventive and resourceful, as well as being clever about adapting her wardrobe to suit the times. In November 1940, shortly after he had left for North Wales, she wrote to him rather sheepishly: 'Please darling love – do you mind if I wear your grey flannel shirt with my slacks, sometimes? I will take great care of it if you say yes, and it will keep it aired, won't it?'[51] She was not only good at sewing and mending but also knew a great deal about design and fashion, as well as patterns, material, buttons, belts and other accessories which she collected. Much of her knowledge came from *Vogue* and *Harper's Bazaar*, both of which she read avidly. Her friend Joan had a yellow swagger coat that was four years old and looking the worse for wear. The two of them unpicked the coat, washed the material and with just a yard of yellow plaid tweed she made it into a smart fitting coat. Joan 'is very pleased with it and so am I as it is really nicer than the original coat'.[52] The following week she started a frock for a girl in her street. 'She is a bit staggering. Lovely figure, very slim but with full round breasts, long thick dark hair, black eyes, a big mouth with lipstick and beautiful teeth. She's lovely to make clothes for because her body is so easy to fit, it's straight and curves in the right places. She hasn't really got a bad feature, the only snag – she is not very intelligent, you feel that such dark, vivid beauty should sparkle with a vivid wit and it just doesn't. The result is most disappointing.'[53]

Like Eileen, Gladys Mason exemplified a type of young working woman in the war. She was interested in the world around her, though she saw it as it affected her and those close to her. A shorthand typist, Gladys was a careful spender and listed neatly in the back of her diary every stitch of clothing and item of make-up she bought. She wrote diaries from 1939 until 1941 and her mood mirrors that of the rest of the country during the early months and years of the war. Her unpublished diaries give world events and everyday life equal weight, which gives us a delightfully understated view of life in Leytonstone during that period. On the day after war was declared, she wrote: 'Went to work. Don't like travelling much. RAF

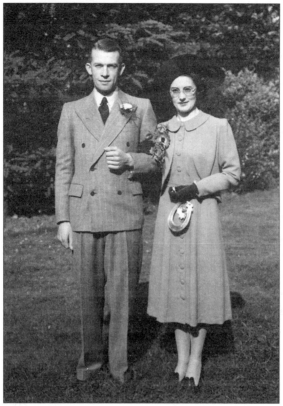

Gladys and Frank Mason on their wedding day, 7 October 1939.

dropped 6,000,000 leaflets over Germany. Had air raid alarm at 2.30 and didn't sleep till 5 am.'[54] Every day thereafter she wrote with updates from the news and sometimes these were juxtaposed by minor disasters happening in hers and her fiancé Frank's lives: 'Three German ships destroyed by navy. Frank had 2 hrs off. Had dropped a hydrant on his finger. I fell in the shelter,'[55] she wrote on 6 September.

Frank and Gladys had met in 1932 and got engaged six years later. They had planned to marry in 1940 but the war focused their minds, as it

did for so many other couples, and they joined the rush for an early wedding, marrying within a fortnight of making the decision. Two days after they had named the date, she wrote: 'Hitler watched German siege of Warsaw. City in flames. Had my wedding dress fitted. Lovely.'[56] That weekend she and Frank bought a bed and dress material. From then onwards she spent the evenings sewing for her wedding trousseau and Saturday afternoons buying for her new household. She purchased a suitcase as a wedding present for Frank and a blue leather handbag for herself. Meanwhile her wedding dress was ready. It was a hand-made, pink crepe, calf-length dress, with a Peter Pan collar, short sleeves, button-through with buttons and belt of the same material. The skirts had slightly flared top-stitched panels all round. There was a matching short jacket with long sleeves and curved front, but no fastenings. She wore a navy hat and matching shoes. The evening before her wedding she wrote: 'We are both looking forward to our wedding very much. Frank went on duty at 6 pm. I did odd jobs. Went to bed about 11. very excited. Hitler made a speech. Wants peace. Won't get it.'[57]

The following day she recorded her wedding: 'Beautiful day. Got up at 8. Heaps of wedding cards, letters & presents. Went up to Leytonstone. Awful spot on my chin. Eva, Aunty Edie & Uncle Jack came. Married at 1.30. Heaps of people in church. AFS made a lovely guard of honour.'[58] Two hours later they were on their way to Eastbourne where they spent three days on honeymoon before returning to London and taking up their new life as a married couple. A week later she was back to her normal evening activities of mending clothes, making new outfits – this time a pair of winter woolly pants – and knitting toy lambs for friends and neighbours. The wedding dress gave good service as she wore it to several other weddings during the war. It survives today along with the blue handbag she carried on her special day, complete with tiny silver shoes from her wedding cake and the powder compact which she bought that summer.

While Gladys Mason and Eileen Gurney could buy material to make their own clothes, the poorest members of urban society had to fall back on second-hand markets, pawnbrokers or clothing clubs. There were thousands of schemes throughout the country and they all operated on

roughly the same lines. A person would be able to obtain a cheque for £10, which he or she would then pay back with interest, usually a pound in every ten, over a period of about twenty weeks. The money could only be spent in the shops associated with the club, so that people using them were restricted to what was available in those particular stores. In general these clubs used shops that produced cheap, poor-quality clothing that did not last. However, there was no option to go anywhere else. The list of what the stores sold included clothes, hats, shoes, pots and pans, hairnets and false teeth. Some people regarded the clothing clubs as money-making rackets, but for families without access to bank accounts this was one of the only ways of getting credit, albeit a very expensive form of it.

The situation of the urban poor was brought to the fore when the evacuation of over a million schoolchildren from the densely populated areas of Britain's cities took place in September 1939.[59] Evacuation had been seen primarily as a way to get children, pregnant women and vulnerable adults out of the path of air raids – in other words, as an emergency measure. The official evacuees came disproportionately from the poorest strata of society because the better-off had been able to afford to send their children off to school privately and, in any case, tended not to live in the most crowded and vulnerable areas of Britain's cities. Many parents had spent their clothing club savings on getting new clothes for their children who were to be sent away and some would not finish paying for them until Christmas.

Oliver Lyttelton, who became the President of the Board of Trade in 1940, had ten evacuees at his house in the country. He wrote: 'I got a shock. I had little dreamt that English children could be so completely ignorant of the simplest rules of hygiene, and that they would regard the floors and carpets as suitable places upon which to relieve themselves.'[60] A sizeable number of schoolchildren shocked their hosts with their undernourished bodies, poor manners and inadequate dress. Some children had just one set of clothes and were wearing gym shoes: 'Their clothing was in a deplorable condition,' wrote a Women's Institute member about the batch of evacuees that had turned up in her village, 'some of the children being literally sewn into their ragged little garments.'[61] Few had winter

coats and fewer still winter footwear. In defence, the weather in September 1939 was glorious and no one had realised that the children would be away for months, or in some cases years, so that the urgent question of clothes for evacuees was not just an indicator of urban poverty but also of inadequate planning and forethought.

Clothes for these children were quickly rustled up, borrowed or exchanged between host families so that by the time the cold weather came in the late autumn most evacuees who had remained in the countryside were adequately dressed and shod for their new lives. Charitable funds were organised, as well as clothing exchanges, and it is known now that the government secretly distributed thousands of pounds to the education authorities for 'necessitous cases'.[62] There were many of these: at this time, over one million men were still unemployed and their children had had to rely on clothes from second-hand markets or the cheap-skate clothing clubs mentioned above. Later in the war, full employment and rising earnings meant that the families of these children were eventually able to afford to buy shoes and clothes for them. This coincided with the introduction of clothes rationing in 1941 and utility in 1942, which in turn improved the quality of clothes that were available, so that by the end of the war this section of society enjoyed a significant improvement in their circumstances. For now, though, things were far from settled. Britain was a country in flux and over the period of the Phoney War, and into the summer of 1940, millions of men and women would start wearing uniform. This would change the look of Britain and have an impact on fashion that would last for almost a decade.

2

A Uniform Solution

It's the fashion to wear service uniform if you can, whether it's the ATS, the WRNS, the WAAF, the Red Cross or the WVS – you who wear it are the fashionables of today.

Harper's Bazaar, March 1942

About a third of the population of Britain were entitled to wear uniform during the Second World War. This would give a figure of somewhere in the region of 15 million people, of whom a large number were women. More than 4.5 million men and women served in the armed forces. Although no women fought on the front line, they worked along-side servicemen in stations and offices around Britain, as well as further afield in the Middle East and the Far East. The remainder, over 10 million people, were in organisations such as the Women's Voluntary Service (WVS), the Auxiliary Fire Service (AFS), the Local Defence Volunteers (LDV), or youth training corps, as well as many others who supported the war effort on the home front. Nurses, factory workers, dock workers, policemen and women, Boy Scouts and Girl Guides all wore some form of

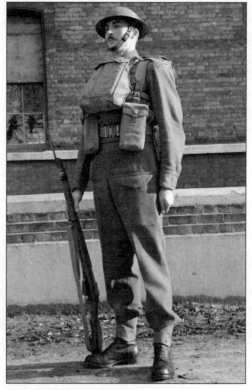

This Guardsman was one of nearly 15 million men and women who wore uniform during the war.

uniform, so that it became a wholly familiar sight to see uniformed men and women walking up and down streets, along country lanes or sitting in parks in Britain's towns or cities.

People's reactions to uniforms were varied, but on the whole positive, especially among the newly founded women's organisations, both military and civilian. May Smith wrote in her diary in 1939: 'Wartime – and yet so far not so very different from peacetime, except for the blackout, earlier closing of school, wireless bulletins and the appearance of uniform in

every public place. Burton seems more prolific of uniform than the other places around us. Almost every girl and woman is swaggering around the streets in her khaki stockings and costume, and soldiers are nipping about here and there, with or without stripes.'[1] Vere Hodgson was excited by the atmosphere of central London in April 1943: 'Piccadilly is such a thrilling place these days. All the uniforms of all the nations jostle you on the pavement ... girls too in their service uniforms by the hundred. Few fashionables – because all the pretty girls are in battle dress.'[2]

There was even a suggestion, at the outset of the war, that the entire population should wear a uniform in order to show unity behind the war effort. This was quickly dismissed as unworkable and probably bad for morale. Nevertheless, a very large number of people wore their uniforms with pride and a sense of excitement. Some were newly designed for the Second World War; others, like the RAF, for example, dated from the last war and many had a long history stretching back over centuries. The Royal Navy, the 'senior service', had been wearing uniform since 1748, when it was introduced because the officers 'wished to be recognised as being in the service of the Crown'.[3] The design underwent many changes over the next two centuries, but the navy blue,[4] contrasted with white, did not alter. By the outbreak of the Second World War, officers had twelve different orders of dress: 'full dress, ball dress, frock coat with, and without, epaulettes, undress, mess dress, mess undress, white full dress, white undress, white mess dress, white mess undress and tropical dress. Full dress, ball dress and the various frock coat orders were all put into abeyance at the outbreak of war.'[5] For normal duties, officers wore the No. 5 Undress, which consisted of a double-breasted jacket ('monkey jacket'), trousers, cap and shoes. The cap was made of blue cloth with a black mohair band and a leather chin strap. Seniority was defined by the peak – blue cloth for the rank of commander and above, black patent leather for the rest. Ratings wore cap, jersey and working overall trousers, but added to this were oilskins and other foul-weather gear, which were issued on board and were known as 'loan clothing'. The bell-bottomed trousers were popular and often altered by adding a gusset down the seam to make the bell-bottoms even wider. Traditionally, everyone in the navy was responsible for his

own uniform. It had to be washed and mended, typically on a Thursday afternoon 'when all hands were piped to "Make and Mend"'. The navy, the Royal Naval Reserve and the RNVR all had distinctive differences in detail and insignia.

The army had a shorter, but nevertheless rich, history of military dress for all occasions from formal attire to the battlefield. During the inter-war years, the army had been considering modifications to the standard uniform, which was the khaki wool service dress which had been worn, more or less unmodified in design, since 1902. In the 1930s the army carried out trials for a new Field Dress Service uniform, improved on the Standard Service Dress with bag-type pockets, darkened buttons that did not need polishing, and open colour facings. In 1938, the Field Service Dress appeared in a lighter denim fabric, followed quickly by Field Service overalls. The overalls were considered comfortable and easy to move about in, but the denim was too light for prolonged use in the field, so that in the end a compromise was reached with the same design using heavier, warm wool-serge material. The new designs were almost universally popular, except with 'those old soldiers and NCOs who had grown up with the tradition of smart, well-turned-out men with shiny brasses, who could out-polish and out-drill any enemy they would ever encounter'.[6] My grandfather, Lieutenant Colonel Philip Toosey, enjoyed pointing out to his great friend and regimental rival, Douglas Crawford, that his regiment always won the 'Shiny Cup' for turn-out, but Toosey's medium artillery regiment won the Ranging Cup (medium-range firing) more often than any other during the 1930s. When it came to war, he teased Crawford, that would inevitably count more than polished brass buttons. This paring down of detail was reflected in civilian dress at about the same time, which shows how military influenced civilian fashion and vice versa.

From then on, the Battle Dress, together with the new web equipment, became the standard uniform of officers and other ranks during the Second World War.[7] There were often issues of sizing – mainly because of the problem of supplying hundreds of thousands of men with a full set of kit in such a short space of time. An unattributed quote from the war summed up the majority opinion: 'There were only two sizes of uniform

in the army – too small and too large.' Percy Bowpitt of the Royal West Kent Regiment remembered exchanging tunics and ill-fitting trousers 'until we had some semblance of uniform that looked reasonable'.[8]

It was estimated that the army's strength, which was 897,000 in September 1939, would more than double the following year, so the number of new uniforms, as well as re-equipment for those already in service, would be well in excess of a million. Over the next few years of the war the uniform underwent a series of minor changes, mostly to make the most efficient use of scarce cloth, but some specifically for added benefit, such as extra shirting in the trousers to protect the kidneys from the cold. Martin Brayley, a former soldier and author, pointed out that soldiers often wore non-matching items of clothing together. One might wear a 'Blouse' from 1940 with a pair of trousers from the 1942 so-called 'austerity BD' (Battle Dress), whereas another might have the opposite configuration or the interim 1941 trouser. This makes photographs from the time confusing when it comes to identifying specific uniforms.

With so many people in uniform, it was unsurprising that the general public knew how to 'read' uniforms across a street or at the scene of an incident, and could identify at a glance a man or woman's job, rank and status. And it was very important to know and trust the person who was issuing an instruction, especially during the Blitz, when people needed to know who to listen to or appeal to in a crisis. Aside from emergencies, uniforms had a hierarchy with implications on many levels, some of them more personal than official.

Some uniforms, such as the Royal Air Force blue, gave men real status in women's eyes. This was partly because it comprised a smaller body of men than the army, and their jobs, especially the pilots, were considered heroic and extremely dangerous. The PBI (Poor Bloody Infantry) suffered in their khaki uniforms from being the least admired of the three services by the general public.[9] Members of the women's services (just over 100,000 in June 1941) were said to grade potential boyfriends in an order of eligibility in which 'RAF officers rated tops, being classified in turn by rank and number of decorations; naval officers came second and brown jobs a long way behind'.[10]

'Our Glamour Boys', as the air force pilots were often known, had a much simpler uniform than the army or the navy. Part of this stemmed from the Air Ministry's deep-rooted desire not to look like the army, but also because the focus of attention during the late 1930s had been on aircraft rather than clothing. Though some crews had specific variations, such as Bomber Command, who had electrically heated clothing, there was in general no difference in the flying clothes for home service or those required for the Middle East or Far East. No significant alterations were made to kit until after the war started, other than the removal in 1936 of breeches, puttees and high collars. For the first four years they wore a variation – depending on rank – of a single-breasted jacket, a field service cap and trousers with black footwear and the shearling jacket, which had and still has such cachet. The beret made an appearance in 1943, but was not universally adopted until after the war. All ranks were entitled to greatcoats, the officers' having five rows of buttons, whereas the airmen had only four rows. 'In addition, officers had a fabric belt and gilt buckle, three small cuff buttons, and shoulder boards bearing rank lace.'[11] Flying suits did, however, develop over the course of the war as ever more research was done into how best to protect the air crew from cold – their main enemy – while building in life-belt bladders and parachute clips. By 1944 the introduction of cockpit heating went further to alleviate this than any developments in flying suits.

Helmets also evolved four times, meaning that each generation of oxygen masks could only be fitted to the most up to date design of helmet. In *The Royal Air Force 1939–45*, Andrew Cormack commented that although flying kit had changed, 'it must be faced that the casualty rate was so high, at least in Bomber Command, that it was a lucky crewman who survived repeated periods of operations long enough to reap the benefits of the development process. New kit was therefore issued to new airmen, the old hands being no longer on the scene to enjoy the increased comfort it bestowed.'[12]

The sheer quantity of uniform produced is impressive and explains why so much civilian factory space had to be switched over to war production, leading to the inevitable clothing shortages. According to

ESCORT !

A Chelsea Pensioner watches dejectedly as two young women hang on the arm of a glamour boy in his RAF uniform in this 1941 Christmas card.

Martin Brayley, the year 1940 saw the highest number of uniform items made during the war: 17.5 million BD blouses and trousers, over 3.5 million greatcoats, 16.5 million shirts and vests, and almost 12 million pairs of ammo boots. Although the quantity of uniform produced fell in the ensuing years, in 1943 the military was still in receipt of some 10 million blouses and trousers, nearly 2 million greatcoats and well over 5 million pairs of boots. And that was just for the army. Add in the navy, air force, the women's services and other uniformed civilians and it is hardly surprising that, in production terms, proportionally half the factory workforce producing cottons, woollen and worsted cloth worked in war production. The remainder was divided between the civilian and all-important export trade,[13] so that two thirds of the population were catered for by well under half of the pre-war manufacturing output.[14]

One of the main suppliers of military uniform was a Leeds-based bespoke clothing business run by Sir Montague Burton. Born in the town of Kurkel in Lithuania as Meshe David Osinsky in 1885, Burton came to Britain in 1900 to escape the escalating Russian pogroms. He began his working life in a small ready-made clothing shop in Chesterfield and

gradually expanded to own a factory in Leeds, adopting the name Montague Maurice Burton. At the beginning of the First World War, Burton had fourteen shops in Sheffield, Manchester and Leeds, and began making uniforms for the forces. The company went public in 1929 as 'Montague Burton, The Tailor of Taste, Ltd', and the rapid expansion of his empire in the inter-war years led to 595 shops by 1939. He concentrated his production on 'affordable bespoke clothing for the working man' and believed passionately in employee welfare, and collective bargaining and arbitration in industry. At his headquarters in Leeds, where he employed 10,500 textile workers, he built a modern canteen, an employee rest-room and provided a doctor's surgery as well as dental and ophthalmic services for his workforce. By the outbreak of the Second World War he claimed to have been paying the highest wages in the tailoring trade in Europe for almost twenty years, which is supported by the fact that there were only two strikes in all his time as chairman of Burton's, and one of those was when he was in the USA in 1936. All this meant that he was ideally placed to take over wartime production of uniforms, and indeed Burton's is credited with having produced a quarter of all the service uniforms made during the six years of war.

The government planned well for uniform production. At the outbreak of war, the 'Wool Control' came into being and was responsible for purchasing foreign wool clips and requisitioning the home clip as well. Supplies of raw wool remained plentiful throughout the war, guaranteeing firms like Burton's sufficient to make up the uniforms needed by the forces (though there were shortages of cross-bred wool which was in demand for service overcoats and other heavy garments). Burton himself made a personal fortune from wartime clothing production and he donated much of his considerable wealth to Jewish educational and charitable institutions in Britain, as well as endowing chairs of international relations at Oxford, Edinburgh, London and Jerusalem universities and of lectureships at Nottingham and Leeds. He remained at the heart of wartime manufacturing, and by 1944 his factories switched to manufacturing demob suits.

With the arrival of the Americans en masse in 1944, there was a great deal of comment about the quality of the British 'hairy' uniforms in

comparison to the well-cut, smooth Class A uniform of the American GIs, 'leading to many a bar-room brawl when local ladies were found to prefer Class As'. Martin Brayley added that this was partially alleviated 'by the issue of collar-attached shirts and ties (and by the strictly unofficial private tailoring sets of 'best BD' – open and faced collars and flared trousers were popular by 1945).'[15]

Mass-produced uniforms, such as those made by Burton's, might have been efficient and given people a sense of belonging, but they were not universally popular. In 1939 the kilt was withdrawn from use within the Highland regiments, a decision that was loathed by the Scottish soldiers who 'resented having to go to war in the battle dress of the Sassenachs'.[16] Many officers continued to purchase their own kilts and eventually the War Office was forced to relent and allow officers and warrant officers to buy other ranks' kilts. It is believed that the last time a unit wore kilts in battle was during the raid on the lock gates in the St Nazaire operation in March 1942. Captain Donald Roy, 'an utterly fearless Cameron Highlander', insisted that his troop must wear kilts both in training and action. He led fourteen commandos ashore to blow up pumping stations and other dock installations. Most of his men were killed holding a bridge from the Germans under heavy fire, but Roy survived and was captured and taken prisoner. He was awarded a Distinguished Service Order (DSO) and lived until the age of eighty-nine.

In the services, the tradition, maintained during the war, was that officers would be responsible for buying their own uniforms out of pay and allowances, whereas the 'other ranks' received their allocation of clothing, right down to socks, underwear and pyjamas, from the army, navy or air force. Preston Hurman in the Royal Army Service Corps (RASC) was horrified by his issue: 'I found my uniform incredibly itchy and couldn't wear it; so either I would have to desert or get the uniform lined with silk. I found a tailor nearby who did the latter for me, from below the knee to the high collar. At that time we were still using First War tunics, buttoned to the neck.'[17]

As Hurman's experience shows, uniforms were hard-wearing but not always comfortable or well-fitting, so that home comforts, especially

knitted scarves, jumpers and balaclavas, were very sought after. Soldiers in the British Expeditionary Force in France suffered the bitterly cold winter of 1939–40 in tents, and their letters to women's groups who had supplied home-knitted items reveal the extent of their gratitude. A fund for Friendless Serving Men had been established for men who had no relations or whose relations were too poor to send anything to their men and boys. Mr E. Hastings-Ord, who ran the fund, wrote to the Women's Institute thanking them for their contributions: 'The thanks we get are quite pathetic in their gratitude and we should like to let all those institute members [know] who have enabled us to give these friendless men the pleasure of opening a parcel of their own to show how much their generosity is appreciated.'[18] The statistics of the numbers of knitted garments sent to the forces is impressive. Sixty thousand members of the Merchant Navy each received a set of six garments: 'a sweater, a scarf, a helmet (balaclava style), a pair of gloves, two pairs of socks; sea boot stockings were added for the deck crew'.[19] On top of that, the Merchant Navy received 60,000 sets of emergency rescue kits. One seaman wrote with gratitude: 'words are inadequate for me to describe the pleasure on the men's faces when they collected their woollies from us on Board their ships. It means so much to men to be warmly clothed, makes all the difference to their cold hours on duty.'[20]

Home-knitting and sewing had been promoted as a public duty and the Red Cross, who took responsibility for sending parcels to prisoners of war as well as to troops in the field, would often make specific requests for certain types of garments. The Women's Institutes of England and Wales sent in excess of 22 million knitted garments to the Red Cross, which averages out at sixty-seven garments per WI member. Given that some did not knit at all, there were other women who knitted on an industrial scale. One lady in Cheshire completed her thousandth pair of socks in 1944. Even when wool had to be bought on the coupon, women continued to knit for the forces. Special stocks of carefully accounted-for wool were supplied to organisations such as the WI so that they could keep up the work. To what extent the amount of private knitting and sewing supplemented the official supplies will probably never be known, but there can be little doubt that it had a considerable impact.

Picture Post featured 'Mayfair's Own Sewing Bee' in an article published in February 1940. The group comprised the wives and daughters of foreign diplomats who worked every Wednesday afternoon at the Mayfair home of the Hon. Mrs Ronald Greville. Lady Halifax, the wife of the Foreign Secretary, was the only other British member of the 'Dip Work Party', as it was dubbed. The others came from neutral Uruguay, Chile and Sweden. The article illustrates these women wearing white overalls and caps over their Paris frocks and pearl necklaces, using sewing machines or hand-knitting. They worked until 4.30 p.m. when Mrs Greville would provide tea, though she was at pains to point out that this was not a frivolous tea party but a group of highly skilled, educated and dedicated women who were keen to contribute what they could to a humanitarian scheme. The women purchased all the material and wool themselves and the finished articles were donated to the Lord Mayor's Red Cross fund. It would be easy to poke fun at such an undertaking but it shows the immense sense of purpose and energy that was unleashed, as well as the latent skills of women who in other circumstances would never have needed to sew on a button. This group was one of hundreds, possibly thousands, throughout the country who wanted to do something to help.

Many young women were keen to join the forces, as it offered the possibility of travel and adventure and some of their mothers would have been servicewomen during the First World War. With the formation of the First Aid Nursing Yeomanry (FANY) in 1907, British women won, for the first time, the right to belong to an official paramilitary organisation. Other services had followed during the First World War. The Women's Auxiliary Army Corps (WAAC) was formed in 1917. The Women's Royal Naval Service (WRNS) came into being the same year and the Women's Royal Air Force formed in 1918, meaning that almost 100,000 women, including nurses, wore uniforms during the First World War.

The WRNS had been disbanded in 1919 but re-formed in April 1939, and by the end of the Second World War there were 75,000 WRNS serving on naval bases, both at home and abroad. Similarly, the WAAC had been disbanded and this re-emerged as the Auxiliary Territorial Service (ATS) and numbered more than 190,000. Most were disbanded after the

Second World War, but some continued until later in the twentieth century, with the FANY still in existence today. Although some of the duties were domestic or clerical, many women learned to maintain vehicles, ferry aircraft from factories to airfields, man anti-aircraft guns and RADAR stations. Others were recruited to help decipher coded German messages and some worked as agents in the new Special Operations Executive (SOE). Women in the SOE held rank in the ATS, WAAF or FANY in the hope that they would be protected under the 1929 Geneva Convention. The majority of these women required uniforms to fit their new roles.

The most popular service was the WRNS. Its members worked with naval officers and they got what was generally agreed to be the smartest kit – flattering and chic. The official issue consisted of two uniforms; a well-tailored navy greatcoat, some of which were made by Hector Powe, a travelling tailor service that operated throughout the country, although the majority came from Burton's; three white shirts; a gabardine mackintosh; two pairs of shoes; a duffle coat for specific jobs of work; and three pairs of directoire knickers in navy commonly known as 'blackouts'.[21] The Imperial War Museum holds a pair of these, which the catalogue describes as 'knee-length dark blue knickers in a warm woollen material', and it is little wonder that they were loathed by the young recruits. The uniform jacket provided for the WRNS had the same cut as that for their male counterparts in the navy and made no concession to waistline or bust. Margaret 'Peggie' Williams was a Surgeon Lieutenant (D)[22] in the Royal Naval Volunteer Reserve (RNVR). One of only two dozen or so female doctors, dentists and teachers in the navy during the war, she had to join the RNVR (known as the 'Wavy Navy' on account of the rings on officers' sleeves being wavy rather than straight) as the WRNS did not have a rank for professionals who were paid the same as their male counterparts. Peggie told her daughter Penny that the only way to create a shape to fit the female form was to steam the jacket and then stretch it over their knees. 'Fortunately my mother was quite flat-chested, but it proved quite a trial for women with a fuller chest.'[23] Peggie was posted to Ceylon in 1943 and they were all given strict instructions about packing their uniforms into

*Wrens collecting their uniforms. For some it was the first
time they had ever had a full new set of clothes.*

metal trunks, lined with a cotton sheet. They should place mothballs in
between the sheet and the metal to protect the clothes. One of Peggie's
friends had not heeded the advice and when she opened her trunk on
arrival it was empty: the moths had had a field day.

The novelist Barbara Pym joined the WRNS in 1943 and wrote about
collecting her kit: 'My hat is lovely, every bit as fetching as I'd hoped, but
my suit rather larger though it's easier to alter that way. I also have a macin-
tosh and greatcoat – 3 pairs of "hose" (black), gloves, tie, 4 shirts and 9
stiff collars, and two pairs of shoes which are surprisingly comfortable.'[24]
Hilary Wayne was fifty-six when she joined up with her fifteen-year-old
daughter. Both lied about their age, Hilary claiming to be forty-two and
her daughter eighteen, and they were accepted into the ATS, where they
worked as cooks. She recalled being marched to the stores to be fitted

out with her uniform, right down to underwear and stockings: 'to people feeling the coupon pinch and wondering where the next pair of stockings was coming from, it was miraculous to be handed four pairs'.[25] The most exciting thing for her was dressing up in her full uniform for the first time and watching those around her 'change from civilians into soldiers'. She said: 'There is no doubt that "dressing up" helps soldiers, as it helps actors, to play their parts. I think we not only looked different we felt different. For one thing, I personally felt less self-conscious ... the fact that day and night we were all dressed exactly alike gave me the comfortable feeling that, whatever happened, I could not be conspicuous.'[26]

Not only was there a pecking order in the women's forces, judged according to their uniforms, just as there was in the men's, but there were differences of distribution that caused exasperation. Colin McDowell, author of *Forties Fashion*, explained that 'a great cause of irritation for women in the WAAF was that WRNS were given coupons for stockings and they were not. To compound the sense of wrong, *their* issue stockings were thick lisle cotton fabric processed to give it a smooth finish.'[27] Although Digby Morton designed the WVS Uniform and Norman Hartnell was consulted about the post-war relief work uniform for the Girl Guides, it was alien to British government thinking to link fashion and uniform in the way that other countries did: 'in Paris, the Benedict Bureau Unit, a nursing auxiliary group, wore a uniform designed by Molyneux.'[28] Barbara Cartland, the novelist and active member of the ATS, St John's Ambulance Service and the WVS, was characteristically outspoken about the style of the uniforms for the women's services. She wrote in her autobiography *The Years of Opportunity 1939–1945*: 'Only a country where men are valued higher than women could have put their women into a uniform which copied the men's without regard to the difference in their figures. The ATS uniform was modified a little during the war, and the pleated pockets on the chest and the big patch pockets on the coat were streamlined, but more in an effort to save material than a women's pride. I thought the WRNS uniform very smart, the WAAF passable and the ATS hideous.'[29]

The Second World War wrought a major change for women in all walks of life. 'Women at home and women in non-military jobs

are almost as likely as soldiers in uniform to be killed (certainly during the Blitzkrieg of European cities in the Second World War),' wrote Mass Observation archivist Dorothy Sheridan in 1989. It was not until September 1941 that the number of British military deaths exceeded the number of civilian fatalities. Initially resistant to the idea of conscription for women, the government gave in to pressure from its Women's Consultative Committee and passed the National Service Act No. 2 in December 1941. For the first time in British history the conscription of single women between the ages of twenty and thirty was made compulsory. Once called up, they could choose either to join the armed services, to work in civil defence, industry or join the Land Army. The age range was later extended to include women between the ages of nineteen and forty-three, and First World War veterans up to the age of fifty. Over the course of the war, almost half a million women joined the armed services and millions more worked in industry, on the land and in jobs that had previously not been open to them. Used in advertisements, not just for the war effort but for domestic products such as clothing, make-up and even floor polish, the uniformed woman was one of the most powerful images from the war.

Uniform meant different things to its wearer as well as to its observers. For some it was a rite of passage, for some a challenge or even a threat, while for others it gave them a sense of belonging and self-worth. But for a number it was simply the first time that they had their own wardrobes. One woman told Colin McDowell that when she went into the forces the most luxurious thing for her was 'to have a pair of shoes that had never been worn before. They were as hard as hell and I was crippled for weeks but it didn't matter. I was so proud. Nobody else's foot had ever been in those shoes before me.' [30]

Women recruited into non-services war work were often equally delighted to get their first uniforms, especially since the jobs that went with the uniforms were often ones that they would have been barred from in peacetime. In 1939, Zelma Katin was a forty-year-old married housewife who had been unsuccessfully seeking work for all of her married life. She was not alone in this. Marriage changed a woman's status in the

pre-war era, especially for those from the middle class, and it was only with the outbreak of the war and the need for full employment that married women were called out of the home. Zelma, like others, was initially resentful that it was only with death and destruction looming that women like her could get work. However, once she got over her irritation, she was pleased at the prospect. Soon after she started work she was struck by the two different women she had become: on the one hand, 'a married suburban woman who once studied botany in a university college, speaks with southern intonation, confines herself to her house, and belongs to the petit bourgeoisie'; and on the other, 'an aggressive woman in uniform who sharply orders people about, has swear words and lewd jokes thrown at her, works amid rush and noise, bumbles and stumbles about in the blackout, and has filthy hands and a grimy neck'.[31]

Given that she had a fourteen-year-old son, two possibilities were on offer: work in a factory or in transport. She decided on the latter because she loved the 'fresh air that blows from the Yorkshire moors across a tram-car platform in my city'.[32] Having passed the interview, she remembered going home and paying special attention to the uniformed girl who took her fare: 'I liked the cut of her dark blue jacket with its nickel buttons, and I wondered how soon I would be able to punch tickets with her sang-froid.'[33]

The following morning she and the other would-be conductors were hurried to the clothing store 'where a tailoress measured us deftly for our uniforms – jacket and skirt, trousers and overcoat. This so far, was the most exciting part of our initiation and we all felt we were getting somewhere at last. It's extraordinary what a profound part in your and my psychology a uniform plays ... I think we were looking forward to donning our uniforms not only because of appearances' sake but because we wanted to be set apart from or above the rest of our sex. Then in addition there was that blessed quality about a uniform; it makes physical defects seem insignificant.'[34] Zelma wore trousers with her uniform for warmth in winter and skirts in summer as they let a draught through. She noticed that some of the male conductors would stand at the bottom of the stairs so that they could see girls' stockings or knickers when the girl was going

up or down. 'The adoption of slacks by so many women must have robbed many a stairway vigilant of an anticipated thrill.'[35]

The rules for her new job were strict and she was amused to hear the instructor on their training course tell them that: "'no one can teach you to be a successful conductor. That is something which you have to learn / yourself in the course of experience." That seemed to me to be placing tram conducting on an extravagantly high level.'[36] Although, after learning how to stop a tram at 35 miles per hour using the emergency brake, punching tickets and working out fares for different zones, she had to admit there was more to the city's tramway service than she had at first thought. On her way to work on the tram for the first time, the woman conductress saw her uniform and passed by her without asking for her fare, and she knew that she had joined 'a band of special workers, linked with them by task-labour of a peculiar kind'.[37]

Zelma was interested in the status conferred by clothes. She watched the way the character of her passengers changed during the day. In the early morning it was the factory workers and schoolchildren who piled into her tram and her hands became black with handling their loose change. Then came the clerks, professional workers and shop assistants: 'Clothing became cleaner, not merely articles of utility; less ragged, more attractive and expensive. Soon these people too had gone, and men of the employing class, middle-aged and elderly, with neat sober suits and overcoats, well-brushed bowler hats, faces very close-shaved, stiff white collars, had taken their place. In peacetime most of them had doubtless driven to business in their own saloon cars.'[38] When, later in the day, she was taking money and issuing tickets to expensively dressed 'ladies of leisure', who showed off sheer silk legs and smelt of perfume, she observed: 'Fancy, they are of the same sex as I. Yet at the moment they look like costly bedroom decorations while I am simply an article of utility.'[39] She and the other conductresses resented 'these svelte women, who do not alight at Woolworth's or the fish market but at the posh emporia where they are "Yes, madam'd" even in wartime and they pay for 20 guinea non-utility frocks by cheque.'[40]

She was as interested in people's reactions to her as she had been in her own assumptions about her passengers. When she went into the

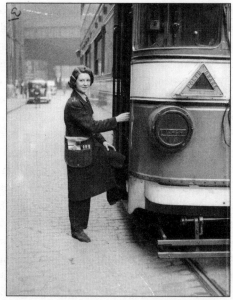

Uniforms gave women a status and commanded respect,
making many feel as if they belonged to a special elite.

greengrocer's, the counter assistants made a big fuss of her, as she was the only local tram-woman. Her uniform gave her an air and she was respected for it. Other uniforms produced the same reaction. Nurses were given the right to free travel between certain specified points, but it meant learning to match the uniform with the stops. The forces, too, were allowed to travel free on production of a contract token, but her bosses had forgotten to tell her about them. After a couple of stumbles she decided that anyone in service uniform could travel without paying the fare.

'The Englishman's inhibitions vanish before the sight of a uniform and he speaks far more readily to conductresses than to fellow-passengers. I suppose he feels that as we are public servants he has a stake in our personal lives.'[41] Louis Katin, Zelma's husband, who helped her to write her autobiography, *"Clippie". The Autobiography of a War Time Conductress,*

wrote in the last chapter of the book about the impact of seeing his wife in uniform in charge of a tram. 'It is remarkable because up till now you've only seen her at work in the home; and, when you have been on the same bus together, it's been simply as fellow passengers ... But now, all at once, something big has happened. It's as though the policeman slowly treading the pavement in front of you has suddenly bent down and rolled his trousers up to his knees and started to do a ballet dance in the middle of the street.'[42] Seen from today's perspective, it is quite extraordinary to read the impact that Zelma's unfamiliar uniformed persona had on him. Had she been a uniformed clerk or an overall-clad worker in a factory, he might have found it less unusual: it was the authority conferred by her uniform as a conductress that really made an impression. He described how Zelma had, as a result of the war, become someone else, part of a disciplined force. 'She commands people. She directs and controls them. She has joined the great army of uniformed workers who minister to the public, and the postman and the policeman are her natural allies. You have known her up till now as a woman. Now you know her as a social unit.'[43]

It was not only women who had started to wear uniform in large numbers but also men who for one reason or another could not serve in the armed forces. When Secretary of State for War Anthony Eden called on 14 May 1940 for men between the age of seventeen and sixty-five to volunteer, there was a surge of enthusiasm throughout the country and by the end of June 1940 some 1.5 million men had come forward to join the Local Defence Volunteers (LDV). He told them: 'This name describes its duties in three words. You will not be paid, but you will receive uniforms and will be armed.'[44]

The LDV was led by ex-soldiers of what Angus Calder described in *The People's War* as the 'Colonel Blimp' type. The LDV was renamed the Home Guard later that year and the process of providing clothing was completed in 1941. The uniform was a set of khaki denim overalls with a belt and eleven buttons and rings. 'Gentlemen with a full waistline suffered from a shortage of the right size denims,'[45] Calder wrote. It is hard now to think of the Home Guard and not to recall the antics of Captain Mainwaring and Corporal Jones and indeed the fact that in 1940 only about one man

in ten in Kent had a rifle did make a mockery of the idea that they could provide a second line of defence in the event of an invasion. One daughter described her father dressed in his LDV uniform: 'Dad has now got his "Parashot" uniform and looks quite good in it. I really think he looks better in a uniform than in an ordinary suit. I think he is rather upset because he only has two buttons on his cap that need polishing and he had to get his old regimental cleaning set out in order to do them. He still has his ribbons for China and India and has sewn them onto the tunic – or blouse rather. I think, personally, he was happy to be "one of the boys again" and should never have left the army.'[46] The Air Raid Precautions (ARP), later to become Civil Defence, also suffered from delays in supplies of uniform and poor equipment. There were some 1.5 million wardens in Britain during the war, the vast majority being unpaid, part-time volunteers. In the early months of the war, Civil Defence wardens wore helmets, armlets and badges on their civilian clothing. In 1940 the government tried to withdraw all uniforms at the same time as it announced a standard badge. One warden wrote bitterly: 'Presumably the new badges were to be sewn onto our pyjamas.'[47] Flo Hyatt joined the Fire Guard and was given an official tin hat. 'It's grey in colour with a sort of black bootlace contraption holding the inside padding in place. You can't see ME when I've got it on and they are not what one would call flattering. It reminds me of a tin washbasin. However, it may come in useful one of these days although as I've got a small head I rather feel it will blow off (the hat I mean) with the first blast of a bomb.'[48]

The largest women's organisation during the war was the Women's Voluntary Service (WVS), founded in June 1938, by Stella Isaacs, Marchioness of Reading. She had been invited by the Home Secretary, Sir Samuel Hoare, 'to form a service of women, to be attached to local authorities throughout the country and giving their services on a voluntary basis, in order to prepare for the dislocation that would inevitably be caused to the civil population if war was to come'.[49] WVS members played a key role in the evacuation scheme in 1939 and from the start ran clothing centres for the needy. These were vital during the Blitz when thousands of families needed to be re-clothed as well as re-housed. WVS rest centres offered not only clothing but food, sanitation and a temporary roof. By 1942 the WVS

had over a million members and was widely respected for the useful work it did with evacuees and later with refugees from bombed-out cities. It is on record that during the second half of 1940 the WVS distributed £1.5 million worth of clothing (about £760 million in 2014), much of which had been donated by America and members of the Commonwealth.

Lady Reading was anxious that her volunteers should have a uniform, but it took time to design one from scratch. She convinced the London couturier, Digby Morton, to design a suit, blouse and overcoat. She then approached Harrods and asked them to make and supply the uniform, emphasising to both designer and retailer the importance of supporting the WVS as a matter of public duty. Over the course of the war articles were added to the uniform so that eventually members had complete summer and winter outfits.

Fortnum & Mason had long had a special relationship with the British armed forces. It began with the sending of hampers to Wellington's soldiers as they fought Napoleon in 1815 and beef tea to Florence Nightingale in the Crimea at the request of Queen Victoria. During the First World War, hampers were sent to the Western Front, including 500 Christmas puddings. However, it was during the Second World War that the officers' department catered, for the first time in its history, for female officers. As arbiters of decorum they developed and patented specialist garments including the 'Fortknee' for drivers. This was a short stocking, knitted from the finest wool, which would be worn over the knee and cover half the thigh, thus preserving the modesty of the driver in the event that her skirt might ride up and expose her legs.

The Ministry of Agriculture needed to increase food production and, in anticipation of labour shortages in the countryside, the Women's Land Army, which had its origins in the First World War, was once again called into action. Lady Denman became the Honorary Director of the Land Army in 1939 and she offered her house at Balcombe in Sussex as the headquarters from which she ran an efficient organisation. Once conscription was introduced in December 1941, women could choose whether to join one of the forces or serve as a 'Land Girl'. At its peak strength in 1943, the number of Land Girls was in excess of 80,000, of whom 6,000 worked in

the Women's Timber Corps, felling trees and running sawmills. The Land Girls were given a complete outfit when they signed up and many who joined the Land Army later in the war, from factories and the inner cities, had a whole set of new clothes for the first time in their lives.

As the Women's Land Army was not a military force, not all women wore the uniform of green jersey, brown breeches, brown felt hat and khaki overcoat, but most who did so wore it with pride. Beatrice Carr worked at Littlewoods Mail Order Limited as an accounts clerk. Based in Liverpool, she saw the devastation caused to human life and property in May 1941 when the city was bombed by the Luftwaffe, with the loss of almost 4,000 lives. She left her job at Littlewoods when conscription came into force in December, and having seen the brutal effect of war at close range, she chose to join the Land Army and was posted to the Montgomeryshire Agricultural Committee. Her delight at the wardrobe she was issued with is evident in her memoirs. She listed all seventeen different categories of clothing and footwear, including her drill jacket, dungarees, wellington boots – a rarely acquired item by the civilian population after February 1942, when the fall of Singapore cut off Britain's rubber supply – and her pullovers and breeches. 'We had to buy our own underwear,' she pointed out, but 'the uniform seemed adequate to me. It was replaced when worn out. The shoes lasted well. We were asked by the ladies of the town whether we would sell them shoes because of the coupons.'[50] The only item of clothing that brought despair was the headgear: 'The hat did nothing for our morale. We steamed, ironed, bent, stitched, pulled and cursed to try to make it into some sort of mode. To no avail, it remained what it was. It never wore out.'[51] The girls could wear civilian clothing in their spare time but Beatrice enjoyed the cachet of her uniform and wrote: 'I rather fancied myself in the breeches and overcoat though, especially when in the city.'[52] Not everyone was so keen on the uniform. Micky Bowman was one of a group of Land Girls from the north-east who travelled to Penzance by train, changing four times and arriving twenty-four hours later. This was her first time away from home: 'Here was I, a girl who had never been more than a cycle ride from Leeds, apart from a holiday in Bridlington once a year, going into the great unknown, and in uniform.

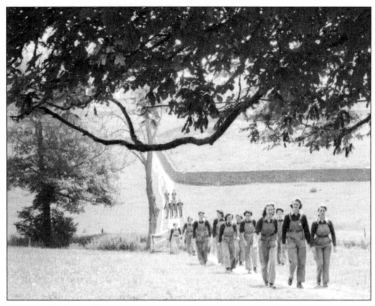

Land Girls marching to work in an idyllic pastoral scene. The reality was often different – long hours, loneliness and cold were features of many land girls' lives.

The uniform – I had never worn trousers before – fawn shirt, green tie and heavy woollen sweater. With a greatcoat I felt like Humpty Dumpty.'[53]

The April 1940 issue of *The Land Girl* magazine ran a general knowledge questionnaire on questions Land Girls should know the answers to, such as how many teeth a four-year-old cow has in its upper jaw or what a hogget was. But for the girls who had come from the inner cities, important questions revolved around clothing and make-up. 'Should Land Girls use make-up?' the magazine asked. It answered: 'This can only be a matter for personal decision, but perhaps it is worth remembering that (a) make-up on the farm is much more conspicuous than in a town; (b) country people are much less used to make-up than town folk.'[54]

Vita Sackville-West felt sorry for the Land Girls: 'their uniform seems to suggest a bashful camouflage of green and fawn to be lost against the

grass or stubble'. She knew that many of them had worked in towns and cities before the war and had worn silk stockings and jaunty hats – but now were consigned to wear corduroy trousers and clumping boots. Vera James was just one such young woman. Before the war she had worked as a court dressmaker in London, making ball gowns and coming-out gowns for royalty as well as for the Queen of Yugoslavia, who spent the war in London. Vera joined the Land Army for a change of scene. And a change it certainly was: the first message given to girls who arrived at the Duchy of Cornwall Farm at Stoke Climsland after joining up was 'cut, cut, cut'. Nails had to be short, especially for those who were involved in milking cows. Despite this, Vera came to love life in the country and she never did return to dressmaking in London. She married a Cornish farmer, even though, she admitted, 'I could not understand what he said a lot of the time'.[55]

So pervasive was uniform by the spring of 1940 that *Vogue* was running advertisements for costumes for the home front but 'with a military touch'. The tailors C. & M. Sumrie were offering to make women's clothes 'tailored by a MAN'S house'. The slacks' suit illustrated was a dark blue, woolly flannel material with a narrow chalk pinstripe, perfect for a slim young woman but anathema to anyone on the larger side.

Unsurprisingly, as more and more men and women went into uniform, fashion melded to fit better with the mood of the country. It seemed that women responded by giving themselves the appearance of strength during 1940. 'All the smartest suits and coats were cut on military lines, with broad padded shoulders, straight fronts, and moderately flared skirts, which had a well-placed pleat at the back. The knitted jumpers followed suit with square shoulders "*smart as a soldier*".'[56] Not everyone liked the look, however. James Laver, keeper of costume at the Victoria and Albert Museum, wrote in *Woman's Own* in May 1940: 'War leads women to straight lines and lack of femininity instead of lovely natural curves. We must strive to keep the colours up, the line more interesting.'[57] It may have been his wish but it was not to be fulfilled. Staying stylish was about to become a great deal harder for the civilian population who did not have the fall-back position of working in uniform.

3
Functional
Fashion

*I think it could be said that, during this
unusual period in Vogue's history, it became The
Intelligent Woman's Guide to much more than fashion.*
Audrey Withers

While a third of the population was getting into uniform of one sort or another, the other two thirds were watching the world around them change. After the first few weeks of war they settled into a routine of partial unease and a new 'normality'. The war was lived daily in the newspapers and on the wireless and almost everybody followed it closely. Diaries and letters often started with a mention of the latest war news or a reference to a friend or relative who was in the services. As wartime life settled down, the fashion editor at *Vogue* looked to see how the industry had changed in the first few months of the war. The momentum over the summer towards a new, tight-waisted Paris fashion had been stopped in its tracks and designers in London had reacted immediately to the new situation. It was described as a quick-change act in which 'easy-fitting, light town tweeds replace dark wasp-waisted cloth; covered-up evening dresses instead of décolleté; clumpy shoes instead of open sandals'.[1] The war look

– like the interest in uniforms – mirrored a change in the way Britain perceived itself. It was described as classic chic that was effortless, unostentatious and well-bred. Costumes had skirts below the knee, either with box pleats or full skirts, often in tweed; long-waisted jackets had square shoulders and a high-fastening front and were worn with turbans or small, neat hats. The emphasis was on practical and casual clothes that could be worn in town or country and dressed up or down as required. 'They do the job, we say; but what makes them fashion and not merely functional is that they play the part with artistry. They turn a brave face on a war of nerves. They fortify us with the feeling that we *could* walk twenty miles in those clog shoes; sleep out, if need be, in those ample, hooded coats; put our prized possessions in those kangaroo pockets.'[2] In this form of dress a woman would be ready for anything, even air raids.

Later in the war it was rationing and shortages that had the most impact, but for the first eighteen months it was the circumstances of their daily lives that wrought this change. More women than ever worked away from the home, so that factory uniforms, everyday work clothes for the office, or practical outfits for physical work, had already taken over from more formal dress. Now the nature of the work was different as so much of it was geared to war production. Dorothy Sheridan, Mass Observation archivist, wrote: 'Most women had to work hard, combining domestic responsibilities with some form of war work, either voluntary or paid.'[3] As the Phoney War came to an end with the invasion of Belgium and Holland in May 1940, followed by the fall of France in June and the Battle of Britain the following month, life on the home front was no longer peaceful. Government ministers and the Board of Trade realised that Britain was in for a long war. 'We cannot afford to live on the scale upon which we are now living,' wrote one high official. 'We must act more ruthlessly than we were prepared to act some months ago.'[4] This was easier said than done. For those who were to lose all but their lives, possessions were of little importance and clothing merely a matter of necessity.

Although the Blitz did not begin until 1940, there was a swift trade from the early months of the war in shelter signage, equipment and clothing. The siren suit, favoured by Churchill, was a one-piece jumpsuit that

was designed to be worn in a shelter and to be as practical as possible. Siren suits designed for women were sometimes made in patterned fabrics, but even if they were in dark blue or green, they would have puffed shoulders, baggy legs with elasticated bottoms and cuffs to keep the wearer warm, or prevent draughts, and a hood. Even a siren suit could look fashionable, *Vogue* maintained. 'Siren suits, one-piece and cosily cowled, respond to a profound need of mind and body, to be warmly, safely enclosed against fear and danger no less than against night frosts.'[5] Clara Milburn had one made by her dressmaker and she wore it for the first time in September 1940: 'I am garbed in it, wishing I weighed a stone or two less, but feeling very cosy.'[6] Other women also found themselves not cutting quite the image they would have liked when dressed up in siren suits: 'It's a "syren suit"!! It's navy stockinette, with a zip front to the "blouse" and to make ankles snug; roomy enough and easy fitting enough to slip on or wear anything extra underneath. It's the maddest, most amusing thing a sedate matron of fifty-one ever possessed!'[7] wrote Nella Last. When worn with a gas mask it would have been terrifying for small children, but it would certainly have been warm.

On the home front, the landscape for female workers changed out of all recognition. It is estimated that, by the middle of the war, one in three factory workers was female and by 1943 at least 90 per cent of single women and 80 per cent of married women between the ages of eighteen and fifty were contributing in one way or another towards the war effort. The workforce demographic changed too. The male workforce was on average eleven years older than it had been in peacetime and the female workforce four years older. These women were building planes and tanks, working in factories, making uniforms and taking part in all aspects of war production. And for each of these roles a form of uniform was required. Women working in factories wore a variety of clothing depending on the exact type of work, but dungarees were a common sight, as were head-scarves, used as turbans, to keep long hair away from dangerous machinery. Some factories kept on their largely female staff but transformed their end products better to fit with the requirements of the war industry. Skilled workers who had previously been involved in the manufacture of

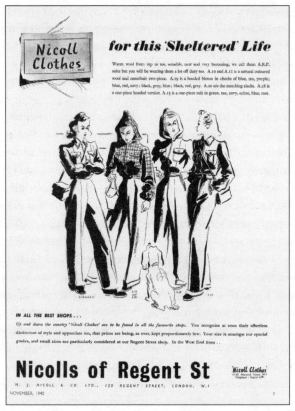

*The siren suit, featured here in the centre of this group, was favoured by
Churchill but was not a good look for women unless they were tall and slim.*

corsets, for example, found themselves making parachutes. They contin-
ued to wear civilian clothing, though many wore overalls to protect skirts
and dresses. Joyce Lucas started work in a dress factory in Northampton
in 1935 at the age of fourteen. It made dresses for Marks & Spencer and
Joyce's first job was to sew button covers. By the outbreak of war she had
progressed to making dresses and had become a skilled seamstress, so
that when the factory switched to war production and focused on light

ammunition, Joyce and her colleagues moved to making bags for cordite for 25-pounder shells. 'I can still remember how to make those little bags. They were well-made out of lovely material. It seemed a shame to waste good material for such an awful use.'[8]

Fortnum & Mason offered a pair of striped dungarees in an 'impudent black and white regatta-cloth, wide or pin-striped' for just 49s 6d (£120 in 2014), which they described as a playsuit. A more practical article was the boiler suit. This was either a one-piece or a bib and braces outfit worn by both men and women in factories. The fashion magazines tried to suggest they were designed to be attractive for women and *Vogue* optimistically described a design sold by Fortnum & Mason as 'streamlined from neckband to ankle cuffs and with patch pockets on the seat. Goggles, smart as sunglass are worn where sparks fly.'[9] These were featured alongside peaked caps and double wrapped turbans. Worn on models in pictures lit by professional photographers, the outfits looked glamorous and easy to wear. They were arguably the latter, but most women who worked in factories and had to wear boiler suits or dungarees would not have found them or their work glamorous. Light colours and cheerful patterns may have been appealing in principle, but they were not practical when dirty work was involved in aircraft production or an ammunition factory. Kathleen Church-Bliss worked in a light engineering factory in Croydon called Morrisons. She jointly wrote a diary with her fellow worker, Elsie Whiteman, with whom she lived in a Tudor farmhouse in Surrey. They both came from affluent families and by the time the war broke out they were middle-aged and had decided to give up their café and volunteer. They refer to each other in the diary by their initials. Here Kathleen commented on the discomfort of wearing factory uniform in the heat of summer: 'Another baking hot day ... K wears nothing but slacks and a blouse and overall, and E has got out her cotton bib and brace overalls. So we can't possibly wear less, though we are still extremely hot. Rapley asked K to approach Hurst for permission for the girls to leave off their caps during the heatwave.'[10] Permission was not granted, she noted.

From the very outset of the war, as we have already heard, imaginative firms designed bags and holdalls for gas masks. These were frequently

advertised in fashion magazines and sold through Fenwick's, Lillywhites and other stores. It was not just bags that became fashion accoutrements to blackout and shelter kit. There were luminous buttons, even luminous flowers to wear on coats in the blackout to make accidents less likely. That became a sad and little publicised statistic of the war. Even though there were – by the middle of the war – just 11 per cent of the number of civilian vehicles on the roads as there had been in 1939, the number of road traffic accidents rose, mainly as a result of restricted lighting on cars and buses. The year 1941 is on record as having the highest number of traffic fatalities of any year in the history of the motorcar: 9,169 people were killed that year, as opposed to 6,648 in 1938.[11]

In an attempt to prevent accidents, the government launched an advertising campaign urging people to wear something white, and in 1943 *Picture Post* ran a feature called 'A Bright Idea for Black Out' which demonstrated a number of hats, shawls and handbags that had luminescent paint. The accompanying photographs show the models in a lit studio and in the dark, with the features brightly visible. In 1937, *Times* columnist Jan Struther created fictitious Mrs Miniver, who wrote short reflections on everyday life. In October 1939 she mused on the strangeness of wearing white: 'But it's odd, isn't it, that the aim of "protective colouring" should now detach us from our background, not to melt us into it?'[12] By 1943 the figures for road traffic fatalities had dropped back to below 1938 levels, but were still some four times higher than they are today.

Housecoats were popular and often worn by women around the home, either over clothes or, in warm weather, as a separate item of clothing. They were practical, durable and could be easily fashioned out of old clothes or material that could be acquired off coupon. Housecoats and aprons were another way that women were able to protect and preserve their everyday clothes. We might look at these garments today and smile at the memory of grandmothers or aunts wearing them, but even *Vogue* considered them important enough to include designs for housecoats in the winter pattern book of 1939.

In March 1940 the War Cabinet had agreed in principle to a scheme for standard clothing and footwear. A month later, the first Limitation

of Supplies Order was imposed. This restricted the amount of cotton, rayon and linen goods that could be supplied to retailers. That spring, the government bought the whole of that year's wool clip from Australia and New Zealand and a large proportion of the South African wool output. This gave them enormous stocks for military use and some for the vital export trade. What was left over could be used for civilian clothing – but the focus was on clothing the forces.

On 13 August, the Luftwaffe initiated Operation Adler, which included aerial raids on south-east England, a prelude to the Blitz. A week later, Churchill announced that Britain now had 2 million soldiers to resist invasion. In truth, Britain was in a woeful state of armament. Historian Angus Calder described the country as 'standing not only alone but unarmed'.[13] The need to continue mobilising home defence had become ever more imperative as Germany began bombing raids, first by accident on London on 24 August, and then night raids on twenty-one towns and cities on the 29th with Liverpool and Birkenhead their principal target. On 25 August, the RAF bombed Berlin in a retaliatory action just days ahead of Hitler's concerted bombing campaign of Britain. The Blitz began on 7 September when 300 German bombers and 600 fighters flew up the Thames and dropped bombs on Woolwich Arsenal, a power station, a gas works, the docks and the City. It was the first of fifty-seven consecutive nights of bombing on London. More than 400 people were killed, 1,600 badly injured and thousands were made homeless in that one night.

Gladys Mason's diary entries usually began with a wry comment about the weather. As the bombing started and she was forced to spend evenings diving under the table and going to bed at night in their Anderson air raid shelter, the entries now began with the time the warning went off. On Saturday, 7 September, 'Mum ... hurried back and we just got in the shelter when guns started. The noise was simply awful. Guns falling near. We were terrified. It seemed continuous. All clear went at 6.20 and we saw masses of smoke over towards Stratford. Awful glow of fire in the sky which lighted up everything. Never known such a raid ever.'[14] When she went to work on Monday morning, she was shocked by the damage done to the East End, to the docks and to the Beckton gas works, which

supplied gas to East London, so that there were no hot drinks or hot food available. By early October she had developed the kind of stoicism that became recognised as the Blitz spirit. On the first Saturday, she bought a hat during an air raid warning which sounded for twenty minutes before the all-clear. Later that afternoon there was a raid. Her Aunt Alice's house was hit and in the house opposite a man's son and friend died. This time there is no sense of fear in her diary, just calm acceptance.

The bombers came to her part of Leytonstone on Friday, 8 November, and this time it affected her directly. 'Just after 11 heard a swish and a thud quite near and then a still closer one. Felt very frightened. We got out of shelter. Everyone in their gardens. Went into house and found glass in the hall, also upstairs.' Twelve houses in the next street had been bombed and sixty condemned, but fortunately no one was killed. A month later she noted that: 'The warning didn't come by bedtime and although it was moonlight and clear we risked it and <u>went to bed upstairs</u>. The first time for over three months. Last time it was 1st Sept.'[15] It was not until Christmas Eve that she was to spend the night with Frank in a bed. On 1 January she reflected on the last three months: 'London spent approximately 1180 hours – equal to 48 whole days – under alerts during 1940. The sirens sounded more than 400 times during the year, almost every warning having been since the latter part of August.'[16]

Two days later she was amused to report that the doctor she had seen was more interested in her gloves than in her cold. As the raids continued during the early months of 1941, she began to knit socks for Frank and a coat for herself out of brown bouclé wool, 'but it won't do, so must find another pattern'.[17] The raids, though still mentioned, had faded into the background and her preoccupation with everyday matters, including her health, the family, clothes-making and embroidery, once again come to the fore. This ordinary young woman in London was adapting to a strange new normality in a sometimes unreal, twilight world, where the threat of air raids was ever-present.

In October 1940, just a month into the Blitz, the Ministry of Supply took the decision that no more raw silk could be supplied for civilian use. Immediately the Board of Trade decided to exercise control over

the existing stocks and they introduced a Woven Textiles Order at the same time. Two months later, supplies of pure silk stockings to consumers 'would be completely prohibited except under licence'.[18] It was the first taste of austerity for the women of Britain and the silk stocking became the most longed-for garment during the Second World War, and the rarest. There were in fact ample stocks of yarn and hosiery remaining in the silk stocking industry but the government decided the yarn could be put to other use and the hosiery would be provided for the export market only. From then on, only 30 per cent of silk and rayon production was destined for the home market. This was a bitter blow.

The winter of 1940 and the following spring saw attacks on the Atlantic convoys escalate with the associated fear of the loss of essential supplies, leading to even greater restrictions on raw materials for the home market. Aluminium was added to silk as a banned material for sale to civilians. Other goods were also restricted, though not across the board. The supply of corsets was reduced to 50 per cent of the pre-war production, but furs went down by 75 per cent, as they were agreed to be non-essential. Some fashion editors put up a spirited defence of fur, arguing that it was a source of warmth in unheated houses, but to no avail – the Board of Trade was not prepared to bow to the lobby. Nevertheless, *Vogue* and *Harper's Bazaar* continued to carry features on fur coats and jackets, but they were a very high-end item that attracted 100 per cent purchase tax so were available only to the very wealthy. In view of how many people were having to hunker down in air raid shelters wearing unflattering siren suits or scratchy woollen coats, it is not surprising that the likes of Linda Radlett (heroine of Nancy Mitford's novel *The Pursuit of Love*), cosy in her mink coat in the middle of the Blitz, were in the minority.

The government knew that civilian consumption would have to be kept strictly under control. They also had good reasons to be anxious to keep Britain's lucrative export market functioning, mainly because it provided much-needed foreign exchange, but also because it kept its customer base supplied, which would be important in the post-war era. However, their main concern was to prevent profiteering and inflation. E. L. Hargreaves and M. M. Gowing, in their official history of civil

industry and trade during the Second World War, explained: 'Prices rose because of depreciation of sterling; increased prices in the countries where goods came from; increased freight rates, war insurance and so forth. Also demand for such goods as sandbags, black out material and torches rose suddenly, as did their prices.'[19]A woman in Sheffield told Mass Observation early in the war that she had gone into a shop to buy gloves and said to the assistant that she wanted to get them now because she feared the new stock would be dearer. To which the assistant replied: 'Ee, bless you, you're too late, we've put up the prices of the old stock already.'[20]

The Limitation of Supplies Order, which required companies to apply for quotas in order to sell into the domestic market, was widely open to abuse. Bogus companies were dreamed up and 'faked auditors certificates were numerous, and attempts were even made to prevent inquiries by offering bribes to the investigating accountants'.[21] This caused the Board of Trade serious problems until they stamped it out by the summer of 1941 with the assistance of Customs & Excise and Scotland Yard. By the summer of 1940, the Limitation of Supplies Order was broadened to include other materials, but by then the government had realised that unless America offered Britain financial help, the country would not be able successfully to prosecute a war on the scale that was developing. Churchill had appealed to Roosevelt during 1940 as Britain was running short of money, arms and other supplies.

Viewed from the United States, the situation in Europe was dire. Only one country to the west of mainland Europe was still standing against the Nazis and that country needed assistance. However, the American position was clear. They had taken an impartial stand, enshrined in the Neutrality Acts of the 1930s,[22] which forbade the sale of arms on credit or the loan of money to nations at war. Roosevelt had to find a solution and the one he came up with was Lend-Lease. The terms were straightforward: the materials were to be used until time for their return or destruction. Roosevelt explained the idea of Lend-Lease at a press conference in December 1940 with a simple example: 'What do I do? I don't say ... "Neighbor, my garden hose cost me $15; you have to pay me $15 for it" ... No! I don't want $15 – I want my garden hose back after the fire is over.'[23] Republican Senator

Robert Alphonso Taft, from Ohio, quipped in response: 'Lending war equipment is a good deal like lending chewing gum. You don't want it back.'

Had America not eventually agreed to the Lend-Lease agreement, Britain's whole position would have been hopeless. Britain could not win the war without America and the expansion of exports in 1940 had been but a drop in the ocean. The effect of Lend-Lease was to end the emphasis on exports and to bring in the much-needed goods that Britain relied on the USA to supply – arms, vehicles, money as well as batteries for torches, alarm clocks and other articles that were in short supply. However, there was no mass import of clothes for sale, although 'Bundles for Britain', an American charity, sent millions of dollars' worth of clothing, as well as ambulances, canteens and X-ray machines, to alleviate the humanitarian crisis. The Lend-Lease policy (which in its formal title revealed its true purpose, An Act to Further Promote the Defense of the United States) was enacted on 11 March 1941. In essence it was a programme designed to supply Britain, Russia, Free France, China and other Allied nations with material to help them fight the war. Everything was now focused on diverting resources to war production, which reached its peak in 1943. By then the US was supplying a quarter of all British munitions, as well as aircraft, food, land vehicles and ships.

How did this affect the public at home? The same month as the Lend-Lease Act was passed, the Chancellor of the Exchequer announced his stabilisation policy. The aim was to reduce the risk of a huge rise in the cost of living index, which had hitherto been kept in check through the control of food prices. However, clothing, the price of which had soared by an unsustainable 75 per cent over the first eighteen months of the war, was beginning to force the index upwards and therefore had urgently to be controlled. Everyone was complaining about it. Phyllis Walther, a mother living with her young son, John, in Dorset, was fed up with the shortages. She had been looking for coconut shampoo, but 'there has been none in Boots for months'. In May 1941 she went into Bournemouth on the bus to buy clothes for her and John: 'Everything was most expensive, no two sizes of anything and only one fitter so when she went to lunch you were stuck.'[24]

Eileen Gurney was concerned about even more basic needs: 'I don't know what we shall do about sanitary towels soon, as they are almost unobtainable. This war certainly affects everything.'[25] As an aside, there was help at hand, at least for women in the forces. Sanitary towels were relatively new-fangled and expensive. In a gesture of extraordinary generosity and understanding, Lord Nuffield, British motor manufacturer and philanthropist, supplied the women's forces with STs for the duration of the war. They were known as Nuffield's nifties and many women remember with gratitude this discreet assistance to women and the war effort. But this was only for the services. Women at home had to make do with shortages of vital supplies and resort to old methods of coping with such matters for the duration.

Meanwhile, people had to think more carefully about what they wore and indeed were encouraged to be both brave and practical. In November 1941, *Picture Post* returned to the question of whether women should wear trousers. 'The question is not so much "should women wear trousers", the answer obviously being yes, but "when, where and how". You can't fight an incendiary in confidence in clothes that flutter, or even sleep decently in a shelter in a skirt.' However, journalist Anne Scott-James,[26] was not impressed. 'Fascinated by their new competent appearance or by their long slim legs, women kept their trousers on in off duty hours. Now you see trousered women in West End restaurants. 16 stone women in flannel bags, young mothers dandling their babes in most un-maternal corduroys; and similar incongruous sights.'[27] She concluded that trousers should only be worn where they look natural: 'In the garden, in the garage, in the country, in your home or on the job. Slacks around the streets may save on stocking coupons, but they certainly don't improve the look of the town.'[28] This chimed with the predominant male view. Cartoons and illustrations by the likes of Edward Ardizzone mocked women who wore trousers, implying that they were slovenly and out of key with the smart men in service uniform. Nella Last wrote of how her son Cliff was concerned that his mother might be about to 'go into pants. Funny how my menfolk hate the idea of women in pants. I do myself, but if necessary for work, would wear them.'[29] In December 1939, *Vogue* was critical: 'We deplore the crop

of young women who take war as an excuse for ... parading about in slacks. Slack, we think, is the word.'[30]

In Oxford, the ARP wardens were issued with full uniform by 1940, having previously only had a tin hat, and they were offered the choice of a skirt or trousers. Ann Spokes Symonds, an Oxford local historian and wartime evacuee in the USA, wrote about the air raid wardens picked from among the women in Summertown: 'Some North Oxford ladies had never worn trousers before and there was a great discussion among them as to what they would choose. Some were still undecided when they reported to the police station in Blue Boar Street where they were issued with the uniform and some even asked the sergeant (on duty with two constables) what he advised. As one practice exercise involved crawling on hands and knees under a smokescreen, trousers were obviously more practical. They could also be put on hurriedly over pyjamas.'[31] Miss Betty Withcombe, one of the younger wardens who was attached to what she called their 'genteel' ARP post, was amused to observe that two of her acquaintances from North Oxford who were practically 'born on bicycles', could not get used to their uniform. One of them, Violet, 'who was used to riding in a long skirt, could not stay on her bicycle in trousers and fell off'.[32]

Despite these initial hiccups, slacks and trousers became increasingly popular during the war, even among older members of society. Women were far too sensible to want to try and escape into an air raid shelter wearing a long silk dress. Practicality therefore took the place of sentimentality and as the war progressed so fashion and design embraced a simplified look for wartime wear. Phyllis Warner wrote: 'I had lunch today with an old friend I hadn't seen for a year. She was telling me about the reaction of her grandmother, who is over 80, to her first air raid. It was a pretty hot one, and the family, huddled together in their shelter, were distinctly anxious about the old lady. As soon as it was over, someone rushed for the brandy, but Granny waved it away, and turning to one of her daughters said with an air of great determination: "Dorothy, I must tell you that I am not going through this again without trousers." One of the surprises of this war has been the toughness of old people. The only cases of bad nerves

I've seen have been in the quite young. How well I remember my first raid when my elderly relatives remained as cool as ice boxes whilst my knees rattled like a door knocker.'[33]

Limiting supplies of clothing in some way or another had been under consideration since the early months of the war. Many suggestions were made to the Board of Trade and all were considered but usually dismissed. A key player with links to the Board of Trade was Lord Woolton in his role as honorary adviser to the then Secretary of State for War (1937–40), Leslie Hore-Belisha. Lord Woolton was born Frederick James Marquis in 1883 to a saddler in Salford. His parents were determined that their only child should rise above the lower-middle-class background he had been born into. After university in Manchester (family circumstances would not stretch to his taking up a place to read Classics at Cambridge), he followed his interest in sociology, studying poverty and labour mobility in Burnley where he was a Maths master at the grammar school. After the First World War, during which he worked as a civil servant with responsibility for civilian boots, having been judged unfit for active military service, he forged a career in business, becoming chairman of Lewis's department store in 1936. He worked hard to establish a link between business and government, and as a result was one of a small number of businessmen brought into the government to help the war effort. He remained resolutely non-partisan throughout. As he had been associated with the Board of Trade via his chairmanship of the Council for Arts and Industry, Lord Woolton was well placed to make recommendations about civilian clothing strategy. He mooted a proposal for standardised clothing towards the end of 1939, but it foundered as no ministry was prepared to enact his proposals.

At this stage of the war, people were far more concerned with what was going on in France and by the threat of imminent invasion of Britain to comment on the restriction of goods. *Vogue* was still focused on summer fashions and Cyclax stockingless cream, believing that morale was more important than ever at such a critical time in the nation's history. In July 1940 they ran an article by a subaltern's wife in which she wrote about the way the war had affected her life and how she had adapted to cope with the stresses and strains of permanently being on the move. Her notebook

jottings show what could still be acquired that summer. She advised readers to 'look out for something warm in woollies – other people's houses seem twice as draughty. Think Jaeger's new camisole is the answer.' She resolved to buy a dozen pairs of stockings, all in the same colour. 'No more picking up an odd pair here or there, when one ladder means goodbye.' She also meant to book a corset fitting 'next time I'm in town: good dressing is wasteful without a good foundation'. This woman represented the moneyed class, married to officers, who could afford to visit London to shop for clothes at Jaeger or Fortnum & Mason. Two months after that article was published, *Vogue*'s offices were hit by debris from a massive bomb that landed a few yards from their building. The following issue featured images of the bomb damage inside and out. 'Our offices have been strewn with broken glass (see the freakishness of blast, that leaves a tumbler of water uncracked, unspilled). Though five storeys up, our floors have been deep in soil and debris flung through the roof.' Undaunted, the editorial team, the photographers and the models carried on 'congestedly, unceremoniously but cheerfully, *Vogue*, like its fellow Londoners, is put to bed in a shelter'.[34]

Phyllis Warner wrote of her experiences under air attack in London for the *Washington Post*, giving the Americans first-hand accounts of the Blitz. In her article, 'Ordeal by Bombs', she wrote movingly and very descriptively about life in London during the Blitz. 'The bombing of great cities is now an old story, but – God help us – it's new when you see with your own eyes what it means in terms of human suffering.'[35] The situation in parts of London in the autumn of 1940 was grim. Phyllis told her American readers as much as she could about the effect of the Blitz by illustrating the change that it had wrought on the city. At the end of September she went to Oxford Street to buy a dress: 'I almost wish that I hadn't; the sight of that fearful destruction makes me feel so much worse tonight. The less one sees of the results of bombs the better. The big stores are carrying on gallantly in spite of their troubles. I bought a dress at D. H. Evans, there wasn't a pane of glass in the shop, and the models were all nakedly exposed to the street, but the shop girls, wrapped in big coats, were models of helpfulness and got just what I wanted. John Lewis's great building was

here is **VOGUE**

in spite of all!

OUTSIDE—on several nights, bombs have spattered within twenty yards. This street below our window now holds a new crater, and another length of the arcade has crashed. We were turned out temporarily for a time bomb

INSIDE—our offices have been strewn with broken glass. (See the freakishness of blast, that leaves a tumbler of water uncracked, unspilled.) Though five storeys up, our floors have been deep in soil and debris flung through the roof

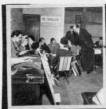

BENEATH—we work on when our roof-watcher sends us down. Our editorial staff plan, lay-out, write. Our studio photograph in their wine-cellar-basement. Our fashion staff continue to comb the shops. Congestedly, unceremoniously but cheerfully, Vogue, like its fellow Londoners, is put to bed in a shelter

19

Vogue: Defiant in the face of attack from the air.

bombed and burned until it is only a blackened shell, but it bears the defiant notice "Reopening on October 7th".[36]

Not all shop assistants were as friendly and accommodating as the girls at D. H. Evans. In St Albans, shop assistants in one store were informed by their managers that the usual rules of courtesy and politeness had been relaxed: 'from now on it was all right to answer back to selfish shoppers who grumbled when they couldn't get swansdown powder puffs'.[37] By and large, however, people were affable even under pressure and J. B. Priestley, who broadcast *Postscripts* on Sunday evenings, spoke of how he admired working women who kept on going through any number of trials and how they had shown their 'high courage and resolution ... crowds of nurses, secretaries, clerks, telephone girls, shop assistants, waitresses, who morning after morning, have turned up for duty as neat as ever – rather pink about the eyes, perhaps, and smiling rather tremulously, but still smiling'.[38]

The brave shop assistants, waitresses and all other civilians were about to have their resolve challenged as life on the home front entered a new era. From the spring of 1941 the government introduced clothes rationing and everyone in the country, rich or poor, male or female, became subjected to the same limitations on what they could purchase. As we shall see, how your wardrobe looked in May 1941 had a considerable impact on how you would cope with the next months and years of the Second World War as far as clothing yourself and your family went.

4

Coupon Culture

England expects economy of clothes,
economy of coupons, but an abundance
of well-dressed women.
The Board of Trade, 1943

While the Blitz continued to rage over London, Liverpool, Plymouth and other cities, the statisticians at the Board of Trade, safely evacuated to three hotels in Bournemouth,[1] were busy trying to work out the clothing needs of the population in wartime. The price of clothes had risen astronomically and garments attracted varying levels of purchase tax which was as high as 100 per cent for luxuries such as fur. The Board estimated that the general cost of living had risen by this date to roughly 25 to 30 per cent, so it became imperative to introduce further, far-reaching restrictions on clothing which would put a stop to the increases. For young women like May Smith, who spent all her earnings on clothes and make-up, the price rises and the extra income tax meant that 'My hopes of a new coat, new ankle socks and new underwear fade. I have to face a reduction of £3 14s. 2d a month from this day forward ... Spend the evening by the fire unpicking my last year's tennis dress to be remade, in the interests of economy.'[2]

The man put in place to run the Board of Trade was Oliver Lyttelton. He had served with distinction in the First World War and had been awarded the Distinguished Service Order and Military Cross. After 1918 he went into business and worked as managing director of the British Metal Corporation. In 1940 he became President of the Board of Trade, a post he held until 1941, and entered Parliament as a Conservative representing Aldershot and was a member of Churchill's war coalition. It was on his watch that clothes rationing was to be introduced.

Churchill had been against clothes rationing as he had been against food rationing. He told Lyttelton that he did not wish to see the public in 'rags and tatters'. When Lyttelton replied that he believed the man on the street wanted rationing, there was an outburst of rage from the Prime Minister: 'Who are you to tell me what the public want? Why, I only picked you up out of some bucket shop in the City a few weeks ago!' This was not entirely fair: Lyttelton had consulted widely. On 28 May he met Miss Frances Farrer, the General Secretary of the National Federation of Women's Institutes, to discuss how best to disseminate the information about the planned rationing and how to enlist the support of WI members to help. On the same day, he also met Lady Reading of the WVS, Miss Keeling of the Citizens' Advice Bureau, Miss Thorley for the Women's Co-operative Guild, as well as the Chairman and Secretary of the Association of British Chambers of Commerce and National Chamber of Trade.[3] All these women belonged to the Women's Group on Public Welfare, to be discussed in chapter 7.

A further 'most-secret' meeting was held with Miss Farrer and Lady Reading at which each was given a draft letter to send to their branches to arrange meetings with envoys from the Board of Trade the following week. Lady Reading was delighted: 'It's splendid – and about time too!' She went on to quiz blushing civil servants at the meeting about the number of coupons that would be required for various items of women's underwear. Lyttelton said later that 'it was upon these two women's organisations that I was relying to explain the scheme to the public.'[4] He had also arranged for 150 representatives to be put in place to help traders to understand the coupon scheme and its workings.

Lyttelton knew that he would have a battle to convince Churchill of the necessity of rationing clothes and footwear. In a memorandum marked 'To be kept under lock and key', he warned the War Cabinet that 'supplies of raw material for civilian clothing have been drastically curtailed; the amounts of cotton and wool available are not more than about 25 per cent of the pre-war normal'. He explained that consumers had been drawing on the large stocks of clothing held by traders, but that those stocks were now dwindling and shortages were inevitable. 'I fear that unless supplies are increased, or the distribution of the existing supplies is equalised (which means rationing), some part of the population will have to go short on clothing in the autumn and winter; there will be panic buying and shop queues, prices will rise and the shops will be cleared by the better-to-do, leaving yet smaller supplies or none at all for the poorer classes. I need not dwell on the social consequences of such a condition of affairs.'[5]

The Clothes Rationing Order, dated 29 May 1941, did not come into force until 1 June, although it had been agreed in principle by the War Cabinet in March. Sir John Anderson, Lord President of the Council, and Sir Kingsley Wood, Chancellor of the Exchequer, were supporters of clothes rationing and agreed to speak to the Prime Minister. Lyttelton wrote in his memoirs of the moment when it finally came to the crunch: 'The day when I wanted to launch the scheme was not far off when the hunt for the *Bismarck* began. Anderson and Kingsley Wood were waiting to see Winston on my business, and eventually got into his room at Church House ... "Clothing rationing?" he rasped to those two senior ministers. "Can't you see I'm busy? Do what you like but please don't worry me now." John Anderson came out and said "You can go ahead" so I rushed back to the Board of Trade and pushed the button.'[6] At first Churchill was furious when he found out that clothes rationing had been pushed through despite the fact that he had been vehemently against it. However, he was magnanimous in defeat and when he met Lyttelton a week later, said: 'Here's Oliver, who rejects the Prime Minister's views on public opinion about clothes rationing and turns out to be right ... We will have an *extra* glass of champagne to celebrate.'[7]

The introduction of clothes rationing on Sunday, 1 June 1941, came, as we have seen, out of the blue for the vast majority of the British population. 'It's wonderful how well the secret has been kept,' wrote Phyllis Warner. 'I can't come across anyone, Civil Servant or journalist, who had the least inkling of it. Everyone was chatting about it all day – it's even more of a loosener of tongues than the Hess landing.'[8] (Rudolf Hess, a prominent Nazi and one of the most influential men in Germany after Hitler and Goering, had made a solo flight to Scotland, landing on 10 May, where he hoped to arrange peace talks with the Duke of Hamilton.) Clothes rationing was introduced on Whit Sunday because Monday was a bank holiday and the shops would therefore be closed for two days, allowing retailers to get to grips with the new regime. Oliver Lyttelton gave a radio broadcast that morning to appeal to the nation to show patriotism by becoming badly dressed: 'In war the term "battle-stained" is an honourable one. We must learn as civilians to be seen in clothes that are not so smart because we are bearing ... yet another share in the war. When you feel tired of your old clothes, remember that by making them do you are contributing some part of an aeroplane, a gun or a tank.'[9]

Everyone would be entitled to sixty-six clothing coupons to last for a year. This reflected the Board of Trade's decision to restrict clothing consumption to two-thirds of the pre-war levels. It was not possible to be wholly accurate, because some garments such as underwear would depreciate more quickly than outerwear, shoes would be got through by children and so forth. Although everyone had the same number of coupons, children's clothes had lower points' values as the Board recognised that they would need new clothes more often. Pregnant women were given no extra allocation for maternity clothes and often had only one or two maternity outfits, which they lived in for months on end. The Board of Trade advised them 'to avoid spending coupons on special maternity clothes. Almost all your existing clothes can be altered easily so that you can wear them comfortably until the baby is born, and you can wear them again afterwards.'[10] For their babies they did get extra coupons and also for some older children who were growing quickly and above average height or weight. It is remarkable that the Board succeeded as well as it did with

rationing, and that although there were changes in coupon allocation and tweaks at the fringes, by and large it worked until it was withdrawn in 1949. However, it was fearsomely complicated and the HMSO was forced to issue 'The Clothing Quiz' annually in order to help people try and understand the system. The detail was extraordinary, for example: 'pair of men's half hose – not woollen, or pair of ankle socks not exceeding eight inches from point of heel to top of sock when not turned down – 1 coupon'.[11] Baby clothes were covered by mention of a pair of knitted booties worth half a coupon.

Lyttelton remarked retrospectively that 'the most difficult part of the scheme on which to form a judgement was, of course, the total number of coupons which each person should have and, within this, the weighting to be given to each coupon ... This in turn posed the question how much, in terms of tentative numbers of coupons, did the lowest paid people in the country spend each year on clothes and shoes? They should in principle be able to buy rather more than they were accustomed to, because they had no stocks to come and go on.'[12] It was a complicated calculation that taxed the statisticians and was made more difficult by the fact that – because it had to remain a secret – there was no opportunity to ask for outside help. By a strange stroke of luck, however, one of Lyttelton's colleagues had been working with a statistician in the Bank of England and together they had spent the last eleven years compiling and exchanging statistics on this very subject. Lyttelton was able to use their research to back up his calculations for the rationing. This colleague had claimed that the estimate of sufficiency was about 90 per cent accurate, which in this situation was deemed adequate and turned out to be so.

Everyone who wrote diaries or letters during the war had something to say about the introduction of clothes rationing. Clara Milburn, having spotted that stockings would be rationed, wrote in her diary: 'The great surprise of this Whit Sunday morning's news is that clothes are to be rationed. It had been a well-kept secret, and the rationing has begun! Of course one did not walk Twink today in silk stockings and best suit.'[13] Molly Rich was surprised by clothes rationing: 'The rationing of clothes broke like a thunderclap. It had not leaked out and no one could lay aside

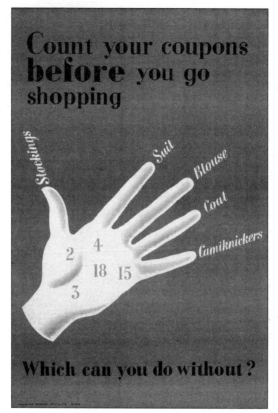

Government poster encouraging shoppers to ever greater frugality.

stocks of stuff. At the moment if we need new clothes we have to hand in our margarine cards.'[14]

Eileen Gurney was also not particularly worried by rationing. She wrote to husband John that evening: 'I'm rather pleased about the clothes rationing as I can easily manage on the coupons allowed. I've got heaps of materials and all sorts of old things I can renovate. Although I can't be as well dressed as a girl who spends lots of money on her clothes, I'm second to none when it comes to dressing for nothing, and looking well turned

out in renovation, wangles and oddments pinched from your old suits.'[15] On the subject of his old suits she suddenly appeared to feel a little sheepish. 'I <u>was</u> going to ask for another pair of trousers but of course you'd better keep them now and I have now got 2 pairs of slacks so I don't really need another. I've got heaps of clothes and several lengths of material that I shan't even begin to make up til next year. So I'm not worrying.'[16]

Mollie Panter-Downes was not nearly so positive. She wrote: 'This morning the President of the Board of Trade came on air to announce the imminent rationing of clothes, thereby ruining the Sunday breakfast of millions of women who regretted not having bought that little outfit they had dithered about the other day.'[17]

The government hoped that clothes rationing would encourage people to take stock of their wardrobes and see what could be made to last. There were, of course, men and women at the extremes of society for whom clothes rationing meant little: some so poor that they had to rely on handouts from the likes of the WVS-run clothing banks to help them make ends meet. Others had immense wardrobes full of clothing to last them well beyond the war. Tory MP Henry 'Chips' Channon wrote in his diary that sixty-six coupons per year was not generous, especially as a man's suit took twenty-six, before adding: 'Luckily I have 40 or more [suits]. Socks will be the shortage. Apart from these, if I am not bombed, I have enough clothes to last me for years.'[18]

The number of coupons to be surrendered for any particular article was set by the Board of Trade and although it changed occasionally – such as the number of coupons for men's short socks, which were 'down-pointed' from three to two coupons in 1942 – by and large any tweaks were to the number of coupons allocated to individuals rather than the coupon value of clothes themselves. A woman's winter coat would require fourteen coupons, while a man's coat was even higher, at sixteen points. Men's trousers were eight points unless they were corduroy, when they were five. Women had to submit seven coupons for a skirt or dress and three coupons for knickers, corsets or aprons. The list ran to at least twenty different articles of clothing.

Coupons also had to be surrendered for most fabrics. Blackout cloth was off-ration, as were furnishing fabrics, but everything else had to be

bought from the annual allocation. A yard of woollen cloth 36" wide was worth three coupons, and any other fabric two coupons on the basis that wool was more durable. As socks and stockings could not be measured by the yard, they had to be estimated on probable usage. The Board of Trade reissued the clothing quiz booklet every year to inform the public of the latest changes to the scheme.

Flo Hyatt spent three of her precious coupons on collars and cuffs before they were struck off the list of items on coupon. 'Of course one does not get redress but it's very annoying. I am saving most of mine for winter things as I shall have to have a warm dress and coat and they will take, let me see, 11 for the frock and 14 for the coat that's 25 gone west. I wish we could grow fur, we wouldn't have to worry about clothes then, would we?'[19] Coupons quickly became one of the most precious items, carefully guarded and by and large not wasted.

The bureaucracy of clothes rationing was mind-boggling. Initially the public used twenty-six margarine coupons as clothing coupons and were issued with a further forty, of which twenty could not be spent before 1 January 1942. This meant that well over 2.5 billion individual clothing coupons were issued in the first year of clothes rationing alone. Initially, the use of margarine coupons caused some confusion. Norman Longmate wrote about a man who tried to spend his cheese and bacon coupons in John Lewis, having used up all his margarine ones. Once a customer surrendered a coupon, it had to be 'banked' by the retailer and cross-checked by the Board of Trade against cloth issued to the manufacturing trade. In the first summer, the Board took on sixty university dons who were asked to help out with this accounting during the long summer vacation. The system worked well and was instituted again the following year.

In 1942–3, individual clothes ration books were issued to the civilian population. Flo Hyatt explained the ration book to her aunt: 'It is quite small and rather like a miniature chequebook. It holds sixty coupons, which have to cover a very long period. They don't go far when you start buying heavy things. Coats, for instance, take 18 coupons and a thick dress, anything up to 11.'[20]

These books contained sixty coupons, rather than sixty-six, after

the Board of Trade was told to reduce the number as clothing shortages were becoming ever more severe. Ministers wanted the number to be closer to fifty, so they extended the ration period to cover fifteen months, from June 1942 to the end of August 1943, meaning that people had effectively forty-eight coupons for a twelve-month period. Coupons were colour-coded in order to limit the time in which they could be spent and to ensure no binge-buying. Green coupons could be exchanged against clothes immediately; brown ones could not be used until 12 October 1942; red had to be held on to. From October 1942 to March 1943, the brown and any remaining green coupons could be used, while the red ones were not valid until 1 April 1943.[21] This required vigilant policing as well as careful management by consumers. Two years into rationing, people were still finding it complicated. As Flo Hyatt complained, 'These coupons present as worrying a problem as the old Income Tax Returns did pre-war.'[22]

The Board of Trade constantly sought to get its message across to the public. Sometimes it was with the help of magazine editors; on other occasions they placed advertisements in periodicals and newspapers, or quite often they broadcast speeches or discussions on the BBC. As over 10 million households had wireless sets, it was a sure way to get the ear of the nation. One evening in March 1942, Nicholas Davenport from the Board of Trade and Mrs Ingillson, co-presenter of BBC radio programme *The Kitchen Front*, but here representing the general public, discussed industrial overalls in a fifteen-minute broadcast at 6.45 p.m., a time of day when they could guarantee that many people would be listening. Mrs Ingillson began by asking him why, with a new president at the Board,[23] the public were not getting extra coupons, and so had to sacrifice part of their ration for work-wear. He replied: 'Then I can tell you, you misunderstand Mr Dalton and the new spirit of the hour which is one of extra sacrifice and extra effort.'[24] That much was true. Hugh Dalton, adapting 1 Kings 12:11, had said: 'If Lyttelton chastised you with whips, I will chastise you with scorpions.'[25] For the previous year, workplace clothing had been coupon-free, as Phyllis Warner described in her journal: 'Clothing coupons have had an odd effect on one's shopping. Today I bought a boiler suit,

technically a "bib and brace" coupon free, because it is occupational cloth-ing. The shops are full of them in all sorts of bright colours. They will be grand for fire-fighting, but it's still a bit of a racket really.'[26]

But the Board of Trade was aware of this and determined to put a stop to it. Mr Davenport explained that, in the early days of rationing, boiler suits and 'bib and brace' overalls were exempted as a temporary measure. 'We knew that some industrial workers were extra hard on their clothes and that many of them had to wear trouser-overalls.'[27] However, having given them a year's grace, those workers had to be brought into line with the rest of the public. He reminded Mrs Ingillson that a factory worker had to submit only three coupons for a coat-overall as compared to eighteen for an overcoat. It did not seem a very fair comparison and Mrs Ingillson expressed particular indignation that factory workers had to surrender clothing coupons to their employers for overalls that did not belong to them but were factory property. The Board of Trade had thought of every possible detail, however, and Mr Davenport was able to assure the public that if a worker left his or her job they would be entitled to a refund of coupons, worked out on the basis that an overall would last for six months and the refund would be calculated according to how far into the six-month cycle of wear and tear the employee left.

It does seem extraordinary by today's standards that such rigid con-trol was maintained over every minute aspect of clothing. Though, as Davenport pointed out, the saving on materials, and therefore shipping, by reducing the number of coupons distributed, was immense. Two cou-pons less per capita represented a saving of 90 million coupons, which in turn represented some 30 million yards of cloth. This 'total war' was being fought not only on the battlefields, in the air and at sea, but in the tiny increments of cloth and patched socks.

William Buller Fagg, known to his family as Bill, was an ethnologist and art historian at the British Museum who worked for the Board of Trade during the Second World War. Since he was not required to help look after the museum's collections in their temporary homes in Northamp-tonshire, he remained in London, waiting to be called up for war duty. But, on account of his poor eyesight, Bill was turned down by the services

and went to work for the Board of Trade, where he was initially employed to monitor corduroy output. He also served with the Home Guard.

Bill Fagg was a meticulous historian and had a phenomenal memory. His niece, Angela Rackham, remembers him as a cerebral, quiet man with a wry smile and a gentle sense of humour. He was a sympathetic man, she said, and let his staff have time off during the Blitz if their families or homes were affected, and for this they were very grateful to him. He found it easier to express himself on paper than verbally, though he was good at putting forward new ideas. One of his main contributions to the shortages was his successful attempt to save yards of cloth in the manufacture of items such as boys' shorts. Enlisting the support of a designer in the cloth trade in Manchester, he worked out how much material could be saved if shorts were cut more economically from the available cloth.

After the war he wrote to the Director of the British Museum explaining his roles at the Board of Trade and how he could put his experience to good use in his former position. The letter shows the human face of the monumental bureaucracy around clothes rationing. He explained that he had spent the first year managing a section of thirty people whose job it was to prevent 'coupon inflation', and had been personally responsible for the issue of 200 million coupons. He was only twenty-seven at the time. Once that was established, he was charged with consolidating the clothing industries of seven important towns in the south and south-west of England. At times he had to do battle with the clothing trade and stand up for the Board in the face of violent disagreements with government policy: 'I believe I have obtained the reputation of being better able than many people to sustain a necessary but unpopular policy against such opposition. At the same time I have been able to carry other important policies by friendly collaboration with the trade.'[28] It was this ability to get the job done that meant Bill Fagg enjoyed a meteoric rise at the Board during the war. His friends were delighted by his success and enjoyed a bit of fun at his expense. One of those friends, Myers Lubran, on hearing of Bill's promotion, wrote: 'Does your high rank entitle you to a carpet, upholstered armchairs and afternoon tea? If so, I must visit you in your palatial office and bask in your reflected glory.'[29]

The Board of Trade returned to London from Bournemouth in the autumn of 1941 and, such was the pressure of work, Bill Fagg often slept in the office. His house in Upper Norwood had suffered bomb damage during the Blitz, losing sixty panes of glass from its many windows and endangering his collection of 18,000 books, which was a constant source of concern, as was his elderly widowed mother who had previously been evacuated to Bournemouth with him. A book of attendance showed that Bill Fagg regularly put in twelve-hour days at the office and worked every Saturday and most Sundays. Yet he still found time to keep up his interest in and work for the Royal Anthropological Institute, which almost certainly owed its survival to Bill Fagg and two other anthropologists who were similarly determined.

During the summer of 1941 Fagg had been trying to oversee the transition from pre-rationing quotas to post-rationing quotas and coupons. It was a task that required painstaking attention to detail and monitoring, and the notes on his files betray his frustrations and moments of triumph. 'These peoples' competitors are presumably the black sheep we are after,' he wrote to a colleague, having spent three weeks trying to work out who was selling material for bib & brace overalls to makers-up outside the coupon system. He was also involved in working out what quantities of material would be made available for non-rationed goods, such as blankets, pillows, oil cloths, table napkins and dress shields. Blankets were limited to 50 per cent of the proportion of cloth used in 1940, pillows and mattresses to one third and 'fancy drapery, table cloths, table napkins, dress shields – NIL.'[30]

The Board of Trade was obliged to keep the press up to date with the detail of rationing plans, and these press releases were often drafted by Bill Fagg. Between September 1941 and August 1942 the Board issued 315 notices regarding the rationing scheme, including details such as this: 'Two coupons are required for women's non-woollen legless knickers of any type, irrespective of the width of leg, provided they have no leg extensions on the inside of the leg below the gusset. This description covers certain types of French knickers, as well as close-fitting "briefs".'[31]

By and large, all the women's magazines could do was to support the

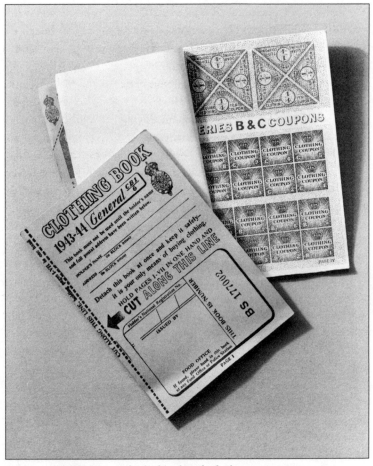

Clothing coupon books, like those for food, were precious items.

women of Britain as best they could in the face of this new obstacle to followers of beauty and fashion. *Vogue*'s guidance to those planning their wardrobes for the coming winter of 1943 was scraping the barrel in terms of cheerful advice: 'This is indeed a time when individual taste can have its head. Fashion has never been so flexible. Off-setting the uniformity of

the services is the variety of civilian dress. All that is asked of you is that you shall look as charming as possible in your own way. So though the new (and *few*) coupons must be spent wisely, let it be your own kind of wisdom; and one woman's wisdom is another woman's luxury.'[32]

Despite initial enthusiasm for rationing, the general public began to feel its effects on their wardrobes and in particular how far their coupons would stretch. Zelma Katin wrote about the price of clothes, complaining that clothing of any quality was twice or even three times its pre-war price. She resented having to surrender twelve coupons (later reduced to eight) for her uniform, knowing that tram conductresses in London were issued with ten extra coupons to make up the difference. In the end she shrugged her shoulders and decided to hunker down for the remainder of the war. Clara Milburn was equally anxious about use of coupons. She wrote in October 1942: 'The shelves are getting emptier and emptier and many other shops space their goods out to look more than there really is.... Many are the considerations before one buys any garment these days. I have seen women hesitating, weighing and pondering over a couple of vests at three coupons each, when in an ordinary time four would have been purchased without a single thought.'[33]

The cost of clothes also bothered people. Garments which were expensive in terms of coupons as well as normal price were noticed and often commented on. Eileen Gurney spotted her neighbour in a new two-piece costume. She told her husband in her next letter: 'It's tweed, nothing very special about it and not very good material. Price – 12½ guineas! Thanks goodness I've got plenty of pre-war clothes. I just wear a blouse and skirt all the time and hoard my nice clothes for the time when you come home.'[34]

In order to be fair, the clothes that were to be produced under rationing had to be sufficient in quantity in all sizes, durable and within everyone's price range. This last point was vitally important as the government had to be seen to understand the needs of all. With full employment there was no longer the desperate poverty there had been during the 1930s and the years of Depression, but with this came a desire on the part of everyone to buy what they liked. The Board of Trade had Area

Distribution Officers (ADOs) sited throughout the country who submitted weekly reports, giving a detailed snapshot of the waves of shortages that affected different areas of the country at times. In November 1942 the biggest issue was boys' boots. The demand included not just boots for boys but 'Wellington hunters (male and female) and a number of women who chose boys' boots to work in',[35] while in Scotland shoe shops were closing because of the supplies being so reduced. In July 1943 there was a severe shortage of underwear and nightwear and outsize stockings in England, and traders complained that they were finding difficulty in supplying 'utility frocks for girls aged 5–16, and also boys' suits in sizes 1 and 2'.[36] However, it was supplies of the wartime corset that caused the ADOs the most shame.

Children were issued with the same number of coupons as adults but their clothes required fewer coupons in recognition of the fact they were harder-wearing on clothes than those who were not growing. The Board of Trade issued a press notice on 2 November 1941 that laid down exact details of the entitlement to extra coupons agreed earlier in the year. It was announced that 'older children who have grown beyond the stage at which they can benefit from the lower coupon rates on smaller children's garments, but who are still growing fast and wearing their clothes hard'[37] would now be entitled to special rations. This was to include all children born on or after 14 July 1925 and before 1 September 1927 (i.e. sixteen to eighteen-year-olds), who would get forty extra coupons; children born between 1 January and 13 July 1925 who would be entitled to twenty extra coupons; and big children, especially, born on or after 1 September 1927, who weighed more than 7st 12lbs or 45kg or were over 5' 3" (160cm) tall, would get forty extra coupons. The purpose of including these figures here is to show the astonishing level of detail that the Board had to consider in order to ensure people got what they needed. The number of children who fell into these categories was in the hundreds of thousands and they were either at school, in jobs or 'falling into no particular category'. These cases all had to be verified and the measurements assessed. Children of school-age were issued with clothing cards which they had to take to school in order to qualify for their coupons. This took place on a certain day every

year. 'I remember my mother telling me to stand up extra tall when I was being measured so that I would get extra coupons.' Iris Jones Simantel recalled.[38]

Even then there were shortages for children and the WVS did magnificent work in setting up second-hand clothing exchanges where mothers could swap clothes for a number of points which they could then spend on 'new' clothes for their growing families. An extra layer of complexity was introduced when the mothers of evacuated children, having obtained their coupon allowance from the foster families, then spent them on poor quality cheap clothing which lasted no time, so that some hosts had to resort to using their own precious coupons to clothe their evacuees.

Nothing was of more concern to mothers than children's shoes, which fast-growing schoolchildren could grow out of within months. They were often forced into buying or exchanging second-hand shoes. This was far from ideal for the children's feet, but there was no choice: they had to be fitted out one way or another or they could not go to school. The number of workers in the shoe industry fell from 135,000 in 1939 to just over 95,000 in 1945. At the same time the wholesale price of leather increased significantly and the demand for children's shoes rose. With so many more people in employment, far more mothers could now afford to buy them 'and with the disappearance of rubber and canvas plimsolls, the great standby of the poorer home, they now turned to leather shoes'.[39] The shortage of shoes for children remained a thorn in the flesh of the Board of Trade as well as of families.

Over the next three years, clothes rationing became ever more complicated, so that by August 1944 the allocation was the equivalent to forty-one coupons a year, just two-thirds of the original number. The main problem was not the overall shortage of material but the fact that so much other clothing had to be produced: jungle warfare outfits for the fighting in Burma and elsewhere in the Far East, relief clothing for the bombed-out victims of the V-bombs, and demob suits for over 4 million men returning from the war. Flo Hyatt complained in April 1943: 'Coupons and Points are our nightmare. My clothing coupons at the moment number 34. I want a new coat (18) a new frock (10–12) Stockings (6) and I've more than

finished my supply, which has to last me to the end of August. My weekends are usually spent darning and patching and soon some of the things will be more darn and patch than anything else.' Even if, she pointed out, 'you have the money, you can't buy what you want'.[40]

Not every fashion item was on ration, however. Somewhat surprisingly, hats were not rationed, though they became increasingly expensive and by 1943 many women were going hatless. 'The prices of some of the hats is prohibitive and they are not worth buying,'[41] wrote one woman, while another, who kept a diary throughout the war, pushed the boat out in November 1942 and bought three hats. She confided towards the end of the month: 'Buy yet another new hat and feel so exceedingly wicked I have stomach ache as I return from making this purchase. Have spent £6.2.9 on three hats in about three weeks but am told no more are to be made and this one matched my blue suit, a difficult colour to get nowadays. Shall have to go on wearing these for five years or so. With thoughts such as this I try all afternoon to convince myself I am justified in this extravagance.'[42]

When the Board carried out a survey in 1944 and compared the coupon value of people's wardrobes against those in 1942, they found that the wealthiest 5 per cent of the total population had over 320 coupons worth of clothing and they had more, not less since 1942; the middle classes, 15 per cent of the population, had similarly seen a slight increase with an average of 260 coupons; while the industrial workers, representing 65 per cent, had seen a slight drop and had wardrobes worth on average 215 coupons. The poorest 15 per cent had just 180 coupons worth of clothes, just over half that of the wealthiest in society.

It was almost inevitable that there would be a black market in clothing coupons, as there was in clothes, food and other limited supplies throughout the war. Forged clothing coupons came onto the market as early as July 1941 in Guildford. In the first few months they changed hands for 2/6d a card, but by 1944 the price could be as high as £5 a book or 2s 6d a coupon. Naturally the Board of Trade was concerned about the danger of abuse of ration books and was constantly trying to increase the security of the documentation. In the second year of rationing, the Board introduced security printing which almost eliminated the possibility of forgery.

'In addition, all clothes ration documents bore serial numbers so that it was possible, with the cooperation of the issuing agents, to identify the rightful holder of any book.'[43] Despite these precautions, it was still relatively easy to evade the orders in the early months of rationing. In the first year alone, some 800,000 people claimed to have 'lost' their ration books and these were replaced without query. A total of 27 million extra clothing coupons[44] were therefore supplied and on the market, thus increasing demand for clothes. In the second year, lost ration books could not be replaced without a letter signed by a Justice of the Peace and accompanied by a 1s stamp. Cases of losses incurred through theft or bomb damage were reported to the police as these books had been lost through no negligence on the part of the holder. Nevertheless, despite these statistics, only about 1 per cent of all the clothing coupons in circulation from the second year onwards were illegally obtained. One of the reasons given at the time for the low level of abuse of the ration scheme was that people understood it was a necessity during a time of war. The Board of Trade issued a publicity leaflet that emphasised the importance of fair shares for all: 'it is *your* scheme – to defend you as a consumer and as a citizen. All honest people realise that trying to beat the ration is the same as trying to cheat the nation.'[45] It is more likely that people who really needed extra coupons could get them some other 'semi-legitimate' way.

Sometimes they could be bought from people who wanted the money, but more often they were obtained from elderly relatives who did not feel the need to make purchases of outer garments. This was known as 'fiddling' and people admitted to it readily after the war. 'There was a lot of fiddling. You used to buy coupons and not feel at all guilty ... there was always someone who didn't use their coupon ration that would sell them to you.'[46] Another woman who was in her twenties during the war recalled how 'you had a lot of friends who would help you with coupons: three elderly ladies who were friends with my grandmother – they would help'.[47] A boy at Harrow was told by his mother that he had to surrender the bulk of his clothing coupons to his sister, whose need was greater than his. He remembered being mortified that his mother then acquired the wardrobe of a dead man for him.

From August 1941, second-hand clothing was subject to new rules. There was a fixed price for dresses, suits, costumes (a two- or three-piece suit for women), blouses, trousers, but not underwear or boots and shoes. This was fixed 'by multiplying the number of coupons that would be required for the article if new by the prices as quoted'. The price was set at 2 shillings so that, 'if a new rayon dress was seven coupons, a second-hand version could only be sold for fourteen shillings or less'.[48] If a second-hand garment were to change hands for more than the fixed price, there would have to be an exchange of coupons. 'These rules had to apply to all such purchases including school uniform, goods sold at charity bazaars, sales of work and jumble sales. Coupons collected from these sales were sent by organisers to Area Collection Centres for the Board of Trade.'[49] This was yet another layer of bureaucracy that shows how far the government was prepared to interfere in people's lives and – equally astonishing – that people were prepared to accept it.

Rose Cottrell worked in London and wrote long letters during the war to her sister Pat, who had married a Swiss soldier called Adolf in the summer of 1939. The family were not to see Pat for the duration of the war and this was a bitter hardship when she was lonely after the birth of her son in 1941. Rose tried to cheer her up by describing the privations in London and the problems they were all encountering with shoddy goods and exorbitant prices.

By April 1945 she was in despair over coupons: 'We are in the thick of a coupon fight at home, as none of us have bought much in the way of clothing during the war, and we really must get something now.' What she described was happening in households throughout the country: with clothes wearing out, people had a genuine need for new coats, trousers or material for dresses and skirts. Whereas previously some mothers and male members of a family might have been able to donate some of their coupons to daughters, this was no longer possible and it caused tension, as Rose describes here: 'Mum wants a coat for her birthday, and she has just enough coupons without buying anything else until the next lot of coupons comes out. Lil wants a costume, shoes etc. which she won't be able to get, I have bought two lengths of material for a summer and winter

frock, and just have enough coupons, I hope, for another winter frock, so I shan't be able to get a costume or anything else. Dad's few remaining ones must go for a pair of flannel trousers for the summer, as he already has a new suit.'[50]

Long before this battle in the Cottrell household took place, the government had woken up to the fact that clothes rationing alone was not producing sufficient savings and that a further change had to be imposed upon civilians. The decision to restrict the amount of material used in the manufacture of clothing would lead to the utility scheme of 1942, which together with the austerity restrictions that it was quickly extended to include, would shape fashion and go on to influence designers for years to come.

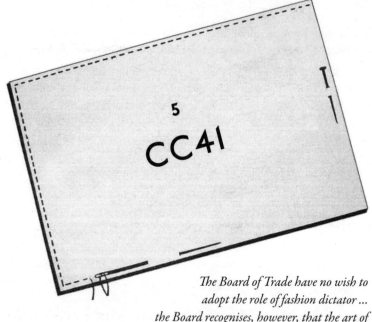

5

CC41

The Board of Trade have no wish to
adopt the role of fashion dictator ...
the Board recognises, however, that the art of
styling belongs essentially to the clothing industry and the
encouragement of good styling is one of the ways in which the
Government can assist that industry.

Board of Trade press notice, 12 May 1942

By early 1942 the war news was grim. In February, the seemingly impregnable fortress of Singapore fell to the Japanese and with that came the greatest defeat in British military history: some 38,500 British soldiers were captured on one day alone.[1] Eventually there would be in excess of 130,000 prisoners of war in South East Asia and several thousand civilian internees. The Japanese empire now extended to cover almost the entire East Asia-Pacific region, cutting off the Western world's supply of rubber and, incidentally, of quinine. In March, the Battle of the Atlantic plunged to new lows as the number of tons of shipping lost in U-boat attacks hit almost double what it had been six months earlier, and Hitler launched the so-called 'Baedeker' raids on the ancient cities of Bath,

The 'double cheese' became one of the most recognisable wartime logos.

Exeter, Norwich, Canterbury and York in revenge for the RAF attacks on Lübeck and Rostock. On the home front, food rationing had been extended to cover ever more items and a poor harvest the previous summer had led to smaller yields in all areas.

The loss of shipping had an effect on imports but, more importantly, on morale. The Board of Trade's solution to ever-increasing shortages of clothes, despite rationing, was to introduce the utility scheme in February 1942, with austerity restrictions on clothing design coming into play in April of the same year. Initially, 'utility' applied to the fabric from which clothes were made up, but eventually it was extended to cover furniture and other household goods. Austerity was imposed to restrict design by limiting, amongst other things, the number of pleats in skirts, the number of buttons used on coats and jackets, and the length of socks for men. The austerity regime also forbade turn-ups on men's trousers, which was a deeply unpopular move. From this point onwards, a new, more sombre mood gripped British fashion.

The main reason for the introduction of utility and austerity was to save material and labour, so that both could be diverted to the war effort.

The loss of factories and the interruption to production caused by the Blitz, as well as shipping losses in the North Atlantic, meant the government needed to control its remaining resources very carefully. What was left had to be 'concentrated' and, as Bill Fagg explained to his director after the war, this meant that 'large quantities of labour and factories [were] available for war industry ... transferring most of the clothing production into other, less difficult areas' such as the counties in the south-west away from the coast. The demands of war production on British industry reached a peak in 1943, when tens of thousands more servicemen and women were mobilised and a further 250,000 labourers were taken away from civilian production to meet the requirements of the war. The combination of utility and austerity saved millions of yards of wool, cotton and rayon, as well as releasing hundreds of thousands of workers into military production. It also meant that the government had unprecedented control over every aspect of people's lives.

In 1940 the Board of Trade invited firms that made labels for the clothing and commercial industry to enter a competition to design a utility scheme label. The brief was that it had to include the letters CC41, standing for Civilian Clothing Order 1941 (also sometimes claimed to stand for Controlled Commodities) but that the design should not be recognisable just by the letters. Reginald Shipp, who designed the 'cheeses', as the 'CC' logo became known informally, worked as a commercial artist for an old established company called Hargreaves that designed and supplied all types of manufacturers' labels from retail and clothing to club and uniform. Shipp was awarded a personal prize of £5 and received a letter of commendation from the Board of Trade. Once introduced onto utility goods, the logo had to be of an exact size whatever the garment or fabric. It was also applied to utility furniture and was not finally withdrawn from use until 1952. It has become one of the most familiar images of the Second World War, instantly recognisable to anyone who lived through those years. Another label, '11 o 11', known as the double eleven, was introduced in 1945 for superior quality material but the mark never achieved the status of CC41.

When it was first introduced to journalists and editors in November 1941, utility was not a directive but a concept, and the public did not see

any utility garments for several months. The idea of a civilian uniform had been considered and dismissed earlier in the war as unworkable and bad for morale: the last thing the government wanted was for people to believe they would be 'dragoon[ed] into wearing some sort of State uniform'.[2] At the outset, the launch was badly handled and the *Drapers' Record* commented in January 1942 that retailers were showing little enthusiasm for utility clothing, preferring to stock what was familiar and, at that stage, still plentiful. The public's initial reaction to utility was uncertain, though the fashion press was prepared to give it a chance. Anne Seymour, the editor of *Woman and Beauty*, told Mass Observation that while she thought it an excellent idea in principle, 'the only thing wrong with it is the name … it's up to the government to see that the clothes are so good that all women will want to wear them. The word Utility is awful, but it will be got over … it'll have to be.'[3]

People imagined heavy, drab clothing with little colour, though that was not in fact the case. There was no restriction on colour for utility cloth and many were bright with interesting patterns such as checks, stripes and even patriotic motifs. The government needed help to get its message across that utility clothing was of similar quality to other stock and that it was here to stay. They enlisted the support of Jean Guest, who wrote for the *Drapers' Record*. She was asked to provide an answer for shop assistants when they were questioned by customers about utility clothing: 'The garments are styled and made from cloths constructed on specified lines or price-stipulated by the Board of Trade. The margin of profit is controlled at every stage. Utility represents reliable value; but of course, there's no control over style.'[4] At that stage, this was at least reassuring for buyers.

Before the war, the number of different varieties of cloths, with slightly differing yarns, weaves and finishes, had run into the tens of thousands for cotton alone. It was clear that under the utility scheme this would have to be reduced drastically. Cloth was firmly controlled by the Materials Committee, through the clothes ration coupons 'which were passed back at every stage of distribution and production until they reached the registered firm.[5] By the summer of 1942 tighter restrictions had been placed on cloth and each type was given a four-figure number, published by the

British Standards Institution, whose list now included 102 cottons and 69 rayons. Each specification was given in a detailed technical document which advised on the weight of cotton per yard, the number of threads per inch, the degree of shrinkage, and the type of bleaching or printing for the finished fabric. Clothes made from these fabrics were then tested for shrinkage, fastness for washing and waterproofing. Everything about the material, including price (but with the exception of colour and design), was restricted (though small-scale dyeing and printing was discouraged as it was regarded as wasteful). In 1943 a Utility Fabric exhibition was held in Manchester, at which over 2,000 different cloth samples were exhibited, all variations on just 160 specifications of cloth. The Deputy Cotton Controller described this as almost a revolution in Lancashire cotton trade practice, writing that 'a wide variety of garments can be produced from a very limited range of weaves and yarns.'[6]

Utility had the effect of replacing poor-quality cloth with better, durable material that was quality-controlled for the first time in its history and benefited consumers both during the war and after. During 1943, 245 million square yards of cotton utility cloth was produced as compared to 64 million yards of non-utility fabric, and 115 million square yards of utility rayon compared to 31 million of non-utility rayon. This period saw the birth of mass production and can be seen as laying the foundations for the consumer culture we know today.

An initial difficulty, even before utility clothing reached the shops, was to persuade manufacturers to make particular garments from particular cloths at clearly specified prices. The Board of Trade achieved this by increasing significantly the manufacturing quotas for these non-utility materials, which they hoped would encourage manufacturers to use utility cloths from choice. The Board further guaranteed that labour in this sector would not be poached for war production. This seemed to work. The price of utility clothing remained stable from August 1941 until there was a fall in August 1942 against a marked increase in the price of non-utility clothing. That month, the purchase tax was removed from almost all utility goods, making them even cheaper by comparison.

However, there was still widespread ignorance about utility clothing

and material in 1942. When shoppers compared utility garments to non-utility, they found the former lacking in design and quality of fabric. Gradually, however, as more good quality utility clothes came onto the market, they began to represent better value for money: wool utility dresses costing £3 to £4 hung on the same rack as non-utility wool dresses costing twice or three times the price, sometimes even more.

One of the unintended consequences of clothes rationing was that people tended to trade up in terms of quality. Both consumer and manufacturer sought the best value per coupon and that necessarily meant buying more expensive goods. Women's magazines continued to support the scheme, however, with Anne Scott-James telling her *Picture Post* readers that she was very impressed with the utility clothing. They were not to be put off by the name as it had nothing to do with boiler suits. 'I have nothing but praise for utility clothes as far as they go. My one complaint is that they don't go far enough. 2/3 of all cloth has to be utility. But what of the remaining third?'[7] She was also concerned that the gulf between the mass trade and luxury trade had grown and wrote that 'If Mayfair hasn't the necessary skill to cut a good dress from 3 to 4 yards of material with 5 or 6 buttons it must learn – or go under.'[8] In this she was wrong. Mayfair was about to get involved in a major way.

The Board of Trade took the bold and imaginative move of hiring top London couturiers to produce designs for the mass production of clothes. After all, this was not about forcing people to dress badly. The women in the services looked smart in their uniforms and, despite critical comments about the regulation underwear, took pride in wearing them. The same feeling should apply to utility clothing and women were encouraged to wear it with pride.

A year earlier, in 1941, at the request of the Board, Harry Yoxall, the Managing Director of Condé Nast and the original founder of London *Vogue,* had invited ten leading designers from London couture houses to a cocktail party to see whether there was any way they could work together to present a united fashion front. He planned to introduce them to American buyers but also to encourage them to prepare new designs jointly for export. He described himself in a letter to the editor of American *Vogue*

as 'a kind of mid-husband at the birth of a body where all the limbs ... are kicking in different directions. But I feel that the couture boys and girls here will never get anywhere unless they form some kind of professional association and maintain as a permanent policy the temporary unity which was rather precariously achieved for the South American collection.'[9] They agreed and in June the Incorporated Society of London Fashion Designers (IncSoc) came into being, with the aim to support and promote British fashion abroad. One of the reasons Yoxall was so keen to see IncSoc flourish was because several designers who had been working in Paris before the war had made themselves at home in London, having fled the Continent after the fall of France in June 1940. He felt it was a gift to British design to have them all working in unison. Norman Hartnell said later: 'Although we were rivals, there seemed no good reason why we should not achieve a unity which might help us with the authorities. We might even gain world-wide recognition for clothes based on a native style and dignity.'[10]

It was to these designers that the Board turned for help in early 1942 to raise the profile of the utility clothing scheme. It was the first joint action of IncSoc, although each house was to propose its own individual designs for outerwear, based on a set of guidelines introduced by the Board to limit the amount of fabric used. The IncSoc members included Norman Hartnell, who had enjoyed enormous success in London during the 1930s. His big breakthrough had come in 1938 when he was asked to design clothes for the Queen's state visit to Paris. He dressed the Queen in white crinoline, the colour of summer mourning, as her mother, the Countess of Strathmore, had died five days before the planned trip. The royal household delayed the visit for three weeks and Hartnell and his salon worked around the clock to convert the thirty colourful dresses, coats and accessories to white. It was worth it. Admiration for the so-called 'White Wardrobe' was universal. In 1940 he received his first royal warrant of 'appointment to the Queen'.[11]

Digby Morton, who had trained at House of Lachasse, a firm that specialised in made-to-measure tailored suits and casual wear in London in the 1930s, set up his own couture house in Palace Gate and began to

work on ready-to-wear collections, the first of which he introduced in 1939. He was much in demand during the war and in 1941 a suit made by Morton featured in *Vogue*'s September issue, in an article entitled 'Fashion is Indestructible', with photographs by Cecil Beaton. As well as submitting designs for utility apparel, Morton designed a uniform for the WVS at the request of Lady Reading.

At the outbreak of the Second World War, Hardy Amies was working as managing designer at Lachasse, having replaced Digby Morton in 1934. Amies was frustrated that he was not able to design under his own name, even though his designs were widely praised, especially in America. He viewed the coming war as a means to escape from his current position and find a new challenge. He joined the Intelligence Corps and was posted first to Canada where his commanding officer, John Buchan, 2nd Baron Tweedsmuir, was somewhat surprised when the Board of Trade applied for Amies to have six weeks' leave to work on a collection that would be shown in South Africa. Not long after he returned to the army, he was moved to the Special Operations Executive, working in Belgium as a training and recruiting officer. After the austerity of London, Amies was delighted to see well-dressed women and well-stocked shops in Brussels. Some of the clothes had come from Paris, he observed. 'The bicycle controlled day clothes. Skirts were short and pleated; suit coats had military shoulders.'[12] Throughout the war he continued to design, now selling clothes in London under his own name through the House of Worth. He joined IncSoc as a private member.

Captain Edward Molyneux had served with distinction in the First World War, winning the Military Cross but also suffering from wounds that caused him to lose the sight in his left eye. After the war, he set up in Paris and was affectionately known within the circles of haute couture simply as 'the Captain'. He was almost twenty years older than Amies and had lived and worked in Paris since the 1920s. He was renowned for his elegant designs, graceful lines and restrained style, which influenced the younger British designers. In 1940 he escaped to Britain after the fall of France via Biarritz and continued to work in London during the war, sending two collections a year to America, which helped to raise valuable dollars for

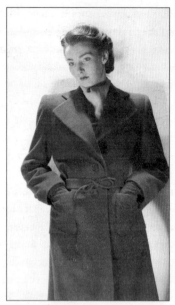

Prototype Utility coat by IncSoc designers.

the war effort. When IncSoc was formed in 1942, Molyneux became its first chairman, an office he held until the end of 1946. For Hardy Amies, Molyneux was the greatest designer of clothes Britain had ever produced. 'He had a great influence on me. He showed me how the sobriety of English style could become international chic.'[13] When the austerity regulations for utility clothing were announced, Hardy Amies said that both he and the Captain laughed. 'We have been making utility clothes for years, we said.'[14]

Two women designers, Bianca Mosca at Jacqmar and Elspeth Champcommunal, who led the world-renowned House of Worth, were among the couturiers. Bianca Mosca, a favourite with *Vogue* readers, worked as a costume designer on films during the 1940s. The signature on her designs was buttons bearing the legend 'Austerity Bianca Mosca'. Elspeth Champcommunal had been the first editor of *Vogue*, a position she held until

1922, when she left to go and work for the House of Worth as a designer. The last member of the group was Victor Stiebel, a South African-born designer who had his own fashion house in Bruton Street. He enlisted in 1940 and closed the house for the duration, but he was permitted to carry on designing while he was in the services.

Each designer was asked to produce four garments: a top coat, a dress, a blouse and a skirt, suitable for mass production. The clothes were designed and manufactured over the spring and summer of 1942, with the designers getting their brief in March but not knowing until several weeks later what the final specifications and austerity restrictions would be.

Meanwhile, in April 1942, seventeen clothing firms presented their own collections of designs made using utility materials to the trade. The reaction to the variety, quality and style of the designs was positive, though they did not yet incorporate the strict austerity requirements included in IncSoc's designs to be unveiled in August. This early show was good for the Board of Trade as it could see that public reaction was at last becoming more positive towards utility clothing, and they knew that the autumn designs could only enhance the scheme's reputation. *Picture Post* featured actress Deborah Kerr wearing utility clothes in March 1942. She was photographed in a raspberry-coloured tweed coat, fastening high at the neck and worn with a brightly coloured Jacqmar headscarf, a turquoise green suit with full skirt and a honey-coloured utility dress with full skirt, gathered-in waist and a high collar, like the coat. 'They are the fashion revolution. They are excellent clothes at government controlled prices. They cut out luxury – and defeat the profiteer,'[15] wrote the ever-positive Anne Scott-James.

As we have seen, the magazine editors were involved in helping the government to get its message across. This time they agreed to promote utility and sell the idea to the public. Special press notices were issued and consultations took place between editors and members of the Board of Trade, as they had done over clothes rationing. Audrey Withers gave the utility scheme a great deal of space in *Vogue*. Her fashion editor had persuaded Digby Morton, Bianca Mosca and others to allow them to show drawings of their early designs in order to reassure *Vogue* readers that the

clothes would be full of interest. She summed up the austerity designs as 'serenely perfect ... one would never guess that at every point they fit the framework of Civilian Clothing Orders'.[16] Audrey Withers had welcomed rationing when it was introduced, as it fitted with her belief in fairness for all, but she also embraced the austerity restrictions which she thought would benefit British design and have a lasting legacy. Long after the war she wrote: 'The utility scheme brought anguished cries from some designers, but it did a great service to British fashion, which had been far too elaborate and fussy for its health, and was now forced to look for the attractions of simplicity.'[17]

Harper's Bazaar agreed. It announced that summer: 'Fashion ... is out of fashion', meaning that the trimmings of haute couture were now considered to be unfashionable. The lack of embellishment on costumes and dresses, and the narrow lines and slim proportions were made to feel patriotic and elegant, liberating women from extraneous detail. The fashion editor of *Homes and Gardens* wrote, 'Curbed in many directions, and unable to indulge in an orgy of pockets and pleats, they are discovering a new beauty in austere lines and the drama of unexpected colour combinations.'[18] Thus one positive effect of removing 'frills and furbelows' was that it exposed poor fabrics and bad workmanship, which had often been camouflaged by fussy trimmings. All commentators during the war and since have agreed that standards of clothing manufacture generally improved as a result of austerity designs.

Using top London designers had been a very clever tactic. It ensured that journalists and editors would take notice. They celebrated the fact that the simplicity of design, which had long been the hallmark of the great British fashion designers, especially Captain Molyneux and Hardy Amies, was now available to all. *The Times* told its readers that 'templates will be available to the trade, in various sizes, at a cost of 7s 6d for blouses and 10s 6d for costumes, overcoats and dresses'.[19] The *Daily Mail* cheered: 'Suburban wives and factory girls will soon be able to wear clothes designed and styled by the Queen's dressmaker.' The *News Chronicle* was equally impressed: 'Before long the society woman who pays 30 guineas for a frock will share her dress designer with the factory girl who pays 30s.'[20]

Once the fashions were presented to the world in a show in August 1942, the fashion editor of *Vogue*, Isabella 'Babs' Bouët-Willaumez, could see the finished outfits in the flesh rather than in drawings. She was pleased with what she saw and what it meant for her readers: 'a basic design of perfect proportion and line for which haute couture has always been famed. Now the women in the street, the government clerk and the busy housewife will all have a chance to buy beautifully designed clothes, suitable to all their lives and incomes.'[21] The democratisation of fashion was one of the consequences of the utility scheme. It had begun to some extent before the war with the mass production of Hollywood and Paris fashion in high street shops, that were so eagerly visited by young women like May Smith, but utility made the availability of good quality, fashionable clothing much more widespread.

The trade was less happy about IncSoc's utility designs. The *Drapers' Record* ran an article with the heading 'Trade Cold-Shoulders "Mayfair Utility"', in which they complained that the Mayfair houses' designers had been brought in to 'show a long-established industry its job'.[22] It is difficult to judge from this historic distance whether this was a question of sour grapes or a genuine grievance. There is no doubt that high street fashion had looked to haute couture for their lead, but perhaps they felt that this time Mayfair had stepped outside its remit and encroached on their territory. Nevertheless, over 100 manufacturers of utility clothing requested patterns (available on paper, like architectural blue prints), which again reinforced the Board's sense that its gamble in using the IncSoc designers had paid off. Not only were the clothes of good quality but, when they appeared in large quantities in the shops, they were popular because of their prices. A woman's utility coat was selling at over £1 cheaper than a 'free range' coat. The price of a child's coat was 18s 6d in comparison to £1.10s od for a non-utility one.

By and large, the reaction of the public was much the same as that of the press. Zelma Katin, on her tram in Sheffield, watched women going out in the evening. 'The smell of scent and powder, sharper than during the day, was wafted through the lower saloon by hatless girls, whose ankle-length crepe-de-chine evening dresses peeped out tantalisingly from drab

mackintoshes and thin top coats. I was impressed, a little cynically, by the standard of smartness of my women passengers. The utility coats and dresses which they wore, stamped though these were by the check pattern or modified tartan which the designers of utility clothing feel it necessary to imprint on their products, were attractive and the textiles were not shoddy.'[23] She came to the conclusion that she was a member of the best-fed and best-dressed nation in the current war, although most would believe that America deserved that palm.

Shoppers were pleased with the simple designs, but the usual gripes about shortages of popular sizes were soon heard, along with the familiar bleat about stockings. Utility stockings, especially the non-fully fashioned lisle stockings, were loathed and despaired over. Rose Cottrell told her sister Pat about the 'awful cheap stockings' that were now in the shops: 'The papers warned us that they would wrinkle round the instep, would not be fashioned and what not else. I saw some of them on a model in Medhursts and my word they are awful. If they can't look nice on a stocking model in a shop window, you can bet they don't stand much chance on a leg.'[24]

By the second half of 1943, some 90 per cent of all hosiery purchased on the civilian market was utility hosiery, a far higher per centage than for any other garment type, and thus the complaints were loudest about the badly designed, baggy stockings. Flo Hyatt wrote to her aunt: 'Utility stockings make you shudder. They bag everywhere they shouldn't and the heels have a habit of showing a line where the lisle joins the rayon of a lighter shade which gives a very ugly effect. They are not selling very freely in spite of the coupons being reduced.'[25] However, the greatest outcry against austerity came from men rather than women. The men also had a complaint about hosiery. One of the most unpopular of austerity restrictions was the length of men's socks. This indignity, which meant that socks could be no longer than 9 inches, caused even more upset among white-collar men than the loss of trouser turn-ups. The argument about men's socks raged over several months after it was instigated and reached the highest echelons. On 22 April 1943, Nigel Colman, MP, asked whether the Board of Trade planned to lift the restriction on the length of men's socks. The then President of the Board, Hugh Dalton, replied in

a written answer that it did not: 'The reduction of the leg length of socks to nine inches saves a great deal of wool and the manufacture of longer socks for the civilian market cannot be permitted.'[26] At first, the sale of men's short socks was sluggish, as supplies of longer socks still existed. So the Board 'down-pointed' the short socks in the hope that this would solve the problem. In fact, it eventually solved itself when retail stocks of long socks ran out and sales resistance to short socks inevitably vanished, though the discontent lingered on.[27] The restriction was not removed for another two and a half years.

A month before short socks were discussed in the House of Commons, Hugh Dalton was forced to turn to the press in order to defend the Board of Trade against complaints about the demise of the turn-up. In March 1943 he attempted to set the record straight and give a final ruling on the question. He was unequivocal: 'Permanent turn-ups on trousers have been prohibited since May 1942. This was done to save an entirely justifiable waste of cloth. In making this and other clothing regulations I was advised by the trade. The economy of materials due to the prohibition of turn-ups runs into the millions of square feet per year. Even if the saving were less than it is, it would still be our duty to make it.'[28] Dalton used the word 'permanent' to reinforce the point that it was unacceptable for men to have their trousers made too long deliberately so that they could have a turn-up after all, which some had been doing as a way of getting around the regulations. And he went further: 'There is no serious case at all for restoring turn-ups while the need for war economy lasts. There are no turn-ups to the trousers of officers or other ranks in either the army, navy or air force, and I should have thought a style good enough for the Fighting Forces should have been good enough for the civilian population. Nor do the police and other wearers of uniform have turn-ups. Nor, as I am glad to see the *Daily Mail* points out this morning, did many men who take a special pride in their appearance, wear turn-ups in pre-war days.'[29] This was a bit harsh: men who insisted on wearing turn-ups were damned as being both unpatriotic and unfashionable. Some did persist and General Montgomery was photographed in front of a tank in France after D-Day wearing turn-ups on his trousers.

In May 1942, the Board of Trade further restricted the style and design of garments. It was decreed that women's outerwear was to have a limited number of seams, pleats and buttonholes and a maximum width set for sleeves, belts and collars. 'Hem allowances were limited and the number of buttons was regulated – only four for a coat, for example.'[30] It was argued that this would save both labour and resources. The lengths of men's shirts were reduced, too, and double cuffs banned, as were double-breasted jackets. No boys under the age of thirteen were allowed to wear long trousers. Nor were coats allowed to have belts, leather or metal buttons or one-piece raglan sleeves. Waistcoats were not allowed to have back straps or chain holes and trousers were not allowed to have zip fasteners. Women's clothes were equally restricted, with all trimmings and accessories forbidden. There was to be no embroidery or ornamental stitching as this required a degree of expertise and took up too much time on the production line. *Vogue*, while pleased with the simple designs, nevertheless regretted the loss of accessories and encouraged women to dress up their outfits themselves: 'Your new clothes will be on long-lasting austerity lines, but your own inventiveness and fashion sense can be given full play in the renovation of your wardrobe. If you have always been known as a smart woman, now is the time to prove that it was really you and your own discriminating taste and not just your dressmaker.'[31]

Flo Hyatt wrote about utility dresses to her aunt: 'They certainly look nicer short than too long but I can't say I really like them above the knee. I think next year the costumes and skirts will have the "hobble" effect. They are not very comfortable for sitting down or moving about quickly but there, I suppose, if the men have to do without their turned up bottoms (trouser, I mean) and go collarless, well it's up to the female species to discard pleats and flares.' She added: 'I should think the limitation of pockets will hurt the men most in their new suits, as they won't have too many places to hide their things in. Yesterday morning my Boss found on feeling in one of his that he had come away with his wife's wallet. Boss No. 2 then said, "Well, I like that, you take your wife to the pictures and then pinch her Wallet – ah well, I suppose we get a free lunch today." Boss No. 1 (Investigating contents of said Wallet) "She's got more than me!"'[32]

It seems hard to believe that the savings were as great as the Board of Trade claimed, but Hargreaves and Gowing made a thorough examination of the statistics and found that the savings were indeed substantial. For example, the Board had estimated that removing two inches from the bottom of men's shirts, along with the elimination of double-cuffs, amounted to a combined saving of some 4 million square yards of cotton annually, as well as 'saving 1,000 operatives in the cloth manufacture alone'.[33] In addition, they found that 'one large-scale manufacturer of women's cheap coats considered that his firm saved a quarter of a yard both of woollen and of lining cloth in every "austerity" coat they made. This represented a total yearly saving of 50,000 yards of each type of cloth.'[34] Multiplied by the number of companies registered to make utility clothing, there can be no doubt that the 'gloomy' Dame Austerity achieved her aim.

Finally, there was a restriction on the number of design templates, intended to encourage longer and therefore more economical runs. 'Women's underwear producers were to work on only six templates for each article manufactured, such as petticoats or knickers.'[35] Two weeks later the same publication, the *Drapers' Record*, reminded the trade that manufacturers of ladies' dresses were restricted to fifty sets of templates per year. These could then be changed each year so that women, at least, had some sense of movement in fashion, even if they were only very small differences in design. It seemed that the promise made in 1942 that there would be no restrictions on style was not being kept.

In the end, almost everything was regulated, even infant wear. Women were encouraged to make their children's clothes and particularly the early months' garments for their new babies. An advertisement by Kamella, which supplied patterns and knitting wool, encouraged mothers to buy Utility Baby Bags as other baby garments were so limited. They regretted that 'The austerity child has had to forego so many of the delightful health garments, which in peace time comprised our Kamella range.'[36] Winifred Holmes was a nursery expert on a London evening paper and had written a book of advice for mothers called *First Baby*. In 1941 she broadcast a ten-minute piece on the Home Service on how to make a baby layette with the fifty coupons expectant mothers were entitled to: 'You get these from

your local Food Office when you present an application signed by your doctor or midwife, giving the approximate date you expect your baby.'[37] She advised mothers-to-be to beg, borrow or steal whatever they could and not be too proud to accept hand-me-downs. Then she talked about her detailed list of what could be bought on coupon, off coupon or knitted. She even worked out that it cost fewer coupons to buy matinee coats, bootees and vests ready-made: 'Three bought wrap-over vests only take one coupon whereas 3 second size knitted vests take 2 coupons.'[38] By the end of the ten minutes, a woman who had been taking notes would know how to buy for her new baby and spend only forty-six of the precious fifty coupons. It is a reminder of the extraordinary amount of planning that was required just to function on a daily basis. Mrs Holmes gave advice not only on what to buy but also on how to care for the baby clothes, such as washing nappies in cold water and woollens in warm water, and suggesting that the baby should not be allowed to sleep on the mother's knee after feeding in case it wet her skirt or dress. It seems strange from today's perspective that all the focus was on efficiency and expediency rather than on the care of the baby itself.

While designs were restricted, colour was not and this led to an array of brightly coloured patterns which aimed to cheer up the otherwise austere lines of the clothes in the utility range. There were also polychromatic scarves which were popular, and had the added advantage of holding back hair from the face, which was vital in factories, and 'camouflaging' the shortage of shampoo. The scarves cost just two coupons and some could be bought for as little as 5s (£9.50 in 2014), though scarves produced by Ascher and Jacqmar[39] cost as much as 55s or £95.00 in today's money.

Jacqmar's designer, Arnold Lever, produced a series of stunning propaganda prints on fabrics and scarves. These were not commissioned or regulated by the government but originated from the firm itself, which recognised that there was a desire for patriotic symbols. A series of scarves by both Jacqmar and Ascher, aimed at these patriotically minded shoppers, had patterns with soldiers, military motifs, aircraft carriers and the colourful British army regimental badges with the words 'Into Battle'. There was another Jacqmar scarf designed in 1942 known as 'Combined

Operations' and another – '8th Army Air Force' – which bore the personalised names of bomber and fighter planes from the US 8th Army Air Force. The 'Churchill' scarf had a picture of the Prime Minister set against a Union Jack, cigar in mouth. Around the edges, as well as in the centre, there are excerpts from his speeches, overwritten with 'We shall fight in the fields and street. We shall never surrender.' Jacqmar and Ascher scarves continued to be produced throughout the war.

Some of the most joyful designs are to be found on the Victory scarves, marking the end of the war in Europe. Lever created a beautiful bouquet from the Allied flags which he had transformed into flowers representing the laurels of victory. Jacqmar also produced scarves with wartime slogans on them. 'London! Alert!!' shows little figures going about their lives, shaking blankets, stopping the traffic and carrying loads with the words 'fire bomb fighters' and 'London! Alert!!' separating the figures. 'Save for victory' and 'Switch off that light, Darling' are two other designs for Jacqmar by Lever. The scarves were particularly popular with the American servicemen who arrived in Britain in the build-up to D-Day. They could afford the more expensive silk scarves and bought them in quantity, often to give away as gifts to their British sweethearts, along with nylons and the occasional pair of oh-so-desirable silk stockings.

In 1944, in his annual Board of Trade message introducing the points for the next rationing period, Hugh Dalton continued to justify the scheme by saying: 'More than half a million men and women have been released from making cloth and clothing for civilians and have gone into the Services or on to War production ... 250,000 tons per annum of valuable shipping space has been saved for essential war cargoes. And yet prices have been kept under control and everybody has had his fair share.'[40]

Towards the end of the war, however, some austerity regulations were relaxed, notably for men's outer clothes on the run-up to demobilisation. The government did not want returning soldiers to be greeted with austerity when they had fought so bravely for their country. The turn-up was reinstated in February 1944, the length of men's socks was de-restricted in November 1945, and various restrictions on men's underwear were lifted in January 1946 – to general applause, one imagines. Hugh Dalton

summed up the benefits of the austerity measures: 'On the whole we have done something to lift the morale of the country – particularly the morale of men. The morale of women has always been high, but that of men has been depressed by not having enough pockets.'[41] One imagines that Flo and Zelma and any other woman struggling with utility stockings might have argued with Dalton over this statement, especially as most restrictions on women's clothing remained in place until spring 1946.

In one respect the President of the Board of Trade was right. Utility and austerity outer clothing had gone down well, and by and large people had accepted it. It was not only the fact that good quality clothing was now available to all (if not in the quantities that people might have hoped for), but that the government had deemed it sufficiently important to keep the public on side by employing the greatest designers in the country. This was the masterstroke and it is one of the reasons why utility clothing is still regarded as stylish and well designed, even from the perspective of almost three quarters of a century. However, when it came to the all-important question of what they wore *under* their outerwear, it was quite a different matter and Hugh Dalton found himself at the centre of a very angry dispute about corsets.

6

Supporting Britain's Women

The appearance of a frock or suit is often spoilt by an ill-fitting corset. Great care should be taken to keep these trim and well repaired.
The Board of Trade, 1944

Never has the British government taken such an interest in its citizens' knickers. Bras, pants, corsets, suspenders, long-johns and children's undies were all specified and regulated under the utility scheme and the austerity regulations. People would try as hard as they could to keep their pre-war undergarments in good repair so that they did not have to buy new ones, thus saving precious coupons. However, it was not always possible: 'I'm alright for outward clothes but my undies won't hang together much longer,' Flo Hyatt lamented. Underwear was a constant topic for discussion at home, in women's magazines, as well as at the Board of Trade. At three coupons each, vests, corsets and knickers were an extravagance that few felt happy to splash out on, though in the pre-war years they would have bought them regularly.

The history of underwear is fascinating and deserves more space than I am able to give it here. If you were a woman in the late eighteenth or

very early nineteenth century you would not have worn knickers, and bras were not to be invented for another century. As social historian Rosemary Hawthorne has written 'before 1800 [...] the only women indelicate enough to wear drawers – a masculine garment – were said to be lewd, loose-moralled creatures of ill repute'.[1] In the nineteenth century, women began to wear split drawers or knickers with separate legs but no gusset. These tended to reach mid-calf and were fastened with a large linen button on the back. Poorer women, who could not afford to have drawers made up, would often use cotton sacks that were used by grocers to store flour, rice or sugar. These were boiled white and made up into underclothes. Men had long worn pantaloons under their trousers or breeches, so that changes in what they wore were less dramatic.

During the First World War, underwear design, along with general clothing and fashion, underwent an enormous change. The late Victorian and Edwardian era had been characterised by long elegant lines, tall, stiff collars for men and broad hats for women. Many working women had been in service and wore housemaids' uniforms. By 1914, clothes became simplified and easier to wear, so as to be practical for a new era that found women moving between the social classes for the first time. Many took jobs that were hitherto the province of men. They worked in ammunition factories; they were employed as nurses in Britain and abroad; and they took the place of men as bus conductors, lorry drivers and engineers. Some became chimney sweeps or worked on the land in the newly formed Women's Land Army. The clothing they had worn before the war was no longer practical. By 1915 the hemline for skirts had risen to mid-calf. In 1918 there was even an attempt to introduce a utility garment as a 'National Standard Dress',[2] which 'had no hooks and eyes but metal buckles and was supposed to be an all purpose garment that could be a dinner gown, day gown or nightdress. It never took off.'[3] Simpler outerwear naturally required simpler underwear and there was something of a revolution in what women wore next to the skin.

The envelope chemise, also known descriptively as the 'step-in slip', was the first incarnation of what became cami-knickers. It was an all-in-one silk slip that buttoned between the legs, had thin shoulder straps

and was favoured by those women who wanted the boyish shape of the 1920s. Knickers with an elasticated waist appeared before the end of the war and the colours changed too. Most underwear was white, a hangover from the Victorian era. In the post-war period it changed to pale green, peach or flesh coloured, a trend which was still prevalent over twenty years later when the first utility knickers were designed. It was also decorated with lace and beautiful trimmings, perhaps echoing women's increasing confidence in their role in society. The emancipation of women, coming hard on the heels of the First World War, when women had stepped up to the plate and taken on men's roles in many instances, gave them a greater sense of individuality and self-worth. This was reflected in the changes in underwear as well as outerwear. As skirt lengths grew shorter, old-fashioned drawers were not worn so frequently and the 'directoire' appeared. This was the closed-gusseted garment, elasticated at both top and bottom, sometimes known as 'bloomers'. Bloomers were often made of silk, came to just above the knee and were popular when they first appeared. Once knickers went on ration in 1941, women became extraordinarily inventive, using a wide variety of materials and techniques to create comfortable undies. Advertisements for pattern books for bras and pants popped up in all the women's magazines and some even showed knitting patterns for knickers and pants for both sexes, suggesting that women unpick old cardigans or other garments to knit 'new' underwear. But even if satin or rayon could be sourced, it was difficult to find elastic. Rose Carr remembered taking elastic out of her underpants every time she washed them, threading it into her clean pair for the next day's use. Other women resorted to buttons to hold their knickers up. There were complaints from mothers that utility underwear had buttons on the side, not the front, so that they could not be let out and made larger for growing children.

Later, when silk disappeared and bloomers were made in heavier materials for the Forces, they were loathed. In the case of knickers, these were directoire-style in uniform colours – khaki, navy, black or blue/grey – and of course no longer in silk, but warm wool or flannel. They were considered necessary to wear under the Forces' knee-length skirts of 1941. 'These unflattering horrors were dubbed "passion killers" and the name is

now part of the nostalgic annals of war. They do, however, seem to have gathered a few other emotive names over the years: ETBs (elastic top and bottoms), "boy bafflers", "wrist catchers" and the obscure "taxi cheaters", are among the best known.'[4] They were hated and many women admitted to wearing them only on kit muster inspections or for their annual medical check.

Bras are an even more recent development, having been in commercial production for less than 100 years. The first brassiere was patented in 1914 by Mary Jacobs under the name of Caresse Crosby. She made a few bras for friends and went on to design a backless bra, which was not a commercial success. She was so disillusioned that she sold the patent to Warner Brothers for $1,500; it was later valued at $15 million. The early designs for bras drew their inspiration from corsets and presented the bosom as a single object. Rosemary Hawthorne described the Edwardian woman as 'definitely mono-bosomed, with an august swell to her frontage, like a roll-top desk'.[5]

During the 1920s and early 1930s the fashion was for a flat chest and a youthful look, again with the bust as one, undivided piece. It was only in the mid-1930s that a new fashion emerged and bras were designed to reveal a more natural figure with the breasts separated. The drop waists and long, straight lines of the 1920s and early 1930s were replaced by a nipped-in waist, capped sleeves and a greater focus on feminine curves. Two-piece costumes became increasingly popular as daytime wear, with skirts worn just below the knee. 'The female shape was serious business and many great firms were now in existence, both at home and abroad – Warner Brothers, Triumph, Maidenform, Berlei, Twilfit, Gossard, Symingtons, Spirella and so on. By this time, too, the diminutive word "bra" had come into general use.'[6] In 1935 Warner Brothers introduced A, B, C and D cup sizes for bras. Double D came along a little later and double A later still, though the British did not adopt this classification until after the war, and bust sizes were instead labelled 'junior', 'medium', 'full' and 'full with wide waist'.

For women with a big bust, there were supportive bras made by companies such as Bestform and with descriptive names such as bra-O-matic,

but the most popular bra was the so-called 'Kestos' bra, which was light-weight and made from three triangles of material. Home-made bras, while not commonplace, were not unknown. Eileen Gurney told her husband John that she had 'made two brassieres for Joan, though why she wants them I don't know as she is quite firm and very small, she may just want to be seductive. Anyhow I think they are quite pretty ones, pale green.'[7] Mabel Anslow was in a civilian internment camp in the Far East and made herself a Kestos-type bra out of two Scout ties. It served her well and survived her captivity.

A most glamorous pair of silk cami-knickers and a Kestos bra were created from a silk map for Patricia, daughter of Lord and Lady Mountbatten. When donating this exquisite set to the Imperial War Museum, she wrote: 'I am so pleased to hear that the Museum Archives might be interested in this little packet containing some "undies" which belonged to me during the war and were very useful in saving precious clothes coupons. I had them when I was 19 in 1943 ... and serving as a Wren. I had a boyfriend in the RAF who gave me one of the silk maps which had been issued in case our planes were shot down over Europe.' She told the Museum that she had had them made up into underwear, with the Gulf of Venezia on the front of the beautifully hand-stitched cami-knickers. As there was no elastic available, both garments have small cream buttons and the waist size is a tiny 22 inches.

Most underwear in the 1930s was decorated with lace. Since the end of the previous century, 'lace had made a valuable contribution towards feminine allure – particularly in the state of undress'.[8] Utility underwear, in contrast to the unflattering knickers issued to the women's services, was not unattractive and women who wore it found the quality good, but it was more austere in design than the pre-war cami-knickers, bras and pants. As utility designs came in, the lace went out and underwear lost its pretty trimmings. The Board of Trade specified that a pair of austerity knickers should be made from carded cotton yarn in navy, saxe blue, cream, peach or fawn, and to exact measurements 'across the seat, including gusset when folded'.[9] The overall weight was fixed and the price was set at 18s a dozen for regular sizes and 21s a dozen for outsize, whereas men's pants

were slightly cheaper at 17s a dozen, but were only available in white. May Smith bought cami-knickers in September 1943 and embroidered them 'to make them less utility'.[10] Eileen Gurney decorated her underwear with little bits of left-over lace, while Flo Hyatt resorted to buying what she could when she could. She wrote: 'I expect you know we now have "Austerity" lingerie, that is, lingerie without either lace or embroidery. If I have to buy any I usually get Kayser undies, because they are tailored and well cut and wear well. They are more expensive but worth it in the long run.'[11]

While women were driven to extremes of resourcefulness in constructing their own underwear, some items were beyond them. Supplying sufficient underwear to the civilian market was a balancing act for the Board of Trade, but nothing exercised them more during the war than corsets. These unseen garments were the focus of the Board's concern even before clothes rationing was introduced, and continued to be a concern until after the war. In the official history, *Civil Industry and Trade*, published in 1952, a whole section is devoted to the question.

Although the height of the corsets' popularity was reached in the Victorian era, when young girls and women were laced into impossibly uncomfortable and unhealthy stays, they were still widely used in the early twentieth century. By the time the Second World War broke out, the corset as a garment was lighter and more elastic than the tight-laced articles that had been fashionable prior to the First World War. They were comfortable enough to be worn next to the skin and supported rather than restrained the figure. In the summer of 1939, the Paris fashion houses were beginning to reintroduce the 20-inch waist, but fortunately for women, the war put a stop to that restricting design. In March 1940, *Picture Post* published a four-page illustrated article on the wartime corset. It suggested that the modern woman's desire to wear corsets would continue throughout the war. 'She takes her figure seriously, she trains it, exercises it, diets it, soothes it with delicate creams and lotions, and corsets it.'[12] Fashion historian James Laver had suggested the same month that 'war should cause women to discard their corsets and cut off their curls. That was the way it worked out in the last war.'[13] However, the journalist at *Picture Post* was not impressed with his suggestion. 'That was twenty years ago,' she wrote. 'Whatever else has

been lost or gained since then in Europe, women, at least, have gained – they have gained appreciable figures. Gone are the boyish contours of the '20s. The modern woman is as feminine as she has ever been in history, and she does not propose to allow war to deprive her of her figure at this stage.'[14]

The War Office agreed, and announced that the women who had enrolled in the ATS 'must be corseted, and corseted correctly'.[15] The WAAF, the AFS and the WRNS would also benefit from this directive. They asked Frederick R. Burley to come up with a design that would 'preserve the feminine line, and at the same time be practical under a uniform'.[16] The new 'Berlei' design dispensed with metal and was made of elastic, firm lace, net, satin and cotton batiste to give directional control. This was an ideal undergarment for those young women whose uniforms had skirts. It also had the added benefit of a pocket where loose change for a bus fare or a handkerchief could be kept. Women in the services were not allowed to carry handbags, nor were they allowed to wear jewellery or accessories to enhance their uniforms. It was not considered safe to carry loose change in jacket pockets as they could be easily picked, especially in the blackout, so the pockets were popular as they would have been hard to pick without the wearer noticing. For the AFS and Land Army, Berlei designed a corset that could be worn under slacks. 'It gives perfect freedom of movement and – especially important for the ambulance driver – supports against the danger of those spreading hips that may come from long hours of sitting.'[17] A corset fashion show held in February 1940 was attended by fashion critics, 'clad in fox and ermine', who scrutinised the models who moved around the stage in various new Berlei designs. Editors from *Vogue*, *Woman's Own* and other women's magazines spent an afternoon in a West End salon in what was described as a graceful atmosphere of warmth and perfume. Sitting on spindly gilt chairs, they 'settled to an afternoon's concentration of "figure foundations" as many of them prefer to call corsets ... The fashion experts liked these new corsets. So will you. So will the people who see you wearing them. A decisive moment in the history of the corset,' wrote the editor of *Picture Post*. Readers were promised that the new designs would soon be available in the shops.

Whilst the services were well supplied with corsets, civilian provision

was woefully inadequate throughout the war. According to their own statistics, the Board of Trade estimated that there were 18 million corset wearers in the country, but the number of corsets produced annually from 1942 onwards was never more than 9 or 10 million. Every woman I have spoken to in her fifties or older remembers her mother wearing corsets and the octogenarians also recall their own Berlei corsets from wartime. Even the men in the Board of Trade recognised that one wartime corset was unlikely to last as long as two years. The main problem was the materials needed to make them up. They contained three of the scarcest of raw materials: cotton, steel and rubber. Steel production was at full stretch supplying aircraft manufacturers, shipping and tank production, as well as factories making machines to be used in the war industry. Understandably, steel for corsets was not a priority. Raw cotton supplies during the Second World War also dropped, world cotton prices rose and the numbers employed in the cotton spinning and weaving industries were reduced by a third between 1939 and 1945. At the same time, the demand for cotton goods rose.

Rubber was an even greater problem. After the fall of Singapore in February 1942, the Japanese controlled the majority of the world's rubber. The trouble with rubber was that there was no effective replacement and certainly no satisfactory alternative was found for use in making corsets. The final issue was manpower and machinery. The corset industry had released a high proportion of its resources to the war effort. As it was particularly well equipped for making parachutes, several leading corset firms had taken on Ministry of Aircraft Production contracts and ceased to produce corsets at all. As a result of this diversification, a shortage of skilled workers and damage caused by air raids, 'the amount of factory space employed on corset production had been reduced by a third and the labour force engaged on civilian corset production by more than half'.[18] To add insult to injury, the original corset cloths were amongst the worst supplied in the utility range and it was only in the summer of 1944 that a better quality cloth was introduced. Supplies did not become adequate until the Services released a large quantity of cloth suitable for the civilian market that year. Hard strip steel – for which there was no real substitute – was released for corset production at the same time.

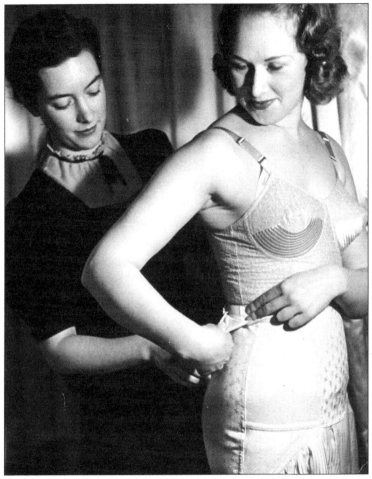

The model demonstrates the useful pocket in her
'Berlei' corset for stowing loose change.

Corsets were treasured by those who still had good quality garments to wear. Marion Platt remembered her mother carefully rolling hers up every night before she went to bed. It stood like a cylinder next to her

clothes, ready for wear the next morning. There were some women who were sufficiently proud during the Blitz that they refused to go into the air raid shelter without their corsets. Margaret Watkins' mother, Gladys, was one of those. Margaret recalled her grandfather calling her to hurry up and get into the shelter during an air raid and she heard her mother shout back from the top of the stairs: 'If Mr Hitler's coming I'm not going to meet him without my corsets on!'[19]

Flo Hyatt had a similar tale: 'My next-door neighbour was telling me the other day she still goes to bed with her corsets on and ready to get up the moment "Minnie" [air raid alarm] goes. Well, I think that's silly. You are out to make yourself nervy and I shouldn't think you could rest very well cased in with corsets. We come into this world without anything on so if we get blown out of it what does it matter if you are dressed or undressed?'[20]

One young mother, who had just given birth in the summer of 1944, wrote a furious letter which was published in *Time* magazine in which she took the Board of Trade to task, even naming Hugh Dalton, the then president, in her diatribe: 'There should be no false modesty about this very essential article ... After the birth of my second child the sight of my figure enclosed in a utility corset nearly paralysed me. True, it caused a certain amusement to my family, but I didn't feel funny, only ill and unhappy ... I found that the boning at the front consisted of three pieces of compressed cardboard. I defy even the most pugnacious cardboard to do anything but follow the shape of the figure it encloses ... A band of infuriated housewives should force Mr Dalton into a utility corset and a pair of the best fitting utility stockings he can buy. I would add a saucy black felt hat for which he had to pay four guineas and a pair of those ghastly wooden-soled shoes. He should be made to walk one mile, then stand in a fish queue for an hour. By the end of this time his utility stockings would [droop] from knee to instep in snakelike coils and twists. His corset would have wilted into an uncomfortable, revolting mass of cotton and cardboard. He would find himself supporting the corset, instead of the corset supporting him. May I suggest this would be a very speedy remedy?'[21]

This colourful image of a trussed President of the Board of Trade standing in a fish queue is funny, but it is also a reminder of how vital a

part corsets played in the lives of women. Those who had relied on corsets to help support their figures struggled to cope with the poor quality ones supplied under the utility scheme. Their bodies were used to the support and it was not easy to go without. Those women who were on the large side, or who had to stand for long hours in their jobs, for example women working on production lines in factories, suffered greatly from the lack of corsets, as did those who required surgical corsets. The Board of Trade were understanding about the hardship cases and tried to assist by supplying 'super utility' corsets to certain groups. It was only young, slim women who found that they could get used to a corset-free existence.

Bill Fagg was still hard at work, and responsible for writing and issuing press notices on every possible subject concerning civilian clothing. Between June 1941 and June 1942 his department issued 162 notices. Number 151 concerned outsize corsets: 'A general licence has been issued under the Making of Civilian Clothing (Restrictions) (No. 8) Order, 1942, permitting corset manufacturers to put not more than 5 ozs of metal, other than in the suspenders, into corsets, the waist measurement of which exceeds 35 inches. This is 1 ounce more than is allowed in ordinary sizes.'[22]

The Board of Trade's figure of 18 million corset wearers implies that most adult women wore them. This figure fits with the research I have carried out for this book. Mr Fagg's Area Distribution Officers received more complaints about corsets than any other item of utility clothing. An ADO summary for the whole country from 1943 read: 'Still the item that causes the ADOs most shame. The complaints that corsets suitable for figures which need corseting are scarcest and that cheap badly-boned corset are a waste of material are the most difficult to answer. It is suggested that a 12/11d corset of a semi-surgical type with uplift belt (as made by C. B. Royal) is what is needed most.'[23]

There was plenty of advice on offer on how to maintain a corset. For those women who had two, they were advised to alternate them, while women with just one were encouraged to treat it with care, keep it clean and store it in a cool dark cupboard, not to overstretch it, to protect it from grease, perspiration and sunlight and where possible to wear it over a lightweight garment to give it a longer life. In 1943 the Corset Renovating

Company at 126 Baker Street promised to refurbish corsets for a minimum price of 12s 6d. 'Knowing the difficulty you are experiencing in obtaining your "pet corset", the higher prices now prevailing, and purchase tax in addition, our renovation service will be invaluable to you. No matter what make or their present condition they will be reconstructed by experts with any adjustments or renewals required, and returned to you, post free, as good as new.'[24]

Spirella, which supplied an individual corsetry service in the home, placed an advertisement encouraging women with Junoesque lines to invest in a proper fitting. 'Your Spirella, designed in conformity with nature's own laws of support and control, accomplishes the preservation of womanly grace. The hands of the clock are set back. As your Spirella Corsetiere I am ready to attend you.'[25]

Fashion editors were also concentrating on posture and body shape. In a remarkably unflattering sweeping statement, *Vogue* declared that 'most figures fall into categories, top-heavy, peg-top, sway-back, square etc etc'.[26] Now that trained fitters were scarce it was important for women to fit their own corsets, once they had decided which category they belonged to, and to make sure they were comfortable: 'In a one-piece, be sure the hips fit; the bust is more easily adjusted. Avoid a tight belt. It pushes the flesh up in a spare-tyre effect. Get support without compression – that's bad for the circulation. Bones are no longer considered essential for support. Be sure your belt is long enough. Always try the fit by sitting down too. And do remember that to wash a corset regularly is to prolong its life.'[27] Berlei continued to advertise its corsets in *Vogue* for the duration of the war, though by mid 1943 they were warning their customers that not all products were available immediately and asked for forgiveness if there were delays in processing orders, especially for popular sizes. By late 1944 they had to admit that they could no longer supply corsets.

Despite the Board's best efforts, there was never a sufficient supply of corsets and it was heavily criticised for its inadequacies in the press. In April 1943, *Home Companion* magazine suggested that women could perhaps try to make do without corsets: 'If your figure is in good trim you'll be able to save coupons on corsets and belts. We weren't meant to rely on

elastic and bone to keep our waistlines neat, because each of us is provided with a perfectly good belt of muscle, which, if used correctly and kept in condition, will give us a better figure than any belt. On the other hand, once allowed to get soft and flabby, they can ruin the lines of your most expensive frock.'[28] James Laver had suggested the same thing in *Vogue* in 1939 but had been rebuffed by the fashion press. Nevertheless, for girls working in jobs that required a lot of movement, such as on the land or in buses or trams, the corset was no longer necessary or even comfortable. Shelagh Lovett-Turner was a Land Girl in Oxfordshire for seven years from 1940. She wore a bra and pants under her uniform and when she was wearing a dress she wore cami-knickers: 'You didn't know they were there. They were so comfortable.'[29]

Women's magazines were not prepared to give up the case for the corset as quickly as young women were happy to go without. They published article after article venting their frustration. In 1944 a rant appeared in *Vogue*: 'And where can one buy good corsets? Nowhere. There's the rub. Why not? Ask the Board of Trade, Mesdames. Ask them why such labour and materials as are allowed for the home markets are wasted on trashy belts which do not give coupon value, which lose in a week or two what quality they had, which fail to give the support they should and are ultimately more expensive, in money and coupons, because they have constantly to be replaced. You are the women of England. You are the people who need better corsets. It's up to you to see that you get them back – as the men of England saw to it that they got their trouser turn-ups back.'[30] It was deeply frustrating to women that the men got the restrictions on their clothing lifted a full year before those on women's clothing.

If corsets were missed for their support, stockings were even more so for their look and feel. When the Second World War broke out, most women could aspire to own several pairs of fully-fashioned silk stockings. These were stockings that were knitted flat and then the two sides sewn together to form the seam, which was worn up the back of the leg. Even then they were an expensive item, but they were popular and deemed to be a necessary luxury. Silk, however, was one of the first items to be limited. The material was needed for parachutes and in October 1940 silk

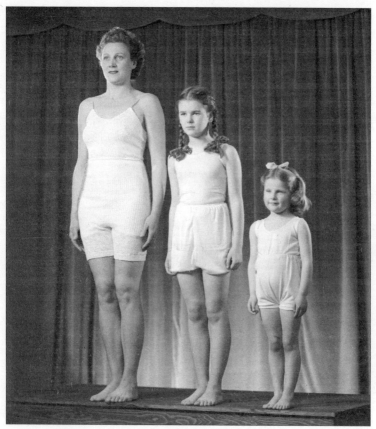

The Board of Trade had control even of the most intimate items of clothing.

stockings were banned from sale, except for the export trade and under special licence. Silk stockings were the single most missed item in wartime Britain, and the rayon stockings which replaced them were never produced in sufficient numbers. The other material on offer was lisle, which was deeply loathed. Like many, Flo was frustrated by the shortage of stockings and complained to her aunt: 'We are rather hoping they will reduce the number of coupons for stockings or ration them to so many pairs per

person per period. A woman is heavier on stockings than on anything else; we won't know ourselves when we get our feet in a real pre-war stocking and feel the silk cling to our legs. Baggy knees, baggy ankles and feet that don't properly fit, that's the unfinished wartime stocking!'[31]

Stockings were a recurring theme in personal letters and diaries, as well as a subject for discussion in women's magazines – and they were a thorn in the flesh for the Board of Trade. There were simply not enough to go around. The Board announced that if women did not go without stockings in the summer of 1942 they would be without stockings in the winter. *Vogue* ran a short article with the headline 'Sock Shock' in which they suggested that socks were the acceptable alternative to stockings. 'Don't go bare-foot, they say: it's bad for your shoes, bad for your feet. Socks are the solution. A shock ... but they contrive to look charming. Here's the secret: flat heels; socks picking up the colour scheme; pulled-up socks for town.'[32]

Vogue was quick to offer advice to those women who were appalled at the idea of wearing socks, urging them to go with bare legs either smoothly tanned or with make-up. To preserve the shoes, 'footlets' should be used. They added that they hoped the Board of Trade would put them into production, but in the meantime 'you'll be advised to knit your own: a 6d stamp will bring instructions'.[33] The fashion for going stockingless and painting legs is one of those images from the war which has endured. In the summer of 1940, a cream came onto the market which women could rub on their legs and then draw a line with an eyebrow pencil down the back of the leg to suggest a stocking seam. Not an easy manoeuvre for women trying to do this at home alone, though there are many photographs of young women painting each other's legs. *Vogue* advertised Cyclax stockingless cream in July 1940. It claimed to be non-greasy, non-tacky and the extreme of elegance, comfort and economy. It would be greeted by leaders of style and fashion as 'beautiful' and 'so incredibly real in its likeness to the sheerest, most luxurious stockings that only touch can reveal the illusion!'[34] The advert went on to boast that it was cool for the warm summer days and most becoming with an evening gown. Elizabeth Arden produced a more sophisticated sounding cream, Fin 200, which was sold as

the perfect stocking substitute. It was easy to apply, did not run and could 'resist rain, mud splashes and even snow'.[35]

Flo Hyatt wrote that the cream/pencil solution was all very well for 'those that looked at a tub once a week', but was far too expensive if used every day. The other solution was to use cheaper or even home-made products. Face make-up could be used but it, too, was soon in short supply, so other substitutes were tried out, often with disastrous results. Horror stories abounded of colours running, legs turning yellow or blotchy in the light of a nightclub, suits and skirts stained forever. Such tales would lead one to believe that every woman in Britain had to resort to gravy browning or cocoa to stain their legs and an eyebrow pencil to draw the line – though that appears to have been something of a stunt 'invented by the newspapers so that their readers could, at least, have some light entertainment in their reading'.[36]

It was only with the arrival en masse of the GIs in their sharp, well-tailored uniforms from the USA, bringing with them nylons, that some young women were able to get the precious hosiery they so desired. Some were even fortunate enough to be given gifts of silk stockings, the ultimate treat. However, in the main, women had to make do with what they could purchase on coupon or 'make-do and mend'.

7
Make-Do and Mend

Everyone should understand that it is patriotic to wear old clothes. That does not mean of course that you have to look shabby. You can always look neat if you keep your clothes clean and well repaired.
From *Can I Help You* on the Home Service, 10 March 1942

Make-do and mend: these four little words have become synonymous with the British home front, yet many women, especially in the country or from middle- and low-income families, had been making do and mending their clothes for years. 'Make-do and mend' became official policy during the war years so as to encompass those women who, while not necessarily extravagant with clothes, would have been able to discard outfits or garments that were dated or worn out and buy new ones. 'Wardrobes are shrinking fast, and the smaller they get the more perfect they have to be,' trilled *Vogue*'s fashion editor, Babs Bouët-Willaumez. Now that it was deemed wasteful and unpatriotic to throw away clothes, the attitude towards wearing patched or darned garments changed. A patch was no longer the badge of the disadvantaged and by 1942 even the glossiest fashion magazines were supporting the idea of mending existing

garments and claiming that 'dressiness' was outdated. Cecil Beaton wrote: 'Extravagant spending and waste, bad things at all times, are now downright heathenish. There is a biblical beauty about the way that the housewife gets the best result from slender means.'[1]

While not every woman was as accomplished a seamstress as Eileen Gurney, for whom sewing was a way of life, many were handy with a needle and thread. They had been encouraged, if not expected, to make baby garments and clothes for their young children. It was only the richest and very poorest in society who would not know how to turn a collar or mend a sock. Poor women were working and would not have had the time to repair clothes, nor would the quality of clothing they had been used to buying stand up to much patching. With full employment, the purchasing power of working women was greater than it had ever been, but, ironically, shortages and coupons meant that they could not buy as freely as they would have wanted.

Even with the introduction of coupons and utility, the government was still stretched to provide sufficient clothing to meet the civilian population's needs. As we have seen in earlier chapters, one of the issues was the mass production of uniforms for the armed services and other civilian and military organisations. Less than half the manufacturing capacity was dedicated to civilian apparel, even though well over three-quarters of the population needed everyday clothes. If you included those service personnel who wished to buy clothes to wear when on leave, then the figure was even higher. Ever vigilant, the Board of Trade considered what to do about the problem, and on 2 July 1941 it published a paper written by one of its Area Distribution Officers, entitled 'Extension of the Life of Clothing – A Preliminary Investigation into Possibilities'. The conclusion, following contact with women's groups, including the Women's Group on Public Welfare, the WI and the Townswomen's Guild among others, was that the care of clothing needed promoting, particularly among 'middle class and lower class women and girls'. The Board considered making it compulsory for people earning between £3 and £4 a week to attend 'Make-do and mend' classes, but got cold feet and announced later that it wished only to provide 'an authoritative lead'.[2] However, the WI was already leading the

way with its 'thrift classes'. With 5,800 Institutes across England and Wales and more than a quarter of a million members, the WI formed a strong, tight-knit network of women in country villages and was in a position to assist such a programme. The National Council of Social Services and affiliated councils, too, could point to 700 clubs, mainly comprising low-wage earners, who were focusing on dressmaking and renovation classes. Other groups, such as the WVS, were involved in clothing exchanges, so that by the time the government launched Make-Do and Mend in 1942, the momentum was there. Hugh Dalton wrote to women's groups on 16 September, urging them to do 'all in our power to make the whole nation conscious of the need to Mend and Make-do'.[3] From this time on, thrift officially became a major part of the war effort.

By 1943, when the Board of Trade finally produced their Make-Do and Mend leaflet, most women would have argued that they had been busy doing so for the best part of three, if not four, years. The leaflet advised not only on patching, darning and general maintenance but on laundering, airing and storing clothes. The message was quite clear: nothing should be wasted, every scrap of clothing should be rendered useful. They would have been proud of May Smith who made 'a nifty brassiere out of an old petticoat'.[4] As a campaign, Make-Do and Mend was aimed at women. Some observers argued later that the motive behind this was to ensure that women maintained their perceived feminine, home-making skills for the future. The war had given many women the freedom to work outside the home, often away from home altogether, and to develop skills that ranged from welding to ploughing. Whether that was the idea behind the scheme or not has never been clear, but it is the case that many women who had worked in traditional male roles felt deposed after the war was over. Then the government and their menfolk expected them to adopt the role of housewife once again and to start to rebuild traditional family life. For some this was a bitter disappointment.

For now, however, they were required to make the best use of what they had. Magazine journalists urged everyone to look to their old garments and see what could be made out of them, as well as repairing and darning clothing worn on a daily basis. And this extended to every level

of society: Digby Morton offered to alter last season's suits 'into a short-sleeved tweed dress with a velvet collar and a jump suit',[5] if his clients cared to send him their outfits. Many were happy to take advantage of this new service.

Men's clothes had been used by wives and sisters in the absence of alternatives and had been converted into jackets and skirts, dresses and even slacks. One young woman described greeting her husband on one of his rare visits on leave, wearing 'his pants (a bit of lace had made them into knickers), his shirt blouse, his pyjama jacket as a blazer and a skirt made from a bleached food stuff bag, and a belt made from Cellophane. And he never even noticed.'[6] Pyjama tops seemed to be popular amongst women and were often converted into blazers or shirts worn under pinafore dresses. They were easy to alter and brought a welcome dash of colour to a plain outfit.

Vogue's editors also tried to be upbeat. Their April 1943 edition was dedicated to offering advice on making-do. The first page shows the 'austerity bird feathering its utility nest'. 'Spring is here again, and this is our traditional tra-la-la number – but with a difference, of course, for it's utility, if not austerity, all the way now.'[7] Fewer clothes meant less bother with non-essentials; anything elaborate looked out of place and women should buy sensibly and for the duration, and beyond. The advice was to buy grey flannel costumes and to dress them up with colourful scarves and blouses. One new costume could be dressed up to form nine different outfits, if the wearer was prepared to be creative. 'You went to work wearing something different most days, even with austerity … once you'd got a basic, which was my pinafore dress … that meant you could ring the changes. I know I never went to work in the same thing two days running,'[8] an interviewee told Maggie Wood in 1989.

Women were also encouraged to renew their wardrobes by stitching pockets onto skirts or dresses in contrasting colours, by sewing different coloured ribbons into the pleat of a black silk skirt to 'become a walking kaleidoscope'[9] or attempting to 'give your workaday shirt a Byronic air by knotting two red linen handkerchiefs beneath the collar'.[10] The shortage of elastic from 1942 left milliners designing hats that had to stay on without

that vital assistance. Hatpins reappeared and the journalist suggested this offered 'a good chance to hunt for amusing antique pins, or have new ones made out of lovely filigree insides of old gold watches.'[11] If you happened to have a spare old gold watch to hand, that is.

Leather had also become a problem by this time and shoes were being manufactured with wooden heels, which were heavy but hard-wearing. They were not particularly attractive so belonged in the category of practical rather than beautiful. When Muriel Redman bought a pair of walking shoes in April 1942 'for next winter', she was told by the shop assistant that in future it would be almost impossible to guarantee availability of the right size of shoes and that it would soon 'be a case of taking not something that fits you but the nearest there is'.[12] Once she had managed to make the purchase, she was 'disgusted to find that my expensive blue shoes colour my stockings when my feet get hot and perspire' – a double insult.[13]

Like almost everyone else, Flo Hyatt found shoes a challenge, writing: 'Utility shoes have taken the place of the pre-war styles, the heels are lower, but as one has to walk much more than in the old days this is, if anything, an advantage. I like the crepe-soled shoes for walking but they cannot be obtained now except at prices like 59/6d, which to me represents nearly a week's wages. We have to give 5 coupons for shoes.'[14]

People were walking far greater distances than they had pre-war and footwear had to be adapted to last. Some of the utility shoes were good, however: 'I bought some shoes the other week and they are not at all bad, square toes, and lace-ups. I want to invest in a pair of real walking shoes, as I now walk to the office (about 1½ miles) each morning and the drive up to the house is made of flints, which the weather has worked loose. As I said to one of the girls the other night, it was like walking on a slab of that old fashioned "hard-baked toffee". I don't know whether you remember it. It was usually brown and full of lovely bits of nuts. We never see it now!'[15]

While making-do was meant to make women feel inventive, mending was raised to the status of a respectable art. Women were advised to have an attractive box or workbasket, not just a dirty old shoebox, and to be well organised so that pins, needles and darning wool or thread were

quickly to hand. 'You can be proud of the ability to prolong the life of something you have enjoyed owning and wearing. Relax and mend at leisure and do not resent it, for when you mend hurriedly, you have not mended well.'[16] That was all very well but it soon became difficult to get hold of items such as crochet hooks, knitting needles and press-studs. Flo Hyatt was fed up with the lack of hooks and eyes, elastic and zips, 'things you don't miss till you need them'.[17]

In the foreword to the Board of Trade's Make-Do and Mend booklet, Hugh Dalton thanked the readers for the way in which they had accepted clothes rationing and now urged them to 'get the last possible ounce of wear out of all your clothes and belongings'.[18] He was unequivocal: 'clothes have simply got to last longer than they used to'.[19] The advice was sound and practical, offering tips on drying wet leather-soled shoes or hanging dresses evenly on hangers, with plenty of space around them in wardrobes. They recommended taking all the clothes out once a month and giving them a good brushing, as well as checking for moth eggs. But all of this had to be done when women were busier than they had ever been, trying to keep house and home together, as well as working, looking after their own children and evacuees, and often undertaking voluntary work to boot. Nevertheless the booklet was popular, selling half a million copies in the first two weeks after publication and reflecting the Board's success in getting its message across.

The Board of Trade also devised a puppet character called Mrs. Sew-and-Sew, who wore a black and white apron and had a resolutely cheery expression on her face. She was portrayed as highly competent and happy to tell readers how to hem stockinette vests or mend three-cornered tears. By the middle of 1943 it was almost impossible to open a magazine without seeing her face beaming out from the advertisement pages. She dispensed wise advice, but she also encouraged women to attend the Make-Do and Mend classes run by the WVS and WI which had sprung up all over the country, while booklets with titles like *New Clothes from Old* appeared on the bookshelves.

And, of course, women's magazines featured article after article of hints and tips. *Picture Post*'s women's editor, Anne Scott-James, wrote an

The puppet character created by the Board of Trade,
Mrs Sew-and-Sew, was resolutely cheerful about making-do and mending.

essay celebrating the art of patchwork. She described it as a new 'brand' for fashion, and Digby Morton helpfully designed a blouse which she featured. According to her, the advantage of patchwork was that it took no coupons but used up pieces of old material. The art was in the cutting out, she emphasised. The squares had to be just that, square. 'The usual method is to tack them first on to a piece of canvas or casement backing, turning the edges of each piece in all round, and then to hem or herringbone the pieces together. Now that casement is rationed it is better to use three thicknesses of newspaper, and to cut the paper away afterwards. Alternatively, turn over the edges first with an iron, and stitch the pieces together without any backing at all.' Not all materials could be used to make a patchwork garment, she explained: 'cottons or ginghams are by far the best, in pale demure colours, with an occasional patch of Victorian

purple or red. And you mustn't mix in velvets and brocades. They are for the crazy patch workers who use quite a different technique.'[20]

The same month Anne Scott-James suggested that mothers should consider dressing themselves and their children in similar fashions. 'If you sew or knit your own clothes, you can make plenty of things for your small son or daughter with the odd corners of material and half ounces of wool.'[21] She suggested that girls would particularly enjoy dressing like 'Mamma'. 'You'll find your daughter takes more care of the dress that's a counterpart of your own than any other she possesses.'[22]

Many women resorted to making clothes for winter wear out of blankets. Coats and jackets were popular, although cream-coloured garments tended to look too much like the reused blankets they were made from. One young woman was lucky enough to have an overcoat made for her out of an air force blue blanket. 'I have a feeling we had something we used as the lining because otherwise it would have been very rough. It was very useful and very warm of course – lovely.'[23] She wore the coat with a navy blue duster as a head scarf, which 'fortunately went rather well with the coat ... anything that could be used we made use of'.[24]

Women used whatever materials they could lay their hands upon. One wartime favourite was the paper used by architects for their drawings. 'If you were lucky enough to know a draughtsman, you would beg him to give you his old drawings so that you could boil them and get a fine cambric material from them which you could make into handkerchiefs and brassieres. You did not have tissues for noses in those days.'[25] Food and flour bags were also popular staples for conversion into shirts, underwear or household linen items such as pillow cases. One WI member in Cumbria made a boy's shirt out of an old flour bag for a competition, which, the judge commented, 'would have been no disgrace to the smartest tennis party'.[26]

Women regarded it as a matter of pride to take unpromising materials, such as blackout material or blankets, and make something eye-catching. A woman from South Norwood told Norman Longmate, author of *How We Lived Then*, 'One became a little sensitive about wearing new clothes and it was nice to be able to say, when someone asked in incredulous tones:

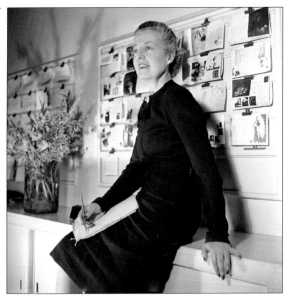

1. *Audrey Withers, editor of Vogue 1940–60, exuding confidence at an editorial conference in 1943, photographed by one of her favourite photographers, Norman Parkinson.*

2. *Flo Hyatt (left) with her friend, Kay. Both were keen walkers. During the war they continued their country ramblings, on one occasion straying into an army training camp.*

3. *Eileen Gurney with daughter Stella who was born while John Gurney was serving in India. Eileen's letters to her husband are full of love, humour and vivid descriptions of the children and the clothes she made for them and others during the war.*

4. Surgeon Lieutenant (D) Margaret (Peggie) Williams joined the Royal Navy Reserve (RNVR) as a dental surgeon in 1942 and served in North Wales and later Ceylon. During training she was found to be a crack shot. Peggie was discharged in 1947 and could still wear her No. 1 uniform and great coat into her eighties.

5. HM The King and Queen in Paris, 1938. The White Wardrobe, created by Norman Hartnell in three weeks following the death of the Queen's mother, caused a sensation and Hartnell was appointed the Queen's designer in 1940.

6. Vogue *introduced its cheerfully coloured spring fabrics with an amusing nod to the context of the war in the barrage balloon design of the samples. 7. Ren'U Process was just one of many small companies who promised to revive and revitalise laddered, holey socks and stockings. 8. Armies of women knitted comforts for the troops. 9. Dress-making and knitting was raised to a patriotic art during the war.*

VOGUE

Wardrobe
Planning

COUPONS
•
FABRICS
•
RENOVATIONS

SEPTEMBER 1943
including
VOGUE PATTERN BOOK
PRICE 3⁴

10. One of Vogue's most stunning wartime covers by American photographer, John Rawlings, who had worked for British Vogue *since 1937. He was described as a precocious talent with great visual style.*

11. Jacqmar's witty and colourful scarves appealed to the patriotic-minded and added a welcome splash of colour to tired outfits towards the end of the war.

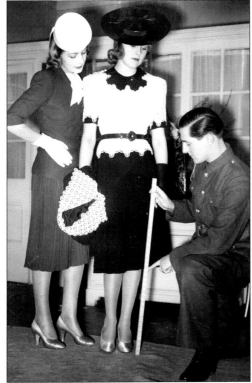

12. Hardy Amies liked his women full-bodied and curvaceous but he had to rein in his design when creating utility clothing. Constrained by the number of buttons and pleats as well as the length of skirts, he and the other IncSoc designers had to work hard to introduce originality in their clothes.

13. This exquisite set is made out of an RAF silk map of northern Italy and was given to Patricia Mountbatten in 1943 by a boyfriend. She asked her dress-maker to create a bra and pants (note: without elastic) so she would not have to spend coupons on underwear.

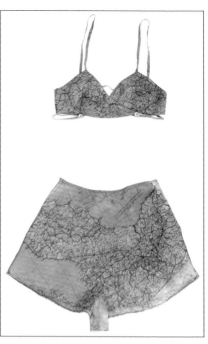

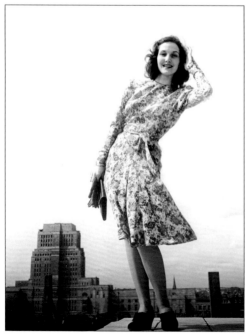

14. A photo shoot for utility clothing was organised on the roof of a building in Bloomsbury. Senate House, headquarters of the Ministry of Information, dominates the skyline behind the model who is wearing a Norman Hartnell dress that was purple, green and mauve and cost 7 clothing coupons.

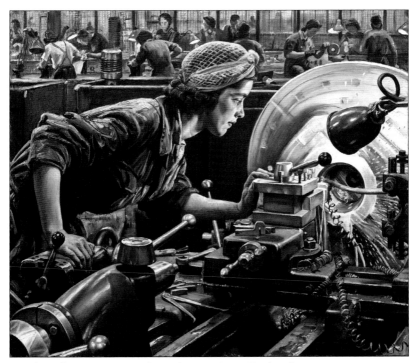

15. Ruby Loftus screwing a Breech-ring *by Dame Laura Knight, oil on canvas, 1943.*

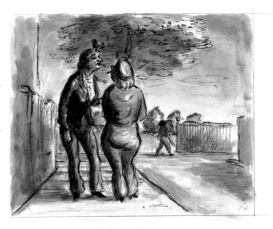

16. War in Maida Vale: 'If only they knew what they looked like' by Edward Ardizzone, 1941 is one of a number of watercolours produced by the artist poking gentle fun at the public. Slacks were still considered 'peculiar' in 1941 according to Mass Observation.

17. Christian Dior's New Look took Paris and the rest of the world by storm in 1947. It was almost two years before British designers embraced this glorious style and it was given the royal seal of approval by Princess Margaret at her parent's silver wedding celebration.

"Is that a *new* skirt?" "Oh, no! I made it out of my old winter coat".'[27] Furnishing velvet or brocade could be used to make warm housecoats and book linen and linings, even an old linen map could be adapted: 'I washed it, dyed it with a fourpenny dye. Ironed it. Cut it out from a much-used blouse pattern. Made it up with a fivepenny reel of cotton and used the buttons from an old dress. Result – one new wearable garment. Total cost ninepence – no coupons. I was very proud of this blouse.'[28]

May Smith was not so lucky with her dyeing experiments, however: 'Distressed, upon fetching home my purple coat which has been dyed black, to find that it is Ruined. It has shrunk so that it will not meet, there are three bald patches on the fur of the left pocket, and the lining is a horrible puce colour. Simply Ruined.'[29]

Other women made nightdresses, baby clothes and tea towels from butter muslin, which like cheesecloth and curtain net, was not rationed, while parachute silk became the firm favourite of women wanting to make underwear and night clothes. Almost every woman who was alive at the time remembers either acquiring some silk or having seen a garment made from it, and it was indeed considered to be a wartime luxury. And yet it is hard to believe that so many faulty parachutes were manufactured that there was enough silk material available for so many women to have formed this pervasive memory. In fact, the silk was available only infrequently during the war, but a large quantity of parachute material was released by the government off-coupon in 1945 and was snapped up by seamstresses and women who would ask their dressmakers to create clothes for them. An advertisement claimed that from a third of a twenty-four panel 'chute one could make two nightdresses, two slips, two pairs of cami-knickers and four pairs of knickers. Eileen Gurney's niece, Joan Harriss, explained how she made her first evening dress out of a parachute covered in mosquito netting in 1945: 'All "government surplus" needing no coupons. My aunt produced a black lace mantilla which she arranged into a sash [and] I went to a dance at the Royal Empire Society.'[30]

Parachutes were initially made from silk, but after 1942 it was discovered that nylon was a more robust fabric and it replaced silk thereafter, though both were still in use during the war. The parachutes were

FASHION ON THE RATION

made up in long triangular sections which could be easily unpicked and reused. 'Silk was preferred to nylon – it was pleasanter to wear next to the skin than the clammy, slippery nylon and was an easier fabric to stitch.'[31] Although so many people claim to have had parachute silk, few can remember how they acquired it. One woman who was very clear about her wartime source, however, told her story to Maggie Wood: 'During the war I worked as a machinist making army uniforms, and the main item, parachutes. These varied in size from very small ones used to parachute pigeons behind enemy lines to the very large ones. The larger they were the more we wanted to work on them because if there was a flawed panel or half panel, after long negotiations the machinist was allowed to keep it. Hence all my pants, bras, petticoats and blouses during the war were made of parachute silk.'[32] Parachutes for pigeons may seem a little far-fetched but, according to *Picture Post*, pigeons were conscripted in December 1939. Two hundred thousand pigeons were used on war service by the British and 32 were Dickin Medal winners.

Parachute silk was a very welcome reminder of pre-war luxury and when it became known that some was available, there was a tremendous clamour to acquire it. There are even some stories of women rushing over to a downed enemy pilot, armed with scissors, not in order to kill him but to salvage what they could of the chute. Apocryphal or not, it is a myth that has endured and gives a vivid picture of how people coveted this mate-rial. Lorna Dorrington was christened in a parachute silk gown that was made for her by her grandmother. There were some disadvantages, how-ever. Some complained that it rustled when they walked, and that it was slippery, as Sally Odd found out to her cost when her mother made her a parachute silk dress with a bow at the back to wear to a dance in Ports-mouth. 'The dress was lovely and the silk was glorious but when I tried to sit down on a chair I almost slid off. The dress was just too slippery.'[33]

The *Make-Do and Mend* booklet also gave detailed advice about mending frayed cuffs and collars, patching lace, darning socks and stock-ings and applying patches. There was advice on how to make cami-knickers from petticoats, how to unpick garments and knit them into a new design. Interestingly, wool that is unpicked and washed will not knit into the

138

same-sized garment as the original and the wool might also have become thinner. 'Of course, you save every scrap of wool when you are unpicking, don't you?' the booklet asked. 'A needleful of wool can be used for mending and sewing seams.'[34] Not only was every scrap of wool to be saved, but it could be gathered from the hedgerows and barbed wire in farmers' fields or even from dogs. The WI ran an article in which they suggested their members should collect fur from dogs using wire brushes and spin it in the usual way. They had even done research into which dogs' coats were best: collies, sheepdogs, chows and Pekinese. Poodle, Labrador and spaniel fur had proved less easy to spin. They concluded that the articles knitted with dogs' fur did not turn out as well as sheep's wool garments as the wool had little loft.

In some cases, 'making-do' meant that previous standards of dress had to be relaxed, and with no increase in the quantity of stockings on the market, it gradually became acceptable to go bare-legged, at least in London. In June 1942 an exchange of correspondence between the Archbishop of Canterbury and Hugh Dalton solved the problem for women going to church. The new Archbishop, William Temple, wrote to Dalton to complain about the woeful lack of material available to the firm that supplied 'nearly all the church furnishing houses'. Their quota had been reduced to one third of its pre-war supply. There would be a grave shortage of hassocks and 'Kneelers will be almost unobtainable to the great inconvenience of men in the forces in whose temporary chapels or churches these are almost the only supply of comfort.'[35] The Archbishop's masterstroke had been the mention of kneelers for the armed forces: Dalton was happy to help out and supplies improved. But Dalton wanted a favour in return, and two months later the Archbishop received a letter from the President of the Board of Trade asking him to announce that women could go to church 'without impropriety, hatless and stockingless'. Temple duly made the announcement and the situation was resolved happily for both parties. May Smith read in the newspaper that the Archbishop 'has decreed that in view of changing conditions, St Paul's decree about covering women's heads in church need no longer be observed. Thank goodness for that!'[36] In fact, Hugh Dalton had referred to the fact that St Paul had

specified veils. The following morning, May attended church and 'gaze[d] curiously around to see if any of the ladies have availed themselves of the Archbishop's decree, but find them all still respectably hatted'.[37] She added, 'Am myself hatted, but not respectably, as I wear my five-year-old pigeon trap as my grandfather used to call it.'[38]

Others were far less flexible about relaxing the dress code. One girl at a convent school horrified a French nun when she and others proposed to present flowers to a visiting Mother Superior without wearing gloves. They simply could not spare the coupons to buy them. "You cannot give flowers with your bare hands! It is not nice. It is horrible," she wailed.'[39] The Vice Chancellor of Leeds University told the *Drapers' Record* in June 1941 that 'there is a strong feeling that women students should not be permitted to attend the university without stockings'.[40] In October 1941, a civil servant high up in the Board of Trade, Mr Metford Watkins, gave permission for his female employees to work in bare legs. In an article in the *Daily Herald* headed 'The Man Who Upset Whitehall', it was explained that Watkins had 'recently advised government departments that they should allow women on their staff to wear slacks so they could economise on stockings'.[41] Clearly, Mr Watkins had gone too far and the paper then reported that he had resigned from his position of Assistant Director General of Civilian Clothing. The press cutting was carefully kept by Bill Fagg and it leads one to wonder just how much this topic was aired in Whitehall.

For those who could not make do without stockings, advertisements for small mending shops appeared in shop windows, in laundries or in boutiques on the high street in towns and cities. Stockings could be mended for a shilling at these little shops and the advertisements made bold promises for what could be achieved. The poster for 'Ren'U Process' (see plate 7) was created by Klaus Meyer, a German Jewish artist who fled to Britain after Kristallnacht (8–9 November 1938). At first he worked as a dishwasher in restaurants, but eventually he made his living creating commercial art posters and illustrating school textbooks for children. This image for Ren'U is probably his most famous.

Sheila Shear, a schoolgirl in the 1940s, remembered the stocking-repair booths clearly. 'They were all glass, quite often within a shop. They

repaired Harris tweed jackets, including picking up all the threads, and silk stockings. They were 1s a hole and 6d a ladder.'[42] Women were advised to rinse new stockings in warm water before wearing them and again afterwards. 'Strengthen new stockings before wearing them by reinforcing the heels and toes with widely-spaced shadow darning, and sewing two circular patches, cut from the tops of old stockings, on the tops where you clip on your suspenders. When a foot is too worn to darn, a new foot can be cut from an old stocking and sewn on.'[43] Again, this required a considerable level of skill, forward thinking and time. I have met several women over the course of my research who remembered wearing gloves to put on their precious stockings, a habit that stayed with some of them for a lifetime.

While stockings were difficult to come by on the ration and were 'expensive' at three coupons a pair, there was a limited black market in the supply of stockings almost anywhere in the country. Occasionally stockings would appear on market stalls and they were quickly snapped up. A woman from Nottingham recalled that 'they used to have great big piles of reject stockings from the factories and if you had enough time and patience you might find a pair the same colour – they might not be necessarily the same length – but you could buy them for about 2d a pair ... everybody used to go for them'.[44]

For some, the only option was to repair their stockings themselves. Magazines offered helpful hints, accompanied by drawings, showing women how to re-foot a much-darned stocking. Odd stockings were saved up and dyed to match. Again, this was often done at home: 'We used to dye with old tea leaves in muslin bags. If you wanted to change the colour of the stockings you put them in cold water and brought them to the boil ... you could bring them up to what colour you wanted.'[45]

It would be wrong to conclude that Make-Do and Mend marked a miserable era. It was often the case that people enjoyed the challenge of making garments from old or unusual materials. Some were very creative and justly proud of their achievements. Eileen Gurney had been busy with her needles once again: 'Do you remember my edge-to-edge black coat?' she asked her husband John in a letter; 'well, I unpicked that old suit of tails

*One of Eileen Gurney's frequent sketches of her latest
creation in her letters to her husband, John.*

I had and used them for the coat. I put a deep hem on it. Put bands up the
front for buttons and button holes, made a turn down collar & – la voila
– a warm and rather luscious housecoat.'[46] Not only had she fashioned her-
self a new housecoat but she had made it in such a way that, if she needed
to, she could unpick all the additions and return it to the edge-to-edge coat
she had started with. Two months later she took a dowdy old coat belong-
ing to her aunt and added a new yoke and sleeves in dark brown, making
the shoulders square, to fit in with the military look now in fashion, and
the bottom turned into a straight box coat in tweed. She was delighted
with the final result and drew a sketch in her next letter to John.

In November 1943, Flo wrote to her aunt that Goebbels had told the
German people that the British were starving and running around in rags:
'And if we are running round in rags, well, they are covered by an outer

covering that doesn't look too bad. The seats of the men's pants might be a bit shiny and the elbows occasionally in need of darning, or he may be wearing his utility 5″ socks or knee-length winter pants, and the girls might have much darned slips, and woolly vests that have shrunk so much they might now be called camisoles, and their stockings no longer attract the roving eye of the stronger sex. We may be shabby but most of us have at least one rig-out that can be worn for special occasions.'[47]

The greatest special occasion for women was of course their wedding day. The year 1939 had seen the greatest number of marriages ever recorded in British statistics. As the war approached, in the autumn of that year, couples all over the country rushed to marry in the face of an uncertain future. The fashion was still for a white wedding with long dress, veil and all the trimmings, but some women, like Gladys Mason, chose to wear a dress and jacket or costume that could be worn on other occasions. Once utility and austerity were introduced, it became increasingly difficult for brides-to-be to afford sufficient material on coupon to make a new, long white dress. Some resorted to borrowing dresses from mothers or relatives while others opted for the two-piece suit, such as Zelda Becker who was photographed on her way to the local synagogue, accompanied by her two sisters and her aunt in a top hat. Zelda's fiancé, Cecil, was in the Royal Air Force, so he married in his uniform, while she looked lovely in an elegant, slim-fitting costume with a nipped-in waist and padded shoulders, echoing the military fashion of the time. The only concession she made to a typical wedding outfit was a piece of veil worn on her round hat. She told her daughter years after the war that the rabbi had wept throughout the service as he mistakenly thought Cecil was a pilot and would be in great danger. In fact, he survived the war and the couple went on to have two children. A Scottish bride from Angus had only seven coupons for her wedding outfit, but she made do with borrowed shoes, a hat and handbag which were coupon-free and a pair of nylon stockings sent as a gift from the USA. Even so, she felt 'exceedingly smart'.[48] May Smith married her sweetheart 'Faithful Fred' in 1944, wearing her friend Ivy's wedding dress and a borrowed veil. She wrote of her wedding day: 'we get married with all due ceremony ... Then we dash off for the Derby bus and have a taxi

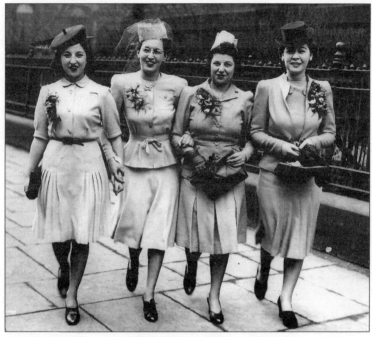

Zelda Becker, second from left, on her way to the synagogue to marry Cecil Faust.

at Ambergate where the rain is gushing down and it is thundering and lightning. Freddie's mother feels sick when we get there, and Freddie has indigestion in the night. But a lovely day.'[49]

Women in the services found themselves in a strange situation when it came to weddings. Service personnel were expected to wear uniform for the event and this applied to women as well. Barbara Cartland worked as an adviser to young women who needed support in their new lives in the services. She was baffled at this ruling. 'I was in the warmest sympathy with the auxiliaries who complained that they wanted to be married in white. As they had an issue of only fourteen coupons a year with which to buy handkerchiefs, it was obviously impossible.'[50] She learned that it was the Board of Trade who stood in women's way. They were adamant

that there would be no concession for extra coupons for wedding dresses. A year later she was still trying to find ways to get around the problem, even suggesting that the ATS might advertise for women to sell their wedding dresses free of coupons. Her request fell on deaf ears, but she was a romantic at heart: 'I thought of all the brides I had admired ... of Rosamund Broughton in white satin on the arm of dashing Lord Lovat; of the fair young Duchess of Norfolk in shimmering silver lamé, and I thought of the ATS brides in their ugly, ill-fitting khaki uniforms. Of course they wanted to look lovely and glamorous on what is the most thrilling day of a woman's life ... It is hard to feel soft, gentle and clinging in woollen stockings, clumping shoes and a collar and tie.'[51]

Cartland was determined not to be defeated. She advertised in *The Lady* and bought two pretty white wedding dresses for £7 and £8 (equivalent to £280 and £320 respectively in 2014). She sent these to the Chief Controller of the women's forces as a gift and suggested that she could source others. In reply she was told that if she would purchase them, the ATS would provide a 'wedding dress pool' at the War Office. 'The Service bride-to-be could apply through her Company Commander for a wedding dress which was lent to her for the day. Afterwards it was returned cleaned and refurbished to be ready for the next bride of the same measurements.'[52] In the end, Cartland bought more than seventy wedding dresses for the War Office and fifty for different RAF commands and stations. She bought them from women from all over the country who she would visit personally to collect the outfit. The War Office set a maximum price at £8 a dress, with veil and wreath, though occasionally she would top that up with a bit more from her own pocket, 'because I understood that those dresses were made of more than satin and tulle, lace and crêpe de chine; they were made of dreams, and one cannot sell dreams cheaply'.[53] Hundreds of women were married in Barbara Cartland wedding dresses and it seems that she really made a difference to the special day of the Service brides. She hoped, as she wrote, that they found fulfilment and lived happily ever after, like the heroines in her novels. 'They had their happiness; however quick, however fleeting, it was theirs ... by this stage in the war love was about the only thing left unrationed.'[54]

Joyce Lucas, who made silk bags in Northampton for the charges of 25-pounder shells, married her fiancé, Ted, in 1942. As a dressmaker, she had the skills to make something out of nothing and even recalled that: 'During the Blitz I remember sitting listening to the wireless making a pink striped dress.'[55] Although Joyce habitually wore pyjamas at night, because she frequently had to spend the night in the Anderson shelter, she was able to make nighties for her wedding night, using three lengths of Celanese, a man-made fabric designed to replace silk, that had been sent to her by her aunt and uncle. Aside from a coat bought from a black marketer (that she was delighted with), Joyce tended to buy lengths of cloth whenever she could and made clothes from basic patterns, which she then altered to make them more interesting and individual. After clothes rationing began, she bought curtain material, which at that stage was still off coupon, and made herself a dress. There is a story, possibly apocryphal, about a young woman who similarly made herself a dress out of furnishing fabric and when she arrived to have tea with an older and more senior woman, was horrified to discover that she exactly matched the pattern of the sofa, which had been covered in the same material.

Make-Do and Mend clothes introduced another layer of eccentricity into people's dress as contrasting colours in patches, on collars and cuffs, resulted in collages that were often bold and distinct. This was encouraged in women's magazines, and *Vogue* ran an article showing how large, contrasting patches could brighten up a tired garment or how white dashes on navy blue dresses and coats could add an accent. The intended result, especially in summer-wear for women, was a feminine, casual look that aimed to make the wearer appear more youthful than she did in winter tweeds and knitted pullovers. While Oliver Lyttelton had been right that men would be happy to look shabby, or at least shabbier than they had done in the 1930s, he was also correct in assuming that women would do anything to keep up their appearances. They became increasingly inventive in the way they wore their clothes and even managed to introduce a variation in seasonal colours, led of course by the main fashion magazines, who welcomed the freedom that coupon culture and utility clothing had offered women who had been hide-bound by fashion not five years earlier.

Clara Milburn wrote in her diary in December 1941 that her friend, Mrs F, was 'jubilant over having found a fifty-year-old chintz dust sheet which she had made into two overalls – it saves coupons'.[56]

The Board of Trade, ever eager to get its message across in as many different ways as possible, organised an exhibition with Harrods to show housewives how to turn something old into something useful and new. In an information film, several recycled garments were demonstrated, made from old coats, patchwork material and even a dressing gown fashioned out of an old dust sheet. The pièce de résistance was a two-piece black costume made by a woman from her husband's old dress suit. The commentator on the film summed up: 'all garments made in make-do and mend are entirely exclusive'. He warned men to 'lock up your favourite old clothes before you leave home in the morning'. The film ended on the shot of a middle-aged businessman in bowler hat, carrying an umbrella, walking down the street in long johns and a shirt.

Shoes were a perennial problem during the war, as we have seen. According to a Mass Observation poll of 1941, most people in the upper pay bracket had two to three pairs of shoes, while most of the poorer people had one for best and a pair of clogs or the like for everyday use. Iris Jones Simantel remembered her father repairing shoes on his cast-iron hobbing foot. 'He had three different sized shoe forms for repairing the different sized shoes. He occasionally managed to get the odd piece of leather, usually an off-cut that varied in thickness, requiring him to try to even out the thickness by shaving it off so we didn't walk with a limp due to the lumpy nature of the new leather. I can still see him with his mouth full of nails.'[57] She was jealous of her older brother who was allowed to wear clogs when his shoes wore out because for some reason her mother refused to let her have clogs: 'she said they'd not be good for my feet. I never did understand that!'[58]

Shoe fashions changed during the Second World War. 'Tottering heels went out when war work came in. Now, the smartest shoes have a clumpy look to them. Not only do flat heels stride about the country; you wear them about town, and down to dinner.'[59] To a modern eye, the shoes do indeed look clumpy. The heels were square or wedge-shaped and often the uppers were made of different colour leather, or even a mixture

of materials, to avoid waste. Bright thongs, colour piping and different coloured laces all went some way towards disguising the fact that shoes were suffering as much from rationing as other types of clothing.

After the Japanese cut off Britain's rubber supply in 1942, the manufacture of crepe rubber soles and heels was banned and the height of heels restricted to a maximum of two inches. 'The gap in supplies was filled largely with wooden-soled shoes known as "woodies", with a suede upper and a hinge in the sole, and in 1944 more than a million pairs were made for women alone.'[60] *The Lady* gave advice on how to walk in woodies: 'If you find yourself walking a bit duck-footed in the first few days, concentrate on placing your toes in a pigeon position and you'll find your muscles will soon co-operate and you'll be walking the right way once more. If you get them wet, dry them on trees away from direct heat so the wood will not crack, or the leather uppers dry out.'[61] All-wooden clogs, which had been worn principally by factory workers in the north-west, were extremely popular as they were hard-wearing and coupon-free. Soon it became impossible to acquire a pair without a certificate from a factory inspector. As soon as any loophole was discovered, the Board of Trade found a way to block it by introducing a new regulation.

Not content simply to mend old clothes and reconstitute old into new, women in particular turned their creativity to making accessories from sometimes unusual material. A young bride-to-be acquired a pair of star-shaped Perspex earrings which were believed to have been fashioned from the windscreen of a crashed German aeroplane, and another woman donated a bracelet to the Imperial War Museum that she had made for herself out of plastic and Perspex remnants left over from aircraft windscreens. Suzanne Petter went one step further and designed an array of patterns and examples of home-made jewellery and accessories. Keen to get beyond the Make-Do and Mend brand, Mrs Petter was insistent that her items, which were made from such materials as carpet braid, bicycle clips and buttons, were original jewellery. They were advertised as such in various women's magazines. *Vogue* spotted the trend for individual jewellery: 'designs that have some personal meaning: a rose, for a Lancaster regiment; mess kit buttons as ear-rings; little drums on a brooch; a nose-dive

bird in diamonds'. Some people chose to wear colours to support their families. One woman remembered buying an air force blue wool dress with a matching hat. She attached an aeroplane badge to the dress in memory of her brother-in-law who was a pilot in the RAF and had just been reported missing over the North Sea. 'The hat was a disaster. It was an air force shape with streamers down the back ... but the material covering the base was crêpe de chine so of course the first shower that I went out in the hat just disintegrated.'[62]

Shopping in Britain's high streets became a sad affair as the war progressed. Many shops tried to keep up appearances by maintaining full window displays, but behind the scenes there was a different story to be heard and seen. Mass Observation carried out a survey of shops and department stores in the West End of London in February and March 1942. They found that ordinary stock was very limited and that supplies of utility clothing had not yet made up for the lack of garments in the most popular sizes. Shoe shops 'have well filled windows, but inside it is a different story. In varying degrees this is true of most things. A good show is made to suggest that the department store is well stocked, but this illusion is seen through when any particular colour or size is required.'[63] D. H. Evans had to resort to closing two floors of their London store and concentrating what clothing they had in order to appear better stocked than they really were. Often the windows were full of things that people would not necessarily want. The observer saw that shoe shops were displaying high-heeled crepe-soled shoes, whereas what shoppers wanted in March 1942 were walking shoes and boots. Although this particular survey only looked at the West End of London, it pointed out that people in the provincial cities would realise that London was not being treated as a special case. There were shortages everywhere, even in the capital.

One of the major aspects of rationing and the Make-Do and Mend campaign that is often overlooked is the impact it had on clothing retailers. With diminished stock and lines, the whole retail sector struggled to survive during the war. Mrs Milburn wrote in her diary of getting her husband's coat lined: 'So off we went to Warwick, calling at Brett's to get a lining put in Jack's winter coat. Brett's shop is almost empty – very few rolls

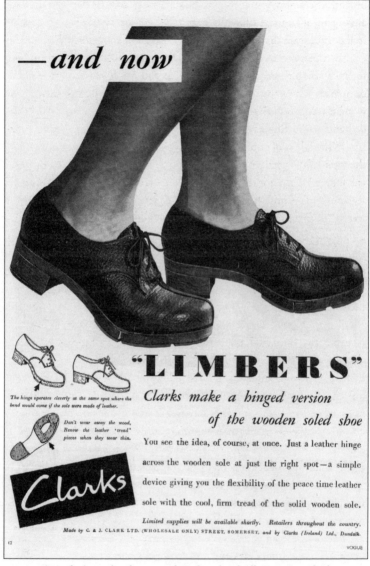

—*and now*

The hinge operates cleverly at the same spot where the bend would come if the sole were made of leather.

Don't wear away the wood. Renew the leather 'tread' pieces when they wear thin.

"LIMBERS"

Clarks make a hinged version of the wooden soled shoe

You see the idea, of course, at once. Just a leather hinge across the wooden sole at just the right spot—a simple device giving you the flexibility of the peace time leather sole with the cool, firm tread of the solid wooden sole.

Limited supplies will be available shortly. Retailers throughout the country. Made by C. & J. CLARK LTD. (WHOLESALE ONLY) STREET, SOMERSET, and by Clarks (Ireland) Ltd., Dundalk.

VOGUE

'Woodies' were hard-wearing but also a hard sell. Consumers had to adjust their gait in order to walk normally in them.

of cloth there now, and it used to be stacked all around. We saw the most awful pair of trousers I have ever seen ... and they were sent in for repair! In fact Brett said that it was all repair work at the moment.'[64]

By this time, in November 1944, clothes rationing had been in place for more than three years and Make-Do and Mend was no longer just a campaign, it was a way of life. And it was grinding people down. One woman told Mass Observation that year: 'I used to look upon "making do" and renovating as a national duty ... now it is just tiresome necessity.'[65] The effort of coping with shortages and privations meant that even the women's magazines stopped trying to offer cheery advice but rather encouraged them not to despair. *Vogue* told its readers in 1943: 'this is the season for planning the one good suit ... which is to see you through the war ...'[66], hardly an upbeat message to women who longed now for a little glamour. People had the money, but there was simply not the stock in the shops available to purchase. Two years earlier, one woman had said, 'For a long time we wondered what we should do when we had no more stockings, now we wonder how we shall keep our last pair of stockings up when there is no more elastic.'[67]

Keeping smart was a theme of many letters of this period. Winifred Musson wrote to a friend, listing almost her entire wardrobe and explaining how she was having to cope with her clothes becoming ever more shabby. There is a sense of underlying despair as well as of the invaluable humour that kept people going. In the autumn she was on the hunt for headwear to go with her latest outfit: 'Had a terrible job getting a hat to go with my new suit. The tweed mixture made a match impossible. In the end found one for colour in Jaeger's in Regent Street but am sure one day I will absent-mindedly beat up a pudding in it, it's just that shape. Think I must get a feather for the front.'[68] Her despair is believable as she described other items in her wardrobe: 'My everyday things are terrible and seem worse than ever compared with our latest standards. I am still wearing Maureen's suit from 1937, a very shabby navy one, 3 years old, do wish I'd bought a better one, that navy is no economy, and a navy shirt and green jacket I got Sept 1939. Also the fur coat D gave me 1938 and the brown one I bought 1936. All very ill-fitting and shabby, and I don't waste new hats or

jumpers on them, just wear navy or brown net turbans.'[69] Some garments did duty year after year with alterations to change the look or even the use of, say, a coat. A girl from Yorkshire made a 'woollen edge to edge coat ... used it as such for a couple of seasons. Next I put buttons and buttonholes and used a fur collar from another coat. Another season I took out the lining and made it into a button-through dress using a white lace bow at the neck. After that I made it into a skirt.'[70]

One way of overcoming clothes rationing and Make-Do and Mend was to exchange clothes with friends or relatives who were a similar size. One sister from a family of four girls remembered how 'we used to interchange a lot with clothes because at that time we were all the same sort of figure ... you'd be amazed, you know, what went from one down to the other'.[71] As a little girl, Gill Tanner remembered going to clothing exchange clubs and coming away with lovely 'new' dresses and skirts.

Dyeing clothes also became popular both with professional renovators and people at home. 'When garments were looking tired we used to dye them with Drummer dyes which were about 1 ½d each.' There was always an element of risk in home-dyeing and things did not always turn out right, but if it worked it could give an old outfit a new lease of life. Some even resorted to using home-made dyes. 'We could only buy white ankle socks so to make a change we used to dye them – for pink ones we used cochineal cake colouring and for blue ones we diluted blue-black ink. They always turned out streaky and sometimes the colour came out on our feet.'[72]

Soap was also rationed in February 1942 in order to save oil and fats for food. There were of course hints on how best to preserve soap and how to make your own, but from today's perspective it is hard not to think how dreary it must have been as life for women became ever harder. In September 1942 *Vogue* told its readers: 'The soap shortage has not yet brought squalor, but planned economies abound. The day of white gloves and the sheer white or pastel blouse is doomed. Thrifty and far-seeing persons have stocked up on patterned fabrics and dark gloves and chiffon or triple nylon lingeries, which require far less soap than satin. Hair gets shorter and greyer. Legs go barer and browner ... make-up is cherished,

a last desperately defended luxury.'[73] Soap rationing produced a snort of derision from some women, despair from others, and a philosophical approach from Molly Rich who wrote: 'Today I drew my soap ration for the month and have decided to become a brunette. It will be quite impossible to stay clean enough to remain blonde. Also I shall dye all my underclothes black.'[74]

The WI offered advice on how to give old clothes a new lease of life, including rubbing hot bran into tweed skirts and jackets, cleaning white materials with ground rice and using powdered magnesia to clean delicate fabrics such as lace, embroidery, white kid and suede gloves. Oil of eucalyptus would revive jaded silk and faded crêpe de chine, while potato pulp could be employed to clean cloth gaiters and leggings. Grandmother's recipes for cleaning clothes were proposed but in some cases sounded very expensive: 'For cleaning silk ... mix well together three ounces of strained honey, two ounces of castile soap and half a pint of gin.'

Towards the end of the war, several diaries and letters reflected the sense that women had been heroic in keeping up appearances and surviving the austere years of Make-Do and Mend. A woman from Wales wrote: 'I think housewives deserve a medal, I'm afraid our slogan "make-do and mend" is almost worn out itself by now, most of our garments won't "make do" or "mend" any more. Still I suppose there will be more to buy soon, if one has "coupons" to buy with?'[75] However, the truth was that there were still years of austerity to come, and the quantities of clothing and general goods decreased rather than increased, as this housewife had hoped. In part this was due to the perennial problem of shipping across the Atlantic, but over the next months and years the government had to plan for the final battles of the war and for demobilisation afterwards. There was no spare capacity to increase civilian supplies. For the foreseeable future, the country would have to continue to make-do and mend.

8

Beauty as Duty

*We cannot leave men to fight this war
alone. Total war makes heavy demands ...
The slightest hint of a drooping spirit yields a
point to the enemy. Never must careless grooming reflect a 'don't care'
attitude ... we must never forget that good looks and good morale are the
closest of good companions. Put your best face forward.*

Yardley advert, 1942

The last two years of the war were uneventful for British fashion. Wardrobes had to be durable and flexible, outfits chosen for their versatility. Fashion now focused on the detail. *Picture Post* warned its readers in 1943 not to 'ache to find something "different"'[1] and advertisements for anything from shoes to make-up warned of scarce supplies and counselled patience. It was a dreary time. Eileen Gurney had a feeling of listlessness about her clothes. She wrote to John: 'Sometimes I have had moments of utter despair when I look so old and colourless that I think you will be shocked when you see me. But I think it's only because my life is rather dreary and colourless, because as soon as I put on a decent frock and make an effort ... I don't think I look any worse than I did five years ago.'[2]

Overseas, the bombing of German towns and cities intensified, while preparations for D-Day were underway. In September 1943, Italy surrendered and Allied troops landed in force at Salerno. Meanwhile, in the Far East, prisoners of war were being used by the Japanese as slaves to build roads and railways. By the October of that year, over 12,000 POWs had died building the Thailand–Burma Railway. Details of their treatment reached the House of Commons in November 1944 and shocked the nation.

Towards the end of 1943, *Vogue*'s fashion editors appeared to have given up trying to cheer their readers with promises of new designs around the corner and bright ideas about making old wardrobes more interesting by adding bows and scarves. In an unusually honest editorial, it conceded that war conditions had slowed developments in the fashion industry dramatically. Now, a woman could order a costume from a designer's summer collection for wearing the following year in the sure and certain knowledge that changes in fashion would be slow and subtle. The resulting timeless outfit was useful, but ultimately depressing: 'In taking the time element out of fashion one has to admit that the edge of excitement is taken away too. There can be few surprises, few thrills. Fashion has slowed into the tempo of a steady marriage, for it takes too many coupons to have clothes with which one falls in and out of love ... That's the way it is, and that's no doubt the way it has to be – for the duration.'[3] A beige suit capable of being turned into nine outfits by the judicious use of slacks, jumpers and contrasting skirts might have been a useful addition to the wardrobe but it was not going to inspire the fashion-conscious woman who, after three years of rationing, longed for something more beautiful and exciting to wear.

Did *Vogue* still have a role? This was a question the editors asked themselves. Their response, as always, was positive: 'Yes, more than ever. Because the more difficult shopping becomes, the greater the knowledge you need. The more precious new clothes grow, the greater the guidance you need. The more service your things must give you, the greater the forethought you must give them ... Two-and-sixpence invested in *Vogue* will save many failures and many pounds.'[4]

Muriel Redman, who worked for the BBC's *The Listener* magazine, expressed her frustration at the everyday situations which were made so much more complicated by the war and thwarted her best efforts at keeping her wardrobe in some semblance of order: 'I find few cleaners who will take my crumpled clothes: since clothes-rationing was announced, so many people have decided to have their old garments cleaned, that cleaners have been unable to accept any. The "6 hour" firm I find promises them back in a fortnight,' she wrote in June 1941. A month later she saw the laundry man. He used to collect on Mondays and deliver on Fridays. 'Now he calls about once in three weeks, and one hardly expects to see the clothes again.'[5] In March 1942 she was trying to find someone who would alter her clothes for her, but all the big stores, who opened alterations departments as soon as rationing was introduced, found they did not have enough staff to meet the demand. Eventually she found a seamstress recommended by a friend. A fortnight later they were ready: 'In lunch hour go to collect dress, coat and skirt, which have all been shortened. Have to carry them home unwrapped over my arm. The charges are, dress 4/6, skirt 3/6, coat 5/6. This seems plenty but is not as much as an Oxford Street store would have charged.'[6]

Now that women could not dress as they wished, the magazine editors tried to encourage them to keep up appearances by focusing on beauty treatments. It was a woman's duty, they continued to argue, to look beautiful and stay lovely. The beauty industry had thought of everything, the fashion editors reassured readers: 'If you have to stay in khaki, don't despair – there is a new lovely make-up for you, especially created for this rather trying colour. Its name is "Burnt Sugar". It is a warm glowing shade that goes beautifully.'[7] Early on in the war, when make-up and other products were in plentiful supply, this was not a problem. There were dire warnings about trying to save on astringents, for example. Never try to go without, *Woman's Own* advised: 'The astringent closes the pores and prevents blackheads, open pores and subsequent spots. Not an economy to save on this. Astringent costs about 1s for three months, and should save 5s worth of skin troubles.'[8] Similarly, they were advised not to have a perm on unconditioned hair, to avoid lipsticks and rouge that did not

match, to use mouthwash to prevent bad breath, to bend to touch toes six times a day without bending the knees to stop spare tyres forming and to brush their hair with a hundred strokes a day. All this was possible, if time-consuming, in 1941 – but two years later it was difficult to come by any beauty products at all.

As today, beauty treatments in the 1940s were sold with promises of eternal youth and no more wrinkles. May Smith was always prepared to try out something new and frequently found herself taken in. Early in the war she had read that water had great, restorative qualities. For a week 'I drenched my tonsils in water. My diaphragm has become worn by the daily passage of this estimable liquid. With what result – three Pimples and a Foul Cold. Huh!' Not to be beaten, May decided to try a face pack, 'expecting to emerge with beautiful pink-and-white complexion', however the exact opposite happened: 'Nearly expired on the spot – a purplish-red horrified visage stared back at me. Never again. Boncilla can keep their beauty preparations.'[9]

Make-up had become increasingly fashionable in the early years of the century, influenced first by the theatre and then the Hollywood film industry. The 1920s saw a surge in the use of make-up, which increased during the 1930s, and nail varnish, eyebrow pencils, mascara, face make-up, powder and lipstick were all in use by the war. They had been introduced to the mass market by Elizabeth Arden, Max Factor and Helena Ruben-stein, who had all developed and supplied the entertainment industry. Max Factor's grease paint, so popular with the movie stars, was available to all from the 1930s, while Helena Rubenstein's non-toxic mascara made her a personal fortune. Elizabeth Arden perfected lipstick and produced a glamorous red to go with service uniforms. All of them advertised in glossy magazines, as did other producers of make-up keen to help women paper over the cracks.

Lipstick was an all-important beauty accessory. *Vogue* offered tips on how to apply it. 'Our own pet way of using it is to apply a spot of cream underneath it, then the lipstick applied with a brush, then another spot of cream on top, then a pat or two with a lip tissue. And we swear by it.'[10] Gala offered lipstick, face creams and powders to its clientele and was

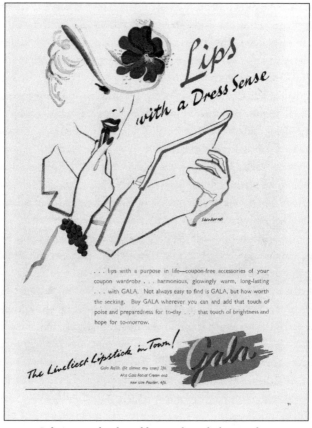

Gala promised style and beauty through their products.

particularly popular because it could refill old lipstick-holders. An adver-
tisement in 1943 read: 'lips with a purpose in life – coupon-free acces-
sories of your wardrobe ... harmonious, glowingly warm, long-lasting ...
with GALA. Not always easy to find is GALA, but how worth the seek-
ing.'[11] Peggy Sage Preparations for nails were equally scarce and although
they advertised widely, warning their customers to 'exercise the utmost
economy and to exercise patience when these preparations are difficult to

obtain'.[12] Crème Simon continued to advertise even though they were no longer able to supply the 'exquisite beauty preparation' as its manufacture had been suspended. The same applied to Chanel who took out quarter-page advertisements in magazines: 'the perfume of the *élite* for more than a decade. Owing to wartime conditions this wonderful perfume is not now available, but Chanel are doing everything possible to give their clientele their favourite perfume in Chanel face powders, lipsticks and toilet soaps.' They added optimistically, 'Chanel greet their public and look forward to the brighter days when they will again have the pleasure of serving them.'[13] Max Factor were more successful in keeping a supply of make-up on the market and their most popular product, Pan-Cake make-up, favoured by the stars, continued to be supplied in stores, chemists and at selected hairdressers.

Magazines gave tips on beauty even when there was a serious shortage of cosmetics available. The government had limited manufacturers of make-up and creams to 25 per cent of their pre-war output. This encouraged a black market in potions, but readers were advised against buying non-branded lipstick which had possibly been cooked up in some unscrupulous person's kitchen and sold for cash to a shopkeeper who could not resist having cosmetics available for his customers. Some lipsticks had even been shown to have lead in them and others caused dermatitis. Rose Cottrell wrote to her sister Pat in December 1941: 'There have been no lipsticks either, except I believe some very expensive ones in some shops, but I don't think I would like to try these on my lips as they might be black market ersatz ones which are made of goodness knows what. Fortunately I still have some of mine left and as I am not very heavy on it, it may last some time yet.'[14]

Although clothing was never a major issue for Joyce Lucas, as she was so clever at sewing, make-up – which she had to buy from Woolworths – was a problem. At first she could acquire Pond's vanishing cream and Max Factor powder quite easily, but later in the war there were shortages of everything. 'The choice of lipstick colours was limited and we didn't have nail varnish until after the war but we made do,'[15] she said. Her father did not approve of her wearing make-up, so she had to put it on in the kitchen

before she went out. Another woman who suffered from shortages was May Smith, who was cross with herself when she forgot her powder puff on a visit to Derby in April 1943: '... they are now unobtainable in velour. Get some cotton-wool as substitute.'[16]

The advice to women was to keep working at their appearance, even with the dearth of cosmetics and creams, and they turned to old wives' tales in the absence of modern beauty treatments. For the face, they advised women of 'scraggy' appearance to say 'Q.X.' very emphatically a dozen times night and morning, promising that that would do wonders for sagging contours. For damaged hands, cracked from hard work, cold and lack of fats, women should wear gloves in bed once or twice a week or roll a walnut in each hand to preserve supple, knuckleless hands. This was apparently an old Chinese treatment. Some women, like those who made camouflage netting, were entitled to government supplies of hand cream as their work was deemed to be so hard on the skin. Those who made potato baskets were not, however, entitled to the cream and there was some question about whether this was fair or not. The government went as far as supplying certain categories of female factory workers with protective face cream, which says something about the nature of the materials they were handling on a daily basis. As the fashion for hair was resolutely short, the recommendation was to have it cut every three months and to wash it often, using soapless shampoo and a dash of vinegar to finish off after the final rinse. 'If you suspect scalp trouble, consult a trichologist, or go to your doctor – do not listen to the mumbo-jumbo sales talk of the ordinary hairdresser.'[17] With the lack of fashion in the accepted sense of pre-war haute couture, the only thing left after making-do and mending, or applying scarves and ties to worn-out shirts and suits, was make-up and hair.

Hairstyles changed during the war. It was very rare for anyone to have straight hair. If it was not naturally curly, then women either had it permed or set; women were used to working with their hair, though the results were not always what they hoped. May Smith had plenty to say about her permanent waves. 'Up to Miss Barnett's by 5 to have my Ends Permed. Sit and freeze and endure 3 hours of agony and torture while I

am washed, baked and set. My soul groans in inward horror as she piles gallons of thick, greasy setting lotion on my locks – assuring me all the while that it is Not Greasy. Emerge with a horrible set look – set waves and horrid little artificial set curls.'[18] It was with a mixture of relief and resignation that she wrote in her diary a few years later that Miss B. had warned her there would be no more perms as there were no more lotions: 'Well, nature will soon be visible in the raw again. No perms, no cosmetics, even a shortage of clothes.'[19]

Women in the Forces had to keep their hair above the collar, but they wanted to maintain a feminine look so braids or a page-boy roll had became fashionable by 1942. The girls and young women who worked in factories were influenced by the Hollywood stars and their hairstyles were dictated not by army regulations but by the dreams created by their heroines. American actress and screen idol Veronica Lake was famed for her 'Peek-a Boo' hairstyle, whereby her long locks covered her right eye seductively. It was copied the world over, but was not the right look for wartime, especially for those working in factories where there was a great risk of getting hair caught in machinery. Miss Lake agreed to help by 'putting glamour in its place and facing the world with both eyes'.[20] She adopted a chignon roll that took the hair right off her face, a look that was quickly copied in America but took a little longer to reach Britain.

Meanwhile, a few well-publicised accidents, helped by the women's magazines celebrating short haircuts, turbans and caps, assisted the government in their drive to get women to wear their hair short. One gruesome incident was described by Kathleen Church-Bliss in the light engineering factory in Croydon where she and her friend Elsie worked in November 1942: 'One of our new turners, going behind one of the lathes, got her hair entangled with a revolving rod of metal which was sticking out of Laurie Charman's lathe. Laurie on hearing her shriek turned off the machine at once and Rapley who was fortunately nearby, rushed up and cut her hair free of the rod. But it had taken the greater part of the hair off one side of her head and also left a completely bald patch about the size of a 5/- piece just above her forehead ... actually we are not very surprised there has been an accident as Rachel obstinately refused to tie her hair up in a scarf and

only wore a stupid little chenille fishnet which was no protection at all. She has now caused retribution to fall on all the machine operators as the decree has gone forth that we are all to wear the hateful khaki convict caps with a peak.'[21]

Following this and similar instances, the government rushed out propaganda posters encouraging women to protect their hair. 'Cover your hair for safety. Your Russian sister does' was one of the slogans. Audrey Withers recalled how she and other editors were contacted by Whitehall to help out with the campaign. She wrote: 'The current vogue was for shoulder-length hair. Girls working in factories refused to wear the ugly caps provided, with the result that their hair caught in machines and there were horrible scalping incidents. Could we persuade girls that short hair was chic? We thought we could, and featured the trim heads of the actresses Deborah Kerr and Coral Browne to prove it.'[22] There was a page in *Vogue* showing these two actresses plus Elizabeth Cowell, one of the first women presenters on the BBC, and the magazine's features editor, Lesley Blanch. In this way they could demonstrate that it was not just film stars but also working women in high-profile roles who embraced the new, short bob. The caption read: 'Neat Heads. War work, whether in the services or factories, has always brought a wave of shorter hair – for neatness, easy cleanliness and good looks. The busy women opposite say it's easier, prove it's attractive.' [23] Eileen Gurney told John that she had restyled her hair into a short bob having seen photographs in *Vogue*. Just the result Audrey Withers and the government would have wanted. Pullouts showing women how to tie up their hair in rolls, chignon or queue curls ran alongside advertisements for the bob.

Wartime advertising was important on many fronts. Government posters had to convey their messages succinctly – 'Dig for Victory', 'Wage War Against Waste', or warn against 'Careless Talk'– but the companies placing advertisements in magazines had a different agenda. They sought to keep people's spirits up, to encourage a sense of defiance and determination. Gala lipsticks promised 'that touch of brightness and hope for tomorrow'[24] in 1942, while Elizabeth Arden claimed their treatments 'are designed to-day to meet the needs of *really busy women!*' They were resolutely upbeat and often had long, detailed stories giving women all

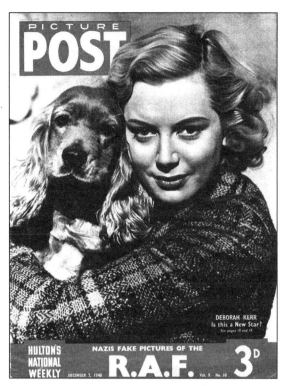

Actress Deborah Kerr was a fashion icon for young women.
Hairstyles were drawn and sketched to be copied by admirers.

the more reason to choose their products. An advertisement for Atkinson's 'Skin Deep' beauty cream offered a choice between never frowning or staying up late and massaging the face every night for a younger look. 'So cream away the years with Skin Deep tonight and awake to a lovelier morning.'[25] For the young women who joined the services there was a message about pride in wearing a uniform: 'Every woman's a heroine in these days, but with an undeniable hint of sex appeal'. Moss Bros advertised an ATS officer's uniform in baratherea or whipcord, claiming that 'Your uniform can satisfy your own preconceived notions of elegance as well as the critical eye of the Commandant – Moss Bros. will see to that!' And Elizabeth Arden stepped in again with encouragement to visit the Hair Shop for 'one of the new Elizabeth Arden hair-dos – both appropriate for the purpose and extremely becoming under a service cap'.[26]

By the middle of the war and with ever more limited supplies, companies had to sell the promise of good things if you could get them. An advertisement for Carnoustie's shoes admitted, 'like all good things today, there are not nearly enough of them to meet growing demand'. In the same month, October 1943, Berlei told its readers that 'there are good stocks of Berlei one-piece Controlettes in the shops but they won't be there for long!' At this stage, companies who could offer mending services stepped in with helpful promises to mend underwear and knitwear, to refurbish corsets or resole shoes. At the end of the war, Cyclax, who had produced creams for stockingless legs in the early years, placed an advertisement praising the women of Britain who 'have paid their share of the price of liberty. Yet through all the trials and sacrifice they have surrendered nothing of the charm that is theirs by right. Much of the small supply of Cyclax has gone to those in uniform – we are glad to have been able to make this contribution to those who have contributed so much.'[27]

With shortages of almost everything, colour became the way to make a fashion statement in 1944. The British Colour Council organised an exhibition at the Royal Academy of Arts entitled 'Colour in Everyday Life'. It encouraged visitors to consider colours for furnishings, new or refurbished, and it advised on the importance of colour for clothing: 'coupons should be used very wisely in selecting accessories (like scarves)

which would enhance existing outfits'.[28] Taken with a positive outlook, this was an encouragement to dress up clothes rendered dowdy from lack of cleaning, endless darning and patches sewn in to lengthen or cover holes. On the negative side, it feels a little as if the bottom of the barrel had been reached: clothing was not likely to improve in the foreseeable future, so people had to do the best they could to patch up, jazz up and put up. Muriel Redman, who had been mending stockings for years, wrote in her diary: 'Many of them I would have thrown away three years ago, but today their price is above rubies.'[29]

One unexpected boost to women's morale came with the influx of Americans to Britain, beginning in 1942 and reaching a high-point in early 1944. 'American servicemen, from the officers down to the enlisted men, came with a love of life which had to some extent been extinguished in England after many years of wartime conditions. British women, old and young alike, had been missing male companionship over these same years. The Americans were exciting; they were fun; they had access to gum and nylon stockings. They brought colour back into British homes, and into the dresses which the women bought.'[30] They also brought a degree of disruption. Love affairs blossomed and by January 1946 some 27,000 English women had set sail for a whole different world from the war-torn land on the edge of Europe. More would follow post-war, bringing the total of GI brides to around 60,000. Not only were the Americans generous with their gifts, they were also noticeably well dressed, with crisp and tightly fitting uniforms made out of good quality fabric. This led to jealousy amongst the British soldiers based at home and sometimes to fights. 'Many of the scarves sold in England from the summer of 1942 onwards were purchased by American servicemen, and some of the impetus for young women to look as attractive as possible was directed at American servicemen.'[31] But in the main it was the verve and vigour that older people remember most about the GIs – along with the gum that all those who were children in wartime eagerly recall.

At about the same time as the first GIs arrived, a new trend emerged to encourage women to focus on their health and to exude a healthy lifestyle in their appearance. As we have seen, women had taken on new

roles in their work lives and self-image became more relevant as salaried workers had money to spend on themselves. There was admittedly little to buy, but interest in how people looked had not diminished. Fashion was undergoing 'a compulsory course of slimming and simplification; and is emerging from those reducing rollers, the new dress restrictions, in fine shape'.[32] With the lack of creams and make-up, *Vogue* appealed to its readers to take up 'four fundamental cosmetics ... which don't come out of jars and bottles'.[33] These were sleep, a proper diet, exercise and relaxation. The clothes that went with this healthy look were practical: skirts and knee-length socks and open-necked shirts with rolled-up sleeves. By 1944 the emphasis on the appeal of the healthy, slim look had been turned into an essay on how to make the body fit the clothes. There was a new 'alchemy' for women that meant beauty was perceived as 'part health, part person, plus a new magic – the fitness of things'.[34] This remained the mantra for the whole of the year, but in 1945 there began to be an interest in the waistline for the first time since 1939. Women were still advised to keep their bodies 'long'. 'The legs are springy, the hips flat, the neck straight, the shoulders wide'.[35] The interest in a shapely waist came from London's anticipation of where Paris fashion was heading, and they were not wrong. Two years later, Dior launched the New Look: the nipped-in waist and full skirt silhouette which used up to twenty extravagant yards of fabric.

In the last year of the war, the fashion magazines moved from resignation to impatience with the government's austerity programme. Editors showed a burning sense of frustration. *Vogue* complained on behalf of the fashion industry, comparing the austerity designs in Britain with those of the American designers and the newly released Paris collection of autumn 1944. In an article headed 'Vogue's View on Austerity', it was argued that the dress restrictions introduced in 1942 to 'conserve scarce fabrics and even scarcer labour prohibits most kinds of dress ornamentation and restrict the use of details'.[36] American designers, on the other hand, were only restricted by an order to save on materials, for example, by specifying measurements such as the sweep of the skirt. In Paris there had been no restrictions but shortages had led to the use of ersatz materials. *Vogue*'s writer feared that if austerity restrictions continued to be applied

to British fashion designers, they would find themselves at a disadvantage in relation to their international competitors. She was also indignant that British designers were allowed more freedom in their designs for the export market: 'One has only to see a Collection designed for export, and the same Collection toned down to comply with austerity at home, to realise how much fashion value has been lost in the process.'[37] If this argument might seem to contradict the first point, she goes on, 'And it is not enough that clothes for *export* shall be free of restrictions (as they are already). For full success, a designer needs the stimulus of seeing his clothes in action: worn by smart women.'[38] The Board of Trade was urged to abolish austerity as quickly as possible and allow a return to full creativity in the fashion industry. But this was a vain hope. There was too much at stake on the home front as 4,653,000 servicemen and women were set to return home.

Despite the grim outlook at home, British fashion had been one of the great commercial success stories of the war. It was encouraged by the government to boost export sales and bring in much-needed currency, and although that imperative disappeared with the signing of the Lend-Lease agreement, the couture houses continued to show magnificent collections to great acclaim abroad, in South America, South Africa and the USA. Over the period 1938 to 1946, fashion export figures rose from £98,000 to £507,000.[39] The collections were reviewed in the fashion magazines with a combination of genuine pride and bitterness that unrestricted design was available to those abroad who could afford it. They reported on a stunning collection produced by Edward Molyneux for export to America in 1943, which included a glorious off-the-shoulder ball gown with a full skirt and a satin shoulder sash decorated with an enormous satin rose – 'a Phoenix-like miracle, springing from our dustsheeted London life'.[40] For the home market there was a slim, skirted dinner suit with a printed blouse top. Even the model wearing the outfit looks miserable. In 1946 an exhibition entitled 'Britain Can Make It' was mounted to prove to the public that design was at the heart of the struggle to rebuild Britain. The fashion houses played a key role in the exhibition but the fashion editors were not pleased, some picking up on the ironic adage: 'Britain can make it but Britain can't have it'.

With less fashion to concentrate the minds of her readership, Audrey Withers took the decision to include longer and more thought-provoking articles in *Vogue* by writers from other disciplines. American photographer Lee Miller had been photographing fashion shoots for the magazine since 1941, as well as writing illustrated articles on the women's services. For example, she spent a night out on an anti-aircraft battery and photographed a WAAF crew launching barrage balloons. In 1944 she was accredited to the US War Department and crossed the Channel about a month after D-Day, photographing everything from the emergency wards of field hospitals in Normandy to the joyous liberation of Paris. From then on, *Vogue* had a direct link to France and published Lee's articles and photographs monthly. Her images are some of the most famous from the Second World War and her writing is perceptive, immediate and deeply moving. From Paris, Lee went across the Rhine and sent back images to Audrey of the released concentration camp inmates at Buchenwald and Dachau, accompanied by a long article on the devastating effects of the Nazis' 'final solution'. Audrey decided to publish this in full, commenting later: 'It is always painful to cut good writing, but particularly in this case, for I felt that Lee's features gave *Vogue* a validity in wartime it would not otherwise have had. It was all very well encouraging ourselves with the conventional patter about keeping up morale, providing entertainment and so on, but magazines – unlike books – are essentially about the here and now. And this was wartime, Lee's photographs and reports taking the magazine right into the heart of the conflict.'[41] Lee was notoriously difficult to work with, but in Audrey she found something of a mother-figure and her often petulant letters were always answered with calm, reassuring responses by the older woman.

Audrey went to Paris in September 1945 and was fascinated to see what the French were wearing, particularly on their feet: 'In England we were wearing big overcoats with hoods, and flat-heeled shoes: the feeling behind them being that we could walk, if there was no transport, and wrap up in our coat somewhere if we couldn't get home. We wanted to be ready for anything asked of us. Paris was in a totally different situation. Occupied by the Germans, its people wanted to cock a snook at them, distancing themselves by being flagrantly unpractical and putting on the most

outrageous fashion show they could. So, with no transport but bicycles and a limited Metro service, they were wearing shoes with platform soles inches high, and towering hats.'[42]

In an article which posed the question 'where is fashion going?', Audrey invited three men from different parts of the world of couture to look into the future. James Laver, the fashion historian and critic, thought that it was likely to follow the path that it had taken after the French Revolution and the First World War: 'no corsets, an abnormal waist (very high in 1800; very low in the 1920s), straight lines, simple flimsy materials used very "skimpily", pale colours, short hair, and a hat, or head gear, fitting close to the head'.[43] He felt fairly certain that the low waist would not come to post-war fashion as 'the nineteen twenties are still near enough to us to be considered "hideous"'.[44] He was sure that the 'tight-waisted, extravagant, frilly and ultra-feminine' designs produced in Paris would not be of the slightest interest to the British fashion designers.

Another critic, C. Willett Cunnington, was not prepared to be as dogmatic as Laver. He warned the readers that the reaction to the end of this war would be different from previous wars because in this case women had participated and many of them had been in uniform themselves. He predicted bright colours and, regrettably, a lot of cheap material for some time to come, as good-quality material would still be hard to come by. However, it was Hardy Amies who correctly predicted the New Look, and seemed to think that Britain's fashion designers would create something similar, with small waists and full skirts. He wrote that the artist in him liked his women both full-bosomed and full-hipped: 'This is what my new woman will be. She will wear her tweeds, cut mannishly, to work; but she will wear her new clothes to play in, to relax, to be herself, to be a wife to the soldier home from the war, to be a mother to his sons. Her clothes will be rich and rather grand, but she won't be afraid to wear them; for she will feel confident that people will know that, like everyone else, she will have had to work hard to earn them.'[45]

By March 1945 a sense of something changing was emerging tentatively in London's fashion houses. The couturiers were reacting to increasingly positive news from the war on the Continent and designing new outfits for

the coming summer that would do away with the severe lines of uniform suits and emphasise the curves of the female form with nipped-in waist, fuller shoulders and other tricks. Still limited by austerity restrictions, it was not possible for designers to go the whole distance and produce full skirts, as they would like to have done, but it was at least a welcome move and there was a mood of excitement amongst the fashion editors.

But the enthusiasm was short-lived. As soon as the war came to an end, it was clear that things were not going to improve quickly, particularly in reference to clothing shortages. Journalists and the public alike became increasingly tetchy. In May 1945 *Vogue* called for better accessories, pointing out that 'no aspect of fashion has suffered more under restrictions and shortages.'[46] On a personal level, women who had put up with so much during the war were frustrated. The ever-inventive Eileen Gurney told John in September that her favourite dress had finally worn out after continual wearing and mending. A week later she sent a letter with a long list of all the things she needed for the children but which she was unable to obtain, the worst of all being shoes for the two of them. Although the war in Europe had been over for six months, there was little to cheer her up. Her husband was not to return to his family until March 1946.

With the end of the war came demobilisation. The task of coping with over 4.6 million demobilised servicemen and women had been placed in the capable hands of the great trade union leader and Minister of Labour and National Service, Ernest Bevin. The release scheme began on 18 June 1945, although a few older men had been demobbed in 1944. In addition to thinking about the returning servicemen and women 'the government began to consider a post-war future for its "bombed-out, worn-out, rationed-out people".'[47] One of the main concerns was the question of housing, which was dire (only about 12 per cent of newly married couples had homes of their own); there was also the question of what returning servicemen would wear. 'It was decided to provide each male member of the Services with an issue of clothing coupon-free and free of charge [its wholesale value was about £12, equivalent to £480 in 2014] and in addition with 90 clothing coupons. This was almost three times what his civilian counterpart was entitled to in 1945, but there seemed to be little griping

about unfairness in letters and diaries of the time. Demobilised women were given coupons and cash instead of the free outfit. This was generous in principle if women could find the clothes to buy.'[48]

In anticipation of demobilisation, the Board of Trade lifted austerity restrictions on men's outer clothes in February 1944. They realised that it would be unacceptable to offer servicemen civilian clothing in utility styles, so trouser turn-ups made a welcome return, though the hated restriction on the length of men's socks was not lifted until November 1945. Restrictions on women's clothing remained in place until the spring of 1946, much to the irritation of the fashion editors of women's magazines as well as the female half of the population.

The demob suits supplied to returning men over the course of 1945 and 1946 were of a better quality and weight of material than anything that had been available under the utility scheme. Mrs Milburn noted this in her diary and complained about stockings once again: 'Men's suits have been "austerity" suits for some time past – fewer pockets, no turn ups on trousers etc – but now they are to be as usual. This change has been made because a soldier coming back to civil life was to be allowed an "unrestricted" suit so now all men may return to normal. I wish they'd let us have stockings for one coupon instead of three.'[49]

The styles of demobilisation suits differed but some were double-breasted with six buttons, an unheard of luxury in wartime, others were three-piece. Soon after the war ended, the government introduced another label – 11011 – which designated higher quality fabric for returning soldiers, for evening wear and haute couture clothing for the export market. It earned the name 'posh utility' in some quarters and it was popular among those who could afford it, but it never gained the fame or notoriety of the double cheese CC41.

The tailoring trade obligingly switched rapidly from uniform production to demob suits. Once again the House of Burton, which had been so successful in winning military contracts and had made a quarter of all the uniforms for the forces during the war, turned its attention to a new need: by the end of 1946, it was believed that Burton had been responsible for the production of one third of all the demob suits. Burton also came

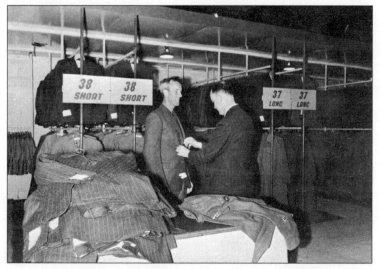

Demob suits were handed out in their millions. Many felt they
entered a sausage machine, going into a store wearing services
uniform, coming out wearing another form of uniform, the suit.

up with the concept of the 'Full Monty', an ensemble of a three-piece suit, shirt and tie. (The expression has also been attributed to the full English breakfast enjoyed by Field Marshal Montgomery, as well as to other, more modern, usages, but most people in the north of England attribute the saying to the suits of Sir Montague Burton.) Suits, trilby hats, overcoats, mackintoshes, shirts, ties and socks (short) were all available to the returning soldier.

Some were delighted with their demob suits. Captain Fred Appleby described his outfit in November 1945: 'I got a good suit – a Simpson (Code II is Simpsons). It is a Blue Saxony with a faint stripe. Double breasted and fits fine – Ron will be the same size as me and the local tailor tells me that this is a very good suit ... the shirt, tie, hat and socks are terrible. The mac excellent, shoes just officers shoes.'[50] Demob suits made some feel good about being home again. Both men and women were glad to

be out of uniform and able to express their own personalities once more. One returning soldier was delighted: 'Large lists of the civvy clothing to which we are "entitled". Shop windows with examples of the civvy garments which we can get; and good stuff too. A polite gentleman (in civvies), eager to measure us, to show us the goods, to hear our choice, to fit and please us in the old way. This raincoat or that? A suit – or sports coat and grey flannel trousers? What colour coat? ... we are back in the land of freedom – of choice.'[51]

The enthusiasm was not universal, however. Some men felt they had exchanged one uniform for another. 'You looked like bookends – everyone looked the same.'[52] And others were downright hostile about the whole get-up: 'I was given a brick-red overcoat, a brown suit, a grey cap, and army shirt with a collar that was mauve in colour and two-and-a-half sizes too big, one blue and silver tie, a pair of army socks and a pair of army boots. I had to travel in this hideous outfit from Durham to Glasgow and I don't think it was my crutches that drew so many looks of pity.'[53]

Joyce Lucas's husband Ted was in the 4th/7th Royal Dragoon Guards and she remembered being disappointed when, after the war, he had to hand back his army issue leather jerkin. It was very good quality and would have been a useful addition to his wardrobe. She was horrified by his demob suit which was dark blue tweed, 'not navy', she complained. 'The quality was adequate but the cut was generic and did not fit him well.'[54] Not all demob suits were as bad as the one Joyce complained about. Some were produced, at a price, by London tailors. Moss Bros of Covent Garden, for example, advertised their range of suits with a poster featuring a besuited man, complete with pork pie hat and umbrella, with the slogan 'Out of Battledress ... into Moss Bros'.

Once men were demobbed, there was a swift turn-around of uniforms into garments for everyday use. Just as men's suits had been commandeered by wives and daughters in the early 1940s, while their men were away at war, so their uniforms were reused in the immediate post-war period. Sailors' whites and kilts from the Scottish regiments made excellent skirts, with excess material used for shirt trimmings and ties. This was probably against service regulations but no one seemed to mind.

When Edna Roper's husband Stan returned from the Far East, she remembered being somewhat astonished: 'When Stan walked off the train in Cambridge in November 1945 I looked at him and said, "You do look well!" and he said to me "You are well dressed". Well, I wasn't. I was wearing a borrowed coat and my mother's hat. My skirt was at least six years old and I had turned it round so that the back was at my front and the sagging that had occurred after sitting down in the skirt was disguised under my cardigan. My underwear was patched but I had managed to get my hair done and Mother had lent me lipstick so I suppose on the face of it I looked quite presentable.'[55] Stan Roper had been a prisoner of the Japanese and for the first eighteen months of his captivity she had no idea whether he was alive or not. Coming home to Britain was a shock for him, as it was for other returning servicemen. What they had seen and endured would never really be understood by those who had been at home in Britain, just as those returning men would understand little about the Blitz and the war of attrition on the home front. Over the ensuing months and years, both returning soldiers and civilians had to re-acclimatise themselves, and for some it was simply too difficult and many relationships did not survive. As the repatriation of millions of men and thousands of women occurred over eighteen months, so Britain had to brace itself for years of austerity that were to follow the war. The fashion industry felt this sting in the tail very bitterly.

Conclusion

*Somehow I can't imagine it ever
reverting to pre-war times. The bowler-hatted,
striped-trousered office worker, the girls in high heels
and silk stockings and smashing hats; now it's crepe-soled shoes, thick
stockings and a scarf round the head.*

Florence Hyatt

While people in post-war Britain were constrained by continued rationing and austerity, Parisians were relishing their freedom. In February 1947, Christian Dior presented his first collection to the press in the salons of 30 Avenue Montaigne. The effect on the fashion press was electric. Here was something dramatically different from anything that had been seen either side of the Atlantic since the late 1930s. Femininity had been recaptured: tiny waists, full skirts and 'devilishly sexy busts'. The fashion editor of *Harper's Bazaar*, Carmel Snow, had long believed in Dior and now he had more than fulfilled her expectations. She exclaimed to him: 'It's quite a revolution, dear Christian! Your dresses have such a new look!'[1] Legend has it that a correspondent from Reuters heard the slogan uttered and wrote it down on a slip of paper which he threw to a

waiting courier below the balcony. It appeared in the USA that same day. The 'New Look' was born and the French press, on strike for a month, missed out on the coup.

Reaction to the style was mixed in Britain. Eric Newby, who had returned from a dramatic war in the Middle East, Italy and a German POW camp, was back working in the family firm of Worth Pasquin when the New Look hit the scene. He described the reaction of British designers: 'half throttled by clothes rationing and frightened by the storm of conflicting emotions which Dior's collection had released, most manufacturers played for safety and made for the Autumn what they had been making for the last seven years with a slightly longer skirt'.[2] Some reactions in the press were as sceptical as those of the designers. In *Picture Post*, the editor complained that Paris had forgotten it was 1947: 'The styles are launched upon a world which has not the material to copy them – and whose women have neither the money to buy, the leisure to enjoy, nor in some designs, even the strength to support these masses of elaborate material ... In this country they are simply an economic impossibility. Think of doing housework, or sitting at a typewriter all day, or working in a factory, tightly encumbered and constricted with layers of hip-padding and petticoats. Our mothers freed us from these in their struggle for emancipation, and in our own active workday lives, there can be no possible place for them.'[3]

But the following year the New Look had washed over Britain like a tidal wave and fashion trends were beginning to change at last. Eric Newby watched as it swept through Mayfair: 'By the spring of 1948 the London Couture Houses had all given up the long suit jacket. By April wholesale versions of the New Look were in all the shops.'[4] The previous autumn, Britain had revelled in the love story of the young Princess Elizabeth who had married her prince on a rainy day in November 1947. She had apparently saved up her clothing coupons in order to buy the silk for her wedding dress. Described by Norman Hartnell as the most beautiful dress he had made to date, the ivory silk, crystal and seed-pearl embroidered gown had a thirteen-foot-long star-patterned train. It captured the public imagination and represented a turning point in post-war Britain. There was now a sense of romance and daring which had been suppressed

by the long years of austerity. The New Look, with its glorious, luxurious folds of fabric, perfectly captured that drama. It was given another royal boost when Princess Margaret appeared in a New Look coat at her parents' silver wedding celebrations in April 1948. This coat had been altered for her by Norman Hartnell – not made from scratch, reminding one that this was still 'Austerity Britain' – but it seemed that at last fashion had turned its back on the war for good.

In spite of the perception of Britain as a grey, tired nation in the aftermath of the war, the periods of utility and austerity had been marked just as much by imagination and flair as deprivation – though it is true that the post-war era saw increased rationing and even more austerity. The return to normality (whatever that was) after such a destructive conflict took longer than anyone had anticipated. In looking back over the utility designs of the second half of the war, the designer Peter Russell, writing to Sir Thomas Barlow at the Board of Trade, came to the conclusion that rationing, austerity regulations and the utility scheme 'had created a vast improvement in the general dressing of the public by teaching them a discipline in dress and the appreciation of simplicity'.[5]

So what, if anything, is the legacy of clothes rationing and trends in fashion during the Second World War? Large-scale garment manufacturing developed during the latter half of the war for the utility scheme helped to accelerate the growth of mass market fashion and this in turn led to flourishing department stores that catered for almost all budgets. It sat well with the changing social attitudes towards equality and benefited society at large at all levels.

Certainly the blurring of class boundaries through war work, evacuation and life in the armed services, which affected almost every member of the population in one way or another, led to a more relaxed and informal style of dress. While this was already beginning to change at the end of the 1930s, it was greatly accelerated by the Second World War. Women in slacks and trousers, unheard of in 1939 – except perhaps in London, and even then it was still considered rather racy – were widely accepted by the end of the war.

The utility scheme operated from 1942 to 1949, and led to consumers

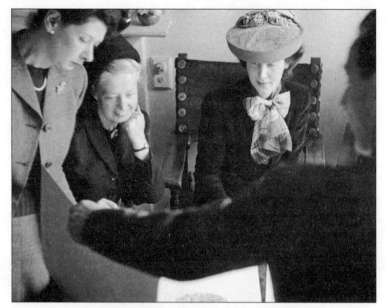

*Audrey Withers (second left) and Anne Scott-James
(centre) studying new designs in 1946.*

having the confidence to demand value for money. It also resulted in the
introduction of regulated standards in material and manufacture. Utility
clothes were produced on a huge scale, which meant greater efficiency in
production and less wastage of materials. As Audrey Withers observed,
fashion actually benefited from austerity in that unnecessary detail was
swept away and the elegant, simple lines espoused by the IncSoc designers
had a lasting impact on the history of British fashion. The utility scheme
was also unique in that high-end designers were involved for the first time
in producing styles for the mass market, a concept that is so familiar today
in our high street shops that we might forget that it originated in a time of
austerity over three quarters of a century ago. These few designers made a
huge contribution to the distinctive look of the period and continued to
influence fashion long after the war. Norman Hartnell's suits of the late

1960s, when he reintroduced the double-breasted jacket, are still in vogue today. Hardy Amies still exists as a fashion house designing couture for men and women: in 2014 they launched the Fitted Suit, characterising 'the modern London lifestyle that Hardy Amies has come to represent'.[6] Edward Molyneux, Digby Morton and Bianca Mosca are also names that are still recognised and well respected within the world of haute couture.

But what of the individual voices in this book who have brought to life the story of wartime clothing? Eileen Gurney had to wait for a full nine months after the war before her husband John returned from India. Flo Hyatt continued to work as a shorthand typist and eventually retired with the ambition to turn the letters she had written to her aunt and uncle into a book for the future. Sadly she died before she could see her work completed. May Smith shared a long and happy life with Fred and lived to see her grandchildren flourish. Bill Fagg returned to the British Museum in November 1945 and worked in the Department of Ethnography with special responsibility for Africa until he retired in 1974. He was also a long-standing member of the Royal Anthropological Institute, whose contin-ued existence he managed to secure during the war. For the last sixteen years of his life he worked as a consultant for Christie's auction house; he died in 1992, widely respected as a brilliant scholar of African art. Audrey Withers continued to edit *Vogue* until 1960. She was given an OBE in 1952 but nearly did not receive the award because – at that time – the royal family would not meet divorcées. Luckily, as she had worked under her maiden name, the Honours Secretary at Number 10 said the matter would be referred. 'I hope they never bothered the Queen with anything so triv-ial, but the official message was that she wished me to accept the honour.'[7]

For servicemen and women who were demobbed over the course of 1945–6 there was a feeling that Britain was not the country they had left to fight for years earlier. The letters and diaries from bewildered young soldiers reveal the extent of their disorientation on their return to civilian life. Lieutenant Frank Stewart walked through Hyde Park on 10 May 1945 and wrote afterwards: 'I remember how we were all surprised, and indeed shocked, by the blatancy of the couples on the benches and on the ground, as we thought back to pre-war days when holding hands in public was

considered rather daring. Also, we noticed how many women now wore trousers ...'[8]

The other great legacy of the war was Make-Do and Mend, which has had a revival in recent times. For women like Flo Hyatt and Eileen Gurney, this played a large part in their wartime lives: darning, mending and occasionally having the money, the coupons and the good luck to find something new to cheer up their tired wardrobes. In recent years, and in our own time of austerity, people have looked back to the concept of Make-Do and Mend and found much to be celebrated. Hand-knitting and sewing are now seeing a popular revival, giving outlets for creativity and invention, just as they did in the 1940s.

Although the war was undoubtedly a time of dreadful loss and suffering on the battlefronts and in the bombed-out cities, and of deprivation and rationing on the home front, there was also a great sense of joint determination to overcome difficulties against all odds. If fashion did stagnate during the war, creativity did not. And creativity is the spirit of fashion.

Acknowledgements

I have many thanks to offer those who have helped me in one way or another with this book. First to those people who kindly contributed stories, interviews, photographs, memories and leaflets, including many in response to an advertisement I placed in *Saga Magazine* in February 2014.

Thanks to Jeanette Acraman, Jean Ayscough, Penny Bevan, Angie Butler, Jill Cole, Lynne Copping, Roberta Cubitt, Eve Davies, Lorna Dorrington, Hilary Faust, Michael Faust, Catherine Fogg, Lindsay Foster, Barbara Hall, Marjorie Harley, Rita Harris, Derek Hill, Mary Hill, Geraldine Howell, Anita Hughes, Jean Hughes, Jenny Hunt, Janine Hyatt, Rosalind Jennings, Pat Jones, Wendy Jones, Hilary Kilby, Joy Knowles, Shelagh Lovett-Turner, Joyce Lucas, Joyce Meader, Honor Meakin, Jon Mills, Joy Mills, Stella Mitchell, Rachel Moore, Eileen Osborne, Deborah Palmer, Jill Pastre, Marion Platt, Penny Pugh, Angela Rackham, Jean Richards, Sheila Shear, Pat Slessenger, Ann Spokes Symonds, Gill Tanner, David Trepte, and Margaret Watkins.

Thanks are also due to the Department of Documents, Imperial War

Museum, Westminster City Library and The Keep and within Imperial War Museums to Terry Charman, Laura Clouting and Amanda Mason. To the team at Profile Books I should like to offer warm thanks and in particular to my editor, Cecily Gayford, as well as to Penny Daniel and Andrew Franklin, Hannah Ross and copy-editor Jane Robertson. My agent, Catherine Clarke, is a tower of strength and dispenses wise advice, as does Michele Topham. My research assistant, Stephen Rockcliffe, helped to unearth facts and figures as ever. A final and heartfelt thank you to my husband Chris and my family, who put up with me and my messy office.

Introduction

1. Stanley Baldwin's speech, 'The Bomber Will Always Get Through' House of Commons, 10 November 1932; at www.emersonkent.com.

2. Dorothy Sheridan (ed.), *Wartime Women. A Mass Observation Anthology 1937–45* (London: Phoenix Press, 2000), p. 1.

3. *Vogue*, December 1939.

4. Maggie Wood, *"We wore what we'd got". Women's Clothes in World War II* (Warwickshire Books, 1989), p. 5.

5. Wood, *"We wore what we'd got"*, p. 5.

6. Edmund Rolfe to Bill Fagg, 16 March 1942, Private Papers of W. B. Fagg, CMG, Imperial War Museum.

7. Eileen Gurney to John Gurney, 29 September 1939, Private papers of J. S. Gurney, Imperial War Museum.

8. Gladys Mason, 3 September 1939 (these are unpublished diaries in the collection of Barbara Hall, Gladys Mason's daughter).

9. Zelma Katin (with Louis Katin), *"Clippie", The Autobiography of a War Time Conductress* (Ipswich: Adam Gordon, 1995), p. 6

10. Audrey Withers, *Lifespan* (London: Peter Owen Publishers, 1994), p. 51.

1 A Slack Time

1. J. Mulvagh, *Vogue History of Twentieth Century Fashion* (London: Bloomsbury Publishing, 1992) p. 151.

2. Iris Jones Simantel, email to author,13 July 2014.

3. *Vogue*, August 1939, p. 33.

4. *Vogue*, August 1939.

5. Julie Summers, *Jambusters, The Story of the Women's Institute in the Second World War* (London: Simon &Schuster, 2013), p. 26.

6. Withers, *Lifespan*, p. 40.

7. Withers, *Lifespan* p. 40.

8. Colin McDowell, *Forties Fashion and the New Look* (London: Bloomsbury Publishing, 1997), p. 26.

9. McDowell, *Forties Fashion and the New Look*, p. 21.

10. Geraldine Howell, *Wartime Fashion from Haute Couture to Homemade 1939–1945* (London: Berg, 2012), p. 24.

11. May Smith, *These Wonderful Rumours! A Young Schoolteacher's Wartime Diaries 1939–1945* (London: Virago Press, 2012), entry for 6 April 1939.

12. Smith, *These Wonderful Rumours*, entry for 8 April 1939.

13. Smith, *These Wonderful Rumours*, entry for 8 April 1939.

14. The Diary of Muriel Green, 3 September 1939, quoted in Sheridan (ed.), *Wartime Women*.

15. Constance Miles, S. V. Partington (ed.), *Mrs Miles's Diary. The Wartime Journal of a Housewife on the Home* Front (London: Simon & Schuster in association with Imperial War Museums, 2013), entry for 3 September 1939.

16. M-AO TC18/2/A interview with Jean Smith, Secretary of the Fashion Group, 29 November 1939 p. 1.

17. *Picture Post*, 25 November 1939.

18. *Vogue*, 20 September 1939 p. 8.

19. *Vogue*, 20 September 1939 p. 8.

20. *Vogue*, 20 September 1939.

21. The ban was lifted in non-vulnerable areas on 9 September and in vulnerable areas such as London on 23 September 1939.

22. 'Here and Now', *Vogue*, 20 September 1939, p. 44.

23. Constance Miles, in Partington (ed.), *Mrs Miles's Diary*, entry for 11 September 1939.

24. E. L. Hargreaves and M. M. Gowing, *History of the Second World War: Civil Industry and Trade* (London: HMSO and Longmans, Green and Co., 1952), p. 78.

25. Withers, *Lifespan*, p. 39.
26. Withers, *Lifespan*, p. 40.
27. Withers, *Lifespan*, p. 42.
28. Withers, *Lifespan*, pp. 48–9.
29. Withers, *Lifespan*, p. 50.
30. Withers, *Lifespan*, p. 50.
31. Withers, *Lifespan*, p. 55.
32. *Woman's Own*, 30 September 1939.
33. *Woman and Beauty*, September 1939.
34. *Mother and Home*, November 1939.
35. *Vogue*, November 1939, p. 20.
36. *Vogue,* November 1939, p. 19.
37. *Vogue*, 17 April 1939.
38. Howell, *Wartime Fashion*, p. 27, quoting from 'The Cases for Slacks', *Vogue* (n.d.), pp. 57–8.
39. *Vogue*, November 1939, pp. 20–21.
40. *Vogue*, November 1939, pp. 20–21.
41. Constance Miles, in Partington (ed.), *Mrs Miles's Diary*, entry for 21 September 1939.
42. Constance Miles, in Partington (ed.), *Mrs Miles's Diary*, entry for 14 September 1939.
43. Fortnum & Mason advertisement in *Vogue*, November 1939.
44. *Vogue* pattern book, autumn 1939.
45. *Vogue* pattern book, autumn 1939.
46. McDowell, *Forties Fashion and the New Look*, p. 30.
47. A one-piece undergarment combining a camisole top and knickers.
48. John Gurney to Eileen Gurney, 28 September 1939, Private Papers of J. S. Gurney, Imperial War Museum.
49. Eileen Gurney to John Gurney, 29 September 1939.
50. Eileen Gurney to John Gurney, October 1939.
51. Eileen Gurney to John Gurney, 30 November 1940.
52. Eileen Gurney to John Gurney, 17 March 1942.
53. Eileen Gurney to John Gurney, 17 March 1942.
54. Gladys Mason's diary, 4 September 1939.
55. Gladys Mason's diary, 6 September 1939.
56. Gladys Mason's diary, 25 September 1939.
57. Gladys Mason's diary, 6 October 1939.

58. Gladys Mason's diary, 7 October 1939.

59. Figures published by the Ministry of Health/Board of Education in 1942.
 PROVINCES 757,583 schoolchildren and 445,580 with mothers
 LONDON 736,652 schoolchildren and 275, 895 with mothers

60. Oliver Lyttelton, *The Memoirs of Lord Chandos* (London: The Bodley Head, 1962), p. 152.

61. Women's Institute, 'Town Children Through Country Eyes: A Survey on Evacuation', January 1940.

62. Angus Calder, *The People's War: Britain 1939–1945* (London: Pimlico, 1992), p. 44.

2 A Uniform Solution

1. Smith, *These Wonderful Rumours*, entry for 28 November 1939.

2. Vere Hodgson, *Few Eggs and No Oranges: Vere Hodgson's Diary 1940–45* (London: Dobson Books, 1976), entry for 18 April 1943.

3. Quote from website of National Maritime Museum, *Rank & Style*.

4. It was first called Marine Blue but changed to Navy Blue within a few years.

5. Ian Sumner, *The Royal Navy 1939–1945* (Oxford: Osprey Publishing, 2001), p. 47.

6. Martin Brayley, *The British Army 1939–45 (1)North-West Europe* (Oxford: Osprey Publishing, 2001), p. 33

7. Brayley, *The British Army 1939–45*, p. 39.

8. See website: www2peopleswar/stories/77/a3331577.

9. Mass Observation Survey, 1941.

10. MO no. 887, *Civilian Attitudes to the Navy compared with Army and RAF*, 30 September 1941.

11. Andrew Cormack, *The Royal Air Force 1939–45* (Oxford: Osprey Publishing, 1990), p. 6.

12. Cormack, *The Royal Air Force 1939–45*, p. 23.

13. Hargreaves and Gowing, *History of the Second World War: Civil Industry and Trade*, p. 641, table II.

14. Board of Trade figures: for the home market 42 per cent cotton spinning and weaving; 44 per cent wool and worsted; 30 per cent silk and rayon.

15. Brayley, *The British Army 1939–45*, p. 36.

16. *Picture Post*, 11 January 1941.

17. See website: www2peopleswar/stories/32/a2057032.

18. Letter from E. Hastings-Ord to *Home & Country* magazine, the Journal of the Women's Institutes, February 1940.

19. Howell, *Wartime Fashion*, p. 124, from Imperial War Museum, Ephemera, Box C, Fashion.

20. Letter from Margaret Watts, Hon. Secretary, Merchant Navy Comforts' Service, quoted in *Home & Country* magazine, February 1940.

21. McDowell, *Forties Fashion and the New Look*, p. 57.

22. '(D)' stands for dentist.

23. Penny Bevan in conversation with the author, 5 July 2014.

24. Barbara Pym, in Hazel Holt and Hilary Pym (eds), *A Very Private Eye. The Diaries, Letters and Notebooks of Barbara Pym* (London: Macmillan, 1984), diary entry for 20 July 1943.

25. Hilary Wayne, in Jenny Hartley (ed.), *Hearts Undefeated. Women's Writing of the Second World War* (London: Virago Press, 1994), pp. 112–13.

26. Hilary Wayne in Hartley (ed.), *Hearts Undefeated*, pp. 112–13.

27. McDowell, *Forties Fashion and the New Look*, p. 56.

28. McDowell, *Forties Fashion and the New Look*, pp. 57–8.

29. Barbara Cartland, *The Years of Opportunity* (London: Hutchinson, 1948), p. 163.

30. McDowell, *Forties Fashion and the New Look*, p. 39.

31. Katin, *"Clippie", The Autobiography of a War Time Conductress*, p. 28.

32. Katin, *"Clippie"*, p. 5.

33. Katin, *"Clippie"*, p. 8.

34. Katin, *"Clippie"*, pp. 14–15.

35. Katin, *"Clippie"*, p. 66.

36. Katin, *"Clippie"*, p. 10.

37. Katin, *"Clippie"*, p. 18.

38. Katin, *"Clippie"*, p. 22.

39. Katin, *"Clippie"*, p. 22.

40. Katin, *"Clippie"*, p. 22.

41. Katin, *"Clippie"*, p. 89.

42. Katin, *"Clippie"*, pp. 102–3.

43. Katin, *"Clippie"*, p. 103.

44. Anthony Eden, speech on BBC Home Service Radio, 14 May 1940.

45. Calder, *The People's War*, p. 125.

46. Miss Florence Hyatt, letter to her aunt and uncle, 4 November 1941.

47. Calder, *The People's War*, p. 195.
48. Miss Florence Hyatt, unpublished MS, p. 173.
49. *Oxford Dictionary of National Biography* (Oxford University Press, 2004), entry for Stella Reading.
50. Beatrice Carr quote from Imperial War Museum document IWM 87/5/1 Beatrice Muriel Richards (née Carr), p. 2.
51. IWM 87/5/1 Beatrice Muriel Richards (née Carr), p. 2.
52. IWM 87/5/1 Beatrice Muriel Richards (née Carr), p. 2.
53. Melissa Hardie (ed.), *Digging for Memories, The Women's Land Army in Cornwall* (Penzance: Hypatia Publications, 2006), p. 2.
54. *The Land Girl*, April 1940.
55. Hardie (ed.), *Digging for Memories*, p. 49.
56. Jane Waller and Michael Vaughan-Rees, *Women in Wartime. The Role of Women's Magazines 1939–1945* (London: Macdonald Optima, 1987), p. 86.
57. *Woman's Own*, May 1940.

3 Functional Fashion

1. *Vogue*, January 1940.
2. *Vogue*, January 1940.
3. Sheridan(ed.), *Wartime Women*, p. 2.
4. Hargreaves and Gowing, *History of the Second World War: Civil Industry and Trade*, p. 100.
5. *Vogue*, January 1940.
6. Peter Donnelly (ed.), *Mrs Milburn's Diaries. An Englishwoman's day-to-day reflections 1939–45* (London: Harrap, 1979), entry for 9 September 1940.
7. Richard Broad and Suzie Fleming (eds), *Nella Last's War. The Second World War Diaries of Housewife, 49* (London: Profile Books, 2006), entry for 12 September 1940.
8. Joyce Lucas in conversation with the author, 12 March 2014.
9. *Vogue*, January 1940.
10. Sue Bruley (ed.), *Working for Victory. A Diary of Life in a Second World War Factory* (Stroud: Alan Sutton Publishing, 2001), Kathleen Church-Bliss diary, 30 July 1943.
11. This compares with 1,754 in 2012 when the number of total miles travelled was 492 billion miles, as opposed to 74 billion miles in 1938. There are no figures for miles motored in 1941 but it would have been lower than 1938.
12. Jan Struther, 'Mrs Miniver's Peace in War', *The Times*, 5 October 1939.

13. Calder, *The People's War*, pp. 116–17.

14. Gladys Mason's diary, 7 September 1940.

15. Gladys Mason's diary, 7 December 1940.

16. Gladys Mason's diary, 1 January 1941.

17. Gladys Mason's diary, 14 January 1941.

18. Hargreaves and Gowing, *History of the Second World War: Civil Industry and Trade*, p. 106.

19. Hargreaves and Gowing, *History of the Second World War: Civil Industry and Trade*, p. 16.

20. Mass Observation, Tom Harrison and Charles Madge (eds), *War Begins at Home* (London: Chatto & Windus, 940), p. 360.

21. Hargreaves and Gowing, *History of the Second World War: Civil Industry and Trade*, p. 111.

22. The Neutrality Act of 1935 imposed an embargo on trading in arms and war materials with all powers during a war; in 1935 the Act was extended and forbade credit or loans to belligerents; in 1937 it outlawed the trade in arms with Spain and specified that the Act had no expiration date; in 1939 Roosevelt lobbied Congress to allow arms trade with Britain and France on a cash-and-carry basis, thus ending the arms embargo, though only the government was allowed to deal in arms. Private dealing was heavily fined.

23. President Roosevelt at press conference on 17 December 1940.

24. Phyllis Walther, in Patricia Malcolmson and Robert Malcolmson (eds), *Dorset in Wartime. The Diary of Phyllis Walther 1941–1942* (Dorchester: Dorset Record Society, 2009), entry for 29 May 1941.

25. Eileen Gurney, letter to John Gurney, 13 January 1941, Private Papers of J. S. Gurney, Imperial War Museum.

26. Anne Scott-James was a journalist and author. In the 1930s she worked for *Vogue* and became the Women's Editor at *Picture Post* between 1941 and 1945.

27. *Picture Post*, 1 November 1941.

28. *Picture Post*, 1 November 1941.

29. Broad and Fleming (eds), *Nella Last's War*, diary entry for 8 October 1939.

30. *Vogue*, 20 December 1939.

31. Ann Spokes Symonds, *The Changing Face of North Oxford, Part 1* (Witney: Robert Boyd Publications, 1998), p. 74.

32. Spokes Symonds, *The Changing Face of North Oxford, Part 1*, p. 74.

33. Phyllis Warner's diary, 22 July 1941.

34. *Vogue*, October 1940.

35. Phyllis Warner published in the *Washington Post*, 6 October 1940.
36. Phyllis Warner, *Washington Post*, 27 October 1940.
37. Virginia Nicholson, *Millions Like Us: Women's Lives During the Second World War* (London: Penguin, 2012), pp. 30–31.
38. J. B. Priestley, *Postscripts* (Heinemann, 1940), transcript of broadcast aired on 22 September 1940, p. 78.

4 Coupon Culture

1. The Carlton Hotel for Persons Registered under the Limitation of Supplies Orders; Granville Court Hotel for Unregistered Makers-Up; and Pine Court Hotel for Retailers.
2. Smith, *These Wonderful Rumours*, entry for 30 January 1942.
3. Howell, *Wartime Fashion*, p. 93.
4. Lyttelton, *The Memoirs of Lord Chandos*, p. 205.
5. Memorandum from the President of the Board of Trade to the War Cabinet (undated).
6. Lyttelton, *The Memoirs of Lord Chandos*, p. 205.
7. Norman Longmate, *How We Lived Then. A History of Everyday Life During the Second World War* (London: Pimlico, 2002), p. 246.
8. Phyllis Warner's diary, 1 June 1941.
9. Oliver Lyttelton, BBC Home Service Radio Broadcast, 1 June 1941.
10. Longmate, *How We Lived Then*, p. 175.
11. Quoted in Mike Brown and Carol Harris, *The Wartime House. Home Life in Wartime Britain 1939–1945* (Stroud: The History Press, 2005).
12. Howell, *Wartime Fashion*, p. 93.
13. Donnelly (ed.), *Mrs Milburn's Diaries*, entry for 1 June 1941.
14. Molly Rich's diary, 1 June 1941, in collection of the Imperial War Museum.
15. Eileen Gurney to John Gurney, 6 June 1941, Private Papers of J. S. Gurney, Imperial War Museum.
16. Eileen Gurney to John Gurney, 6 June 1941.
17. Hartley (ed.), *Hearts Undefeated*, pp. 190–91.
18. McDowell, *Forties Fashion and the New Look*, p. 82.
19. Miss Florence Hyatt, unpublished MS, in Private Papers of Miss F. Hyatt, Imperial War Museum, p. 127.
20. Private Papers of Miss F. Hyatt, IWM, letter, p. 274.
21. Howell, *Wartime Fashion*, p. 95.
22. Private Papers of Miss F. Hyatt, IWM, letter from Florence Hyatt, 21 July 1943.

23. Hugh Dalton became President of the Board of Trade 22 February 1942, a position he held until 23 May 1945.
24. *Can I Help You?* BBC Home Service, 10 March 1942.
25. Hugh Dalton's motto claimed in Lyttelton, *The Memoirs of Lord Chandos*, pp. 206–7.
26. Phyllis Warner's diary, 31 July 1941.
27. *Can I Help You?* BBC Home Service, 10 March 1942.
28. Bill Fagg to the British Museum, October 1945, Private Papers of W. B. Fagg, CMG, Imperial War Museum.
29. Myers Lubran to Bill Fagg, 13 January 1943, Private Collection.
30. Note from Bill Fagg, 9 June 1941, Private Collection.
31. Board of Trade press notice, 28 October 1941, B111, Private Papers of W. B. Fagg, CMG, Imperial War Museum.
32. *Vogue*, September 1943.
33. Donnelly (ed.), *Mrs Milburn's Diaries*, entry for 7 October 1942.
34. Eileen Gurney to John Gurney, 19 December 1941.
35. ADO [Area District Officer] Report, week ending 26 November 1942, Private Papers of W. B. Fagg, CMG, Imperial War Museum.
36. Summary of ADO Report Section 1. Textiles and Footwear. Persistent Clothing Shortages week ending 18 July 1943.
37. Board of Trade press notice, B.119, issued 2 November 1941, Private Papers of W. B. Fagg, CMG, Imperial War Museum.
38. Iris Jones Simantel in conversation with the author, September 2013.
39. Longmate, *How We Lived Then*, p. 256.
40. Longmate, *How We Lived Then*, p. 259.
41. Letter from Florence Hyatt, 10 May 1943, Private Papers of Miss F. Hyatt, IWM.
42. Muriel Redman's diary, 27 November 1942, Private Papers of Miss M. Redman, MBE, Imperial War Museum, IWM 08/33/1.
43. Hargreaves and Gowing, *History of the Second World War: Civil Industry and Trade*, p. 328.
44. Hargreaves and Gowing, *History of the Second World War: Civil Industry and Trade*, p. 328.
45. Board of Trade, *Clothing Coupon Quiz* (London, 1941), Private Papers of W. B. Fagg, CMG, Imperial War Museum.
46. Wood, *"We wore what we'd got"*, p. 8.
47. Wood, *"We wore what we'd got"*, p. 8.

48. Howell, *Wartime Fashion*, p. 134.

49. Howell, *Wartime Fashion*, p. 135.

50. Rose Cottrell to Pat Cottrell, 3 April 1945, Papers of Miss Rose G. Cottrell, Imperial War Museum.

5 CC41

1. The total number of British servicemen captured in South East Asia and the Far East was 50,016. In addition there were 25,600 Americans, 22,376 Australians, 1,684 Canadians and over 60,000 British Empire Troops (Indian). The number of civilian internees in the area was 130,895. Source: Karl Hack and Kevin Blackburn (eds) *Forgotten Captives in Japanese-Occupied Asia* (London, Routledge, 2008).

2. *Drapers' Record*, 15 November 1941, p. 13.

3. Anne Seymour, quoted in Mass Observation report on Utility, dated 9 March 1942.

4. *Drapers' Record*, 14 March 1942, p. 37.

5. Hargreaves and Gowing, *History of the Second World War: Civil Industry and Trade*, p. 441.

6. R. Lacey, article on 'Cotton's War Effort', quoted in Hargreaves and Gowing, *History of the Second World War: Civil Industry and Trade*, p. 443.

7. *Picture Post*, 28 March 1942, p. 18.

8. *Picture Post*, 28 March 1942, p. 18.

9. Howell, *Wartime Fashion*, p. 168.

10. Norman Hartnell, *Silver and Gold* (London: Evans Brothers, 1955), p. 103.

11. *Oxford Dictionary of National Biography*, entry on Hartnell by Edward Rayne.

12. McDowell, *Forties Fashion and the New Look*, p. 9.

13. McDowell, *Forties Fashion and the New Look*, p. 11.

14. McDowell, *Forties Fashion and the New Look*, p. 11.

15. *Picture Post*, March 1942.

16. *Vogue*, July 1942, p. 29.

17. Withers, p. 51.

18. *Homes and Gardens*, September 1942.

19. *The Times*, 4 February 1942.

20. McDowell, *Forties Fashion and the New Look*, p. 88.

21. *Vogue*, October 1942.

22. Howell, *Wartime Fashion*, p. 173.

23. Katin, *"Clippie"*, p. 40.

24. Rose Cottrell to Pat Cottrell, 8 December 1941, Papers of Miss Rose G. Cottrell, Imperial War Museum.

25. Flo Hyatt to her aunt, 15 September 1943, Private Papers of Miss F. Hyatt, Imperial War Museum.

26. Hansard, HC Deb, 22 April 1943, vol. 388, cc.1842–3W.

27. Hargreaves and Gowing, *History of the Second World War: Civil Industry and Trade*, p. 438.

28. PRO, BT 64/305, 11 March 1943.

29. PRO, BT 64/305, 11 March 1943.

30. Hargreaves and Gowing, *History of the Second World War: Civil Industry and Trade*, p. 437.

31. *Vogue*, July 1942, p. 33.

32. Flo Hyatt to her aunt, 20 March 1942, Private Papers of Miss F. Hyatt, Imperial War Museum.

33. Hargreaves and Gowing, *History of the Second World War: Civil Industry and Trade*, p. 437.

34. Hargreaves and Gowing, *History of the Second World War: Civil Industry and Trade*, p. 437.

35. *Drapers' Record*, 18 April 1942, p. 14.

36. Kamella advertisement, 1943.

37. Winifred Holmes, transcript of radio broadcast, in the Private Papers of Mr and Mrs H. Khuner, Imperial War Museum, IWM 96/1/1, p. 1.

38. Winifred Holmes, transcript of radio broadcast, in the Private Papers of Mr and Mrs H. Khuner, p. 2.

39. Jacqmar was a London fashion house, set up in 1932 by Joseph 'Jack' Lyons and his wife Mary. It was common in those days to give French-sounding names, a nod to the fact that Paris dominated fashion during the inter-war years. House of Lachasse had similarly opted for a French name.

40. BS 41/45, *Clothing Quiz*, 'Forward from the President of the Board of Trade', 1944–5.

41. Hugh Cudlipp, *Publish and be Damned! The Astonishing Story of the Daily Mirror* (London: Andrew Dakers, 1953), pp. 148–53, quoted in Calder, *The People's War*, p. 280.

6 Supporting Britain's Women

1. Rosemary Hawthorne, *Knickers: An Intimate Appraisal* (London: Souvenir Press, 1985), p. 9.

2.	See www.fashion-era.com, 1914–1920.

3.	See www.fashion-era.com, 1914–1920.

4.	Hawthorne, *Knickers: An Intimate Appraisal*, pp. 93–4.

5.	Rosemary Hawthorne, *Bras: A Private View* (London: Souvenir Press, 1992), p. 22.

6.	Hawthorne, *Bras: A Private View*, p. 36.

7.	Eileen Gurney to John Gurney, 10 January 1941, Private papers of J. S. Gurney, Imperial War Museum.

8.	Hawthorne, *Bras: A Private View*, p. 36.

9.	Board of Trade Limitation of Supplies (Cloth and Apparel) Order, 1941.

10.	Smith, *These Wonderful Rumours*, entry for 4 September 1943.

11.	Flo Hyatt to her aunt, 5 August 1942, Private Papers of Miss F. Hyatt, Imperial War Museum.

12.	'Wartime Corsets', *Picture Post*, 2 March 1940.

13.	'Wartime Corsets', p. 24.

14.	'Wartime Corsets', p. 24.

15.	'Wartime Corsets', p. 26.

16.	'Wartime Corsets', p. 26.

17.	'Wartime Corsets', p. 26.

18.	Hargreaves and Gowing, *History of the Second World War: Civil Industry and Trade*, p. 466.

19.	Margaret Watkins in conversation with the author, November 2013.

20.	Flo Hyatt to her aunt, 14 September 1941, Private Papers of Miss F. Hyatt, Imperial War Museum.

21.	Letter from an angry housewife in *Time* magazine, 7 August 1944.

22.	Private Papers of W. B. Fagg, CMG, Imperial War Museum.

23.	Summary of ADO Report, Section 1. Textiles and Footwear. Persistent Clothing Shortages, week ending 18 July 1943.

24.	'New Corsets for Old', reproduced in Wood, *"We wore what we'd got"*, p. 9.

25.	Spirella advertisement, *Vogue*, March 1943.

26.	*Vogue*, August 1943, p. 24.

27.	*Vogue*, August 1943, p. 24.

28.	*Home Companion*, April 1943.

29.	Shelagh Lovett-Turner, interview with the author, 14 August 2014.

30.	*Vogue*, November 1944.

31.	Flo Hyatt to her aunt, 2 June 1943, Private Papers of Miss F. Hyatt, Imperial War Museum.

32. *Vogue* (undated, Westminster City Council archive).
33. *Vogue* (undated, Westminster City Council archive).
34. Advert reproduced in *Vogue*, July 1940.
35. McDowell, *Forties Fashion*, p. 77.
36. McDowell, *Forties Fashion*, p. 77.

7 *Make-Do and Mend*

1. *Vogue*, January 1942, p. 31.
2. PRO, BT64/871, twelfth meeting, Publicity Committee, agenda item 5, 9 July 1941.
3. Hugh Dalton, letter to WI, WVS et al., 16 September 1942.
4. Smith, *These Wonderful Rumours*, entry for 25 June 1943.
5. McDowell, *Forties Fashion and the New Look*, p. 88.
6. Wood, *"We wore what we'd got"*, p. 28.
7. *Vogue*, April 1943.
8. Wood, *"We wore what we'd got"*, p. 18.
9. *Vogue,* April 1943, p. 36.
10. *Vogue*, April 1943, p. 36.
11. *Vogue*, April 1943, p. 36.
12. Muriel Redman's diary, 11 April 1942, Private Papers of Miss M. Redman, MBE, Imperial War Museum.
13. Muriel Redman's diary, 1 May 1942, Private Papers of Miss M. Redman, MBE, Imperial War Museum.
14. Florence Hyatt to her aunt, 22 March 1943, Private Papers of Miss F. Hyatt, Imperial War Museum.
15. Florence Hyatt to her aunt, 3 February 1943, Private Papers of Miss F. Hyatt, Imperial War Museum.
16. *Vogue*, August 1943, p. 64.
17. Florence Hyatt to her aunt, 8 October 1942, Private Papers of Miss F. Hyatt, Imperial War Museum.
18. Make Do and Mend booklet prepared for the Board of Trade by the Ministry of Information, 1943, p. 1.
19. Make Do and Mend booklet prepared for the Board of Trade by the Ministry of Information, 1943, p. 2.
20. *Picture Post*, 16 August 1941.
21. *Picture Post*, 30 August 1941.
22. *Picture Post*, 30 August 1941.

23. Wood, *"We wore what we'd got"*, p. 24.

24. Wood, *"We wore what we'd got"*, p. 24.

25. Wood, *"We wore what we'd got"*, p. 24.

26. *Home & Country*, October 1941.

27. Longmate, *How We Lived Then*, p. 251.

28. Longmate, *How We Lived Then*, p. 251.

29. Smith, *These Wonderful Rumours*, entry for 30 October 1941.

30. Joan Harriss to Amanda Mason, 4 January 2014, Imperial War Museum.

31. Wood, *"We wore what we'd got"*, p. 25.

32. Wood, *"We wore what we'd got"*, p. 25.

33. Sally Odd, interview with author, September 2013.

34. Make Do and Mend booklet prepared for the Board of Trade by the Ministry of Information, 1943, p. 56.

35. Calder, *The People's War*, p. 279.

36. Smith, *These Wonderful Rumours*, entry for 7 November 1942.

37. Smith, *These Wonderful Rumours*, entry for 8 November 1942.

38. Smith, *These Wonderful Rumours*, entry for 8 November 1942.

39. Wood, *"We wore what we'd got"*, p. 11.

40. *Drapers' Record*, June 1941, p. 6.

41. *Daily Herald*, 23 October 1941.

42. Sheila Shear, interview with the author, November 2013.

43. Make Do and Mend booklet prepared for the Board of Trade by the Ministry of Information, 1943, p. 11.

44. Wood, *"We wore what we'd got"*, p. 14.

45. Wood, *"We wore what we'd got"*, p. 15.

46. Eileen Gurney to John Gurney, 8 December 1941, Private Papers of J. S. Gurney, Imperial War Museum.

47. Flo Hyatt to her aunt, 8 November 1943, Private Papers of Miss F. Hyatt, Imperial War Museum.

48. Longmate, *How We Lived Then*, p. 162.

49. Smith, *These Wonderful Rumours*, 18 August 1944.

50. Cartland, *The Years of Opportunity*, p. 163.

51. Cartland, *The Years of Opportunity*, pp. 163–4.

52. Cartland, *The Years of Opportunity*, p. 164.

53. Cartland, *The Years of Opportunity*, p. 164.

54. Cartland, *The Years of Opportunity*, p. 165.

55. Joyce Lucas in conversation with the author, 12 March 2014.

56. Donnelly (ed.), *Mrs Milburn's Diaries*, entry for 22 December 1941.

57. Iris Jones Simantel, email to the author, 13 July 2014.

58. Iris Jones Simantel, email to the author, 13 July 2014.

59. *Picture Post*, 19 April 1941.

60. Longmate, *How We Lived Then*, p. 254.

61. *The Lady*, April 1943.

62. Wood, *"We wore what we'd got"*, p. 19.

63. Mass Observation survey, M-OA TC 18/4/F, 3 March 1942.

64. Donnelly (ed.), *Mrs Milburn's Diaries*, entry for 28 November 1944.

65. Quoted in David Kynaston, *Austerity Britain* (London: Bloomsbury, 2008), p. 297.

66. *Vogue*, August 1943.

67. Sylvia Townsend Warner in Hartley (ed.), *Hearts Undefeated*, p. 196.

68. Winifred Musson to her sister Alix, January 1942.

69. Winifred Musson to her sister Alix, January 1942.

70. Longmate, *How We Lived Then*, p. 254.

71. Wood, *"We wore what we'd got"*, p. 8.

72. Wood, *"We wore what we'd got"*, p. 9.

73. *Vogue*, September 1942.

74. Letter from Molly Rich, 11 February 1942, in *A Vicarage in the Blitz. The Wartime Letters of Molly Rich 1940–1944, with Illustrations by Anthea Craigmyle* (Kent: Balloon View Ltd, 2013).

75. IWM Documents 15634, Miscellaneous 3705, Gwlad and Tom (surname unknown), Wales

8 Beauty as Duty

1. *Picture Post*, June 1943, pp. 24–5.

2. Eileen Gurney to John Gurney, 2 March 1945, Private Papers of J. S. Gurney, Imperial War Museum.

3. *Vogue*, November 1943, p. 28.

4. *Vogue*, December 1943.

5. Muriel Redman's diary, 28 August 1941, Private Papers of Miss M. Redman, MBE, Imperial War Museum.

6. Muriel Redman's diary,1 April 1942, Private Papers of Miss M. Redman, MBE, Imperial War Museum.

7. *Woman's Journal*, December 1939, quoted in Waller and Vaughan-Rees, *Women in Wartime*, p. 80.

8. *Woman's Own*, June 1941.
9. Smith, *These Wonderful Rumours*, entry for 4 May 1940.
10. *Vogue*, April 1940.
11. GALA advert, in *Vogue*, September 1942.
12. Peggy Sage advert, in *Vogue*, January 1946.
13. Chanel advert, in *Vogue*, March 1945.
14. Rose Cottrell to Pat Cottrell, 5 December 1941, Private Papers of Miss Rose G. Cottrell, Imperial War Museum.
15. Joyce Lucas in conversation with the author,12 March 2014.
16. Smith, *These Wonderful Rumours*, entry for 2 April 1943.
17. *Vogue*, August 1943, p. 23.
18. Smith, *These Wonderful Rumours*, entry for 3 February 1939.
19. Smith, *These Wonderful Rumours*, entry for 14 November 1941.
20. Pathé News clip, 'Veronica Lake Hairstyles for War Jobs', US News Review, Issue No. 5, 1942.
21. Bruley (ed.), *Working for Victory. A Diary of Life in a Second World War Factory*, Kathleen Church-Bliss diary, 5 November 1942.
22. Withers, *Lifespan*, p. 51.
23. *Vogue*, February 1942.
24. Gala lipstick advert, *Vogue*, September 1942.
25. Atkinson's Skin Deep Beauty Cream advert, *Vogue*, January 1946.
26. Elizabeth Arden advert, *Vogue*, May 1942.
27. Cyclax advert, *Vogue*, May 1945.
28. Alexandra B. Huff and Frederic A. Sharf, *Beauty as Duty: Textiles and the Home Front in WWII Britain* (Museum of Fine Arts, Boston, 2011), p. 17.
29. Muriel Redman's diary, 6 October 1942, Private Papers of Miss M. Redman, MBE, Imperial War Museum.
30. Huff and Sharf, *Beauty as Duty*, p. 14.
31. Huff and Sharf, *Beauty as Duty*, p. 14.
32. *Vogue*, July 1942.
33. *Vogue*, August 1942.
34. *Vogue*, February 1944.
35. *Vogue*, February 1945.
36. *Vogue*, November 1944.
37. *Vogue*, November 1944.
38. *Vogue*, November 1944.

39. £98,000 (equivalent to £5.3 million in 2014), £507,000 (equivalent to £17.34 million in 2014).

40. *Vogue*, March 1943.

41. Withers, *Lifespan*, p. 53.

42. Withers, *Lifespan*, p. 63.

43. *Vogue*, September 1943, p. 31.

44. *Vogue*, September 1943, p. 31.

45. *Vogue*, September 1943, p. 86.

46. *Vogue*, May 1945.

47. Julie Summers, *Stranger in the House* (London: Simon & Schuster, 2008), pp. 7–8.

48. Hargreaves and Gowing, *History of the Second World War: Civil Industry and Trade*, p. 324.

49. Donnelly (ed.), *Mrs Milburn's Diaries*, entry for 27 January 1944.

50. Captain Fred Appleby in a letter, November 1945, Imperial War Museum.

51. Quoted in Alan Allport, *Demobbed: Coming Home After World War Two* (Yale University Press, 2009), p. 123.

52. Tom Hellawell, quoted in Allport, *Demobbed*, p. 119.

53. Hellawell, quoted in Allport, *Demobbed*, p. 119.

54. Joyce Lucas, in conversation with the author, March 2014.

55. Summers, *Stranger in the House*, p. 49.

Conclusion

1. *The Story of Dior. The New Look Revolution*, www.dior.com.

2. Eric Newby, *Something Wholesale. My Life and Times in the Rag Trade* (London: HarperPress, 2010), p. 183.

3. *Picture Post*, 17 September 1947, p. 149.

4. Newby, *Something Wholesale*, p. 187.

5. Peter Russell to Sir Thomas Barlow, quoted in Judy Attfield (ed.), *Utility Reassessed: The Role of Ethics in the Practice of Design (Studies in Design)* (Manchester University Press, 2001), p. 125.

6. Hardy Amies promotional video, 3 February 2014.

7. Withers, *Lifespan*, p. 76.

8. 2nd Lieutenant F. J. Stewart, unpublished Memoirs, p. 95, The Papers of F. J. Stewart, Imperial War Museum, IWM 88/20/1.

Books and articles

Allport, Alan, *Demobbed: Coming Home After World War Two* (Yale University Press, 2009)

Attfield, Judy (ed.), *Utility Reassessed: The Role of Ethics in the Practice of Design (Studies in Design)* (Manchester University Press, 2001)

Board of Trade, *Make Do and Mend* (London: Imperial War Museum, 2007; first published by the Ministry of Information 1943)

Brayley, Martin, *The British Army 1939–45 (1)North-West Europe* (Oxford: Osprey Publishing, 2001)

Broad, Richard and Suzie Fleming (eds), *Nella Last's War. The Second World War Diaries of Housewife, 49* (London: Profile Books, 2006)

Brown, Mike, *The Wartime House: Home Life in Wartime Britain 1939–45* (Stroud: The History Press, 2005)

Bruley, Sue (ed.), *Working for Victory, A diary of life in a Second World War Factory* (Stroud: The History Press, 2001)

Calder, Angus, *The People's War: Britain 1939–1945* (London: Pimlico, 1992; first published Jonathan Cape, 1969)

Cartland, Barbara, *The Years of Opportunity* (London: Hutchinson & Co, 1948)

Cormack, Andrew, *The Royal Air Force 1939–45* (Oxford: Osprey Publishing, 1990)

Cudlipp, Hugh, *Publish and be Damned! The Astonishing Story of the Daily Mirror* (London: Andrew Dakers, 1953)

Donnelly, Peter (ed.), *Mrs Milburn's Diaries. An Englishwoman's day-to-day reflections 1939–45* (London: Harrap, 1979)

Escott, Beryl, *The WAAF* (Oxford: Shire Library, 2003)

Fyfe, Hamilton, *Britain's War-Time Revolution* (London: Victor Gollancz, 1944)

Gardiner, Juliet, *Wartime Britain 1939–1945* (London: Headline, 2004)

Hardie, Melissa, *Digging for Memories, The Women's Land Army in Cornwall* (Penzance: The Hypatia Trust, 2006)

Hargreaves, E. L. and M. M. Gowing, *History of the Second World War: Civil Industry and Trade* (London: HM Stationery Office and Longmans, Green and Co., 1952)

Hartley, Jenny (ed.), *Hearts Undefeated. Women's Writing of the Second World War* (London: Virago Press, 1994)

Hartnell, Norman, *Silver and Gold* (London: Evans Brothers, 1955)

Hawthorne, Rosemary, *Knickers: An Intimate Appraisal* (London: Souvenir Press Ltd, 1985)

Hawthorne, Rosemary, *Bras: A Private View* (London: Souvenir Press Ltd, 1992)

Hawthorne, Rosemary, *Stockings & Suspenders: A Quick Flash* (London: Souvenir Press Ltd, 1993)

Hodgson, Vere, *Few Eggs and No Oranges: Vere Hodgson's Diary 1940–45* (London: Dobson Books, 1976)

Holt, Hazel and Hilary Pym (eds), *A Very Private Eye. The Diaries, Letters and Notebooks of Barbara Pym* (London: Macmillan, 1984)

Howell, Geraldine, *Wartime Fashion from Haute Couture to Homemade 1939–1945* (London: Berg, 2012)

Huff, Alexandra B. with Frederic A. Sharf, *Beauty as Duty. Textiles and the Home Front in WWII Britain* (exhibition catalogue) Museum of Fine Arts, Boston, 2011

Katin, Zelma (in collaboration with Louis Katin), *"Clippie" The Autobiography of a War Time Conductress* (Ipswich: Adam Gordon, 1995; originally published John Gifford, 1944)

Kynaston, David, *Austerity Britain* (London: Bloomsbury, 2008)

Longmate, Norman, *How We Lived Then. A History of Everyday Life during the Second World War* (London: Arrow Books, 1973; first published Hutchinson, 1971)

Lyttelton, Oliver, *The Memoirs of Lord Chandos* (London: The Bodley Head, 1962)

McDowell, Colin, *Forties Fashion and the New Look* (London: Bloomsbury, 1997)

Malcolmson, Patricia and Robert Malcolmson (eds), *Dorset in Wartime. The Diary of Phyllis Walther 1941–1942* (Dorchester: Dorset Record Society, 2009)

Mass Observation/Tom Harrison and Charles Madge (eds), *War Begins at Home* (London: Chatto & Windus, 1940)

Mills, Jon, *Within the Island Fortress. The Uniforms, Insignia & Ephemera of the Home Front in Britain 1939–1945. No. 1, The Women's Voluntary Service (WVS)* (Orpington: Warden's Publishing, 2005)

Mills, Jon, *Within the Island Fortress. The Uniforms, Insignia & Ephemera of the Home Front in Britain 1939–1945. No. 2, Identity Cards, Permits and Passes* (Orpington: Warden's Publishing, 2006)

Mills, Jon, *Within the Island Fortress. The Uniforms, Insignia & Ephemera of the Home Front in Britain 1939–1945. No. 3, Pre-Service Training Corps for Girls* (Orpington: Warden's Publishing, 2008)

Mulvagh, J., *Vogue History of Twentieth Century Fashion* (London: Bloomsbury Books, 1992)

Newby, Eric, *Something Wholesale. My Life and Times in the Rag Trade* (London: HarperPress, 2010)

Nicholson, Virginia, *Millions Like Us: Women's Lives During the Second World War* (London: Penguin, 2012)

Partington, S. V. (ed), *Mrs Miles's Diary, The Wartime Journal of a Housewife on the Home Front,* (London: Simon & Schuster in association with Imperial War Museums, 2013)

Penrose, Antony (ed.), *Lee Miller's War 1944–45* (New York: Thames & Hudson, 2005)

Practical Knitting Illustrated, published by Odhams Press Ltd (undated, *c.* 1946)

Rich, Molly, *A Vicarage in the Blitz. The Wartime Letters of Molly Rich 1940–1944, with Illustrations by Anthea Craigmyle* (Kent: Balloon View Ltd, 2013)

Robinson, Julian, *Fashion in the Forties* (London: Academy Editions, 1980)

Sheridan, Dorothy (ed.), *Wartime Women. A Mass Observation Anthology 1937–45* (London: Phoenix Press, 2000; first published by William Heinemann, 1990)

Sladen, Christopher, *The Conscription of Fashion. Utility Cloth, Clothing and Footwear 1941–1952* (Aldershot: Scolar Press, 1995)

Smith, May, *These Wonderful Rumours* (London: Virago Press, 2013)

Spokes Symonds, Ann, *The Changing Faces of North Oxford, Part I* (Witney: Robert Boyd Publications, 1998)

Struther, Jan, 'Mrs Miniver's Peace in War', *The Times*, 5 October 1939

Summers, Julie, *Stranger in the House* (London: Simon & Schuster, 2008)

Summers, Julie, *Jambusters. The Story of the Women's Institute in the Second World War*, London: Simon & Schuster, 2013)

Sumner, Ian, *The Royal Navy 1939–45* (Oxford: Osprey Publishing, 2001)

Titmuss, Richard M., *History of the Second World War: Problems of Social Policy* (London: HM Stationery Office and Longmans, Green and Co., 1950)

Turudich, Daniela, *1940s Hairstyles*, 2nd edn (Chicago: Streamline Press, 2011)

Walford, Jonathan, *Forties Fashion. From Siren Suits to the New Look* (London: Thames and Hudson, 2008)

Waller, Jane and Michael Vaughan-Rees, *Women in Wartime, The Role of Women's Magazines 1939–1945* (London: Macdonald Optima, 1987)

Withers, Audrey, *Lifespan* (London: Peter Owen Publishers, 1994)

Wood, Maggie, *"We wore what we'd got". Women's Clothes in World War II* (Warwickshire Books, 1989)

Periodicals, Reports and Leaflets

Drapers' Record

Good Housekeeping

Harper's Bazaar

Homes and Gardens

The Land Girl

Mother and Home

Picture Post, 1940–45

Vogue, 1939–47

Woman and Beauty

Woman's Own

Home & Country: The Journal of the Women's Institutes, monthly magazine with county supplements, 1939–42

Ministry of Information, *Make Do and Mend* (London, Ministry of Information, 1943)

Mass Observation Report No. 887, *Civilian Attitudes to the Navy compared with Army and RAF*, 30 September 1941

Town Children Through Country Eyes: A Survey on Evacuation, 1940 (Dorking: NFWI, 1940)

Broadcasts

Priestley, J. B., *Postscripts* (Heinemann, 1940), transcript of broadcast aired on 22 September 1940

Lyttelton, Oliver, BBC Radio Broadcast to announce the introduction of Clothes
 Rationing, 1 June 1941
Can I Help You?, BBC Home Service, 10 March 1942
BBC Home Service Broadcast, 10 March 1942

Unpublished Sources

Robinson, Elizabeth, 'England Expects: Knitting, Women and Gender in the
 Second World War', Ph.D. Thesis, September 2008 (Royal Holloway,
 University of London)
Mason, Gladys, unpublished diaries, 1939, 1940, 1941
[A]Imperial War Museum archives
IWM 08/33/1 Private Papers of Miss M. Redman, MBE
IWM 04/40/1 Miss Rose G. Cottrell
IWM 87/5/1 Beatrice Muriel Richards (née Carr)
IWM 95/14/1 Miss Phyllis Warner
IWM 11/31/1 Private Papers of J. S. Gurney
IWM 02/27/1 Mrs B. MacDonald
IWM 94/39/1 Private Papers of W. B. Fagg, CMG
IWM 96/1/1 Private Papers of Mr and Mrs H. Khuner
IWM 07/87/2 Private Papers of R. F. Tonks
IWM 16685 Private Papers of Miss F. Hyatt
IWM 88/20/1 The papers of F. J. Stewart
IWM 61/212/1–2 Private Papers of Molly Rich

Imperial War Museum Sound Archive

IWM Sound 12918 'Demobbed'

Websites

www2peopleswar/stories/77/a3331577
www2peopleswar/stories/32/a2057032
www.fashion-era.com 1914–1920
Oxford Dictionary of National Biography online, entries for Stella, Marchioness of
 Reading; Norman Hartnell; William Fagg, CMG; Hardy Amies; Captain
 Colin Molyneux

List of Illustrations

Endpapers: Page of clothing coupons. Image © IWM (K11 / 21)

Plates

12. Hardy Amies designs his spring collection. Fred Ramage/Getty Images.
13. A set of silk underwear made by Patricia Mountbatten in 1943. Image © IWM (EPH 10930).
14. A model wearing a Norman Hartnell utility dress. Image © IWM (D 14820).
15. *Ruby Loftus screwing a Breech-ring* by Dame Laura Knight, 1943. Image © IWM (Art.IWM ART LD 2850).
16. 'If only they knew what they looked like' by Edward Ardizzione, 1941. Image © IWM (Art.IWM ART LD 1339).
17. A model wearing Christian Dior's New Look in Paris, 1947. Keystone-France/Gamma-Keystone via Getty Images.

Text

3 'Make Do and Mend' advertisement. The National Archives/SSPL/Getty Images.
11 *Vogue* Pattern Book.
20 'Flattering Daks Suits' advertisement.
29 Gladys and Frank Mason on their wedding day. Private Collection.
34 A soldier in uniform. Image © IWM (D 12669).
39 Christmas card, 1941: an RAF officer escorting two girls. Mary Evans Picture Library.
45 Wrens collecting their uniforms. Fox Photos/Getty Images.
50 Tram conductress. Image © IWM (D 8761).
55 Land girls marching off to work. Image © IWM (D 8797).
60 'For this sheltered life' advertisement.
72 *Vogue* page showing aftermath of air attack, Condé Nast.
79 'Count your coupons *before* you go shopping' advertisement. Image © IWM (Art.IWM PST 8293).
86 Clothing coupon books. Image © IWM (D 14000).
95 CC41 logo. Image © IWM (Documents.2704).
102 Prototype utility coat by IncSoc designers. Image © IWM (D 9646).
121 A model wears the 'Berlei' design of corset. Kurt Hutton/ Getty.
126 Underwear for various different ages. Image © IWM (D 13088).
135 Mrs Sew-and-Sew. Image © IWM (D 18974).
142 Eileen Gurney's illustration of changes made to a coat. Image © IWM (Documents. 15658), image courtesy of Stella.

While every effort has been made to contact copyright-holders of illustrations, the author and publishers would be grateful for information about any illustrations where they have been unable to trace them, and would be glad to make amendments in further editions.

Index

Figures in *italics* indicate captions.

Hitler, Adolf 30, 77, 122
'Baedeker' raids 94–5
bombing campaign of Britain 63
first attempt on his life 17
and siege of Warsaw 30
HMSO: 'The Clothing Quiz' 78, 81
Hoare, Sir Samuel 52
Holland, German invasion of (1940) 58
Hollywood fashion 15, 105, 161
Holmes, Winifred 109–110
First Baby 109
Home and Country magazine 23, 24
Home Companion magazine 124–5
Home Guard (previously Local Defence Volunteers) 51, 84, Pl.4
Homes and Gardens magazine 104
Hore-Belisha, Leslie 70
House of Commons 1, 107, 155
House of Lachasse 100, 101, 194*n*39
House of Worth 101, 102, 103
housecoats 62, 141–2
household goods, utility 95
Howell, Geraldine 25
Hudson, Valerie 19
Hurman, Preston 41
Hyatt, Florence (Flo) 6, 52, 81, 82, 89–90, 106, 108, 112, 113, 118, 122, 126–7, 128, 133, 134, 142–3, 175, 179, 180, Pl.2
Hyatt, Janine 6
Hyde Park, London 179–80

I

Imperial War Museums, London 44, 117, 148, 207, 208
Fashion on the Ration exhibition (2015) 208
imports 95

Incorporated Society of London Fashion Designers (IncSoc) *102*, 178, Pl.12
aim of 100
austerity requirements 103
formed 100, 102
influence of 178
members 100–103
the trade complains about utility designs 105
industry: female conscription 47
inflation 65
Ingillson, Mrs 82, 83
Intelligence Corps 101

J

jackets
bus conductors 48
dinner 10, 19–20
double-breasted 35, 108, 179
drill 54
fur 65
Harris tweed 141
home-made 136
long-waisted 58
shearling 38
short 25, 30
single-breasted 38
tweed 153
Jacobs, Mary 116
Jacqmar 102, 193–4*n*39
scarves 103, 110–11, Pl.11
Jaeger's, Regent Street, London 71, 151
James, Vera 56
Jarrow, Tyne and Wear 9
jersey 54
jerseys 35
jewellery 119
costume 13

About IWM

IWM (Imperial War Museums) is a global authority on conflict and its impact, from the First World War to the present day, in Britain, its Empire and Commonwealth. IWM's unique collections made up of the everyday and exceptional tell the story of how war changes lives.

Frederic A. Sharf

Frederic A. Sharf is a well-known collector, scholar, and author. He specialises in acquiring archives of design drawings which he researches and organises for public exhibitions. Mr Sharf has co-written over forty art books and exhibition catalogues for a range of institutions and has been a generous supporter of many museums, notably the Museum of Fine Arts (MFA) in Boston.

Mr Sharf worked in the East End of London in 1952 as a Winant Volunteer as part of a programme which encouraged young Americans

to volunteer in post-war London to assist in areas of poverty and social deprivation. Mr Sharf worked in the Vallance Youth Club near Brick Lane, and was particularly inspired by the work of the club's director, Mickey Davies, a community leader who had organised the building of a large air raid shelter under Spitalfields Market during the Blitz. Mr Sharf developed a strong and enduring interest in wartime London during his stay in the city.

Mr Sharf's interest in British wartime women's wear in particular, especially scarves, was born in 2005 when he attended an exhibition at The Bard Graduate Center in New York City, entitled *Textiles on the Home Front in Japan, Britain and the United States, 1931–1945*. Mr Sharf and his wife Jean were struck by the propaganda scarves on show, and began to collect such scarves early in 2006.

Acquiring wartime women's clothing seemed a logical extension to the scarf collection, and in 2008 Mr Sharf began to add pieces of women's clothing to his collection. Eventually his interest would focus in on British women's utility clothing. The entire Sharf collection was donated to MFA, Boston and to IWM London and the Sharf WWII fashion exhibited at MFA, Boston, and Norton Museum of Art, West Palm Beach, Florida. Jean and Frederic Sharf have provided generous support for the *Fashion on the Ration* exhibition at IWM London in 2015.